Painting
with Watercolour

2-
084.

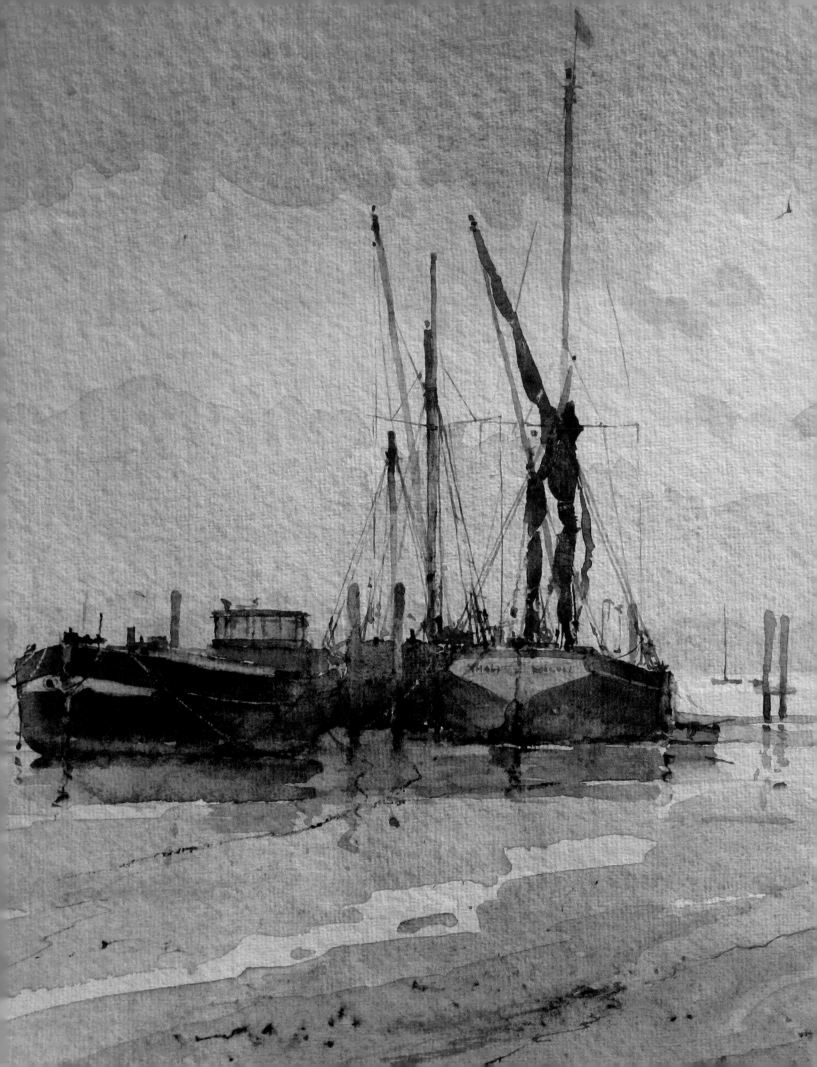

Painting with Watercolour

David Howell

THE CROWOOD PRESS

First published in 2017 by
The Crowood Press Ltd
Ramsbury, Marlborough
Wiltshire SN8 2HR

www.crowood.com

British Library Cataloguing-in-Publication Data
A catalogue record for this book is available from the British Library.

ISBN 978 1 78500 230 4

FRONTISPIECE: *Pin Mill Barges.*

Graphic design and layout by Peggy Issenman, Peggy & Co. Design Inc.
Printed and bound in India by Replika Press Pvt. Ltd.

Contents

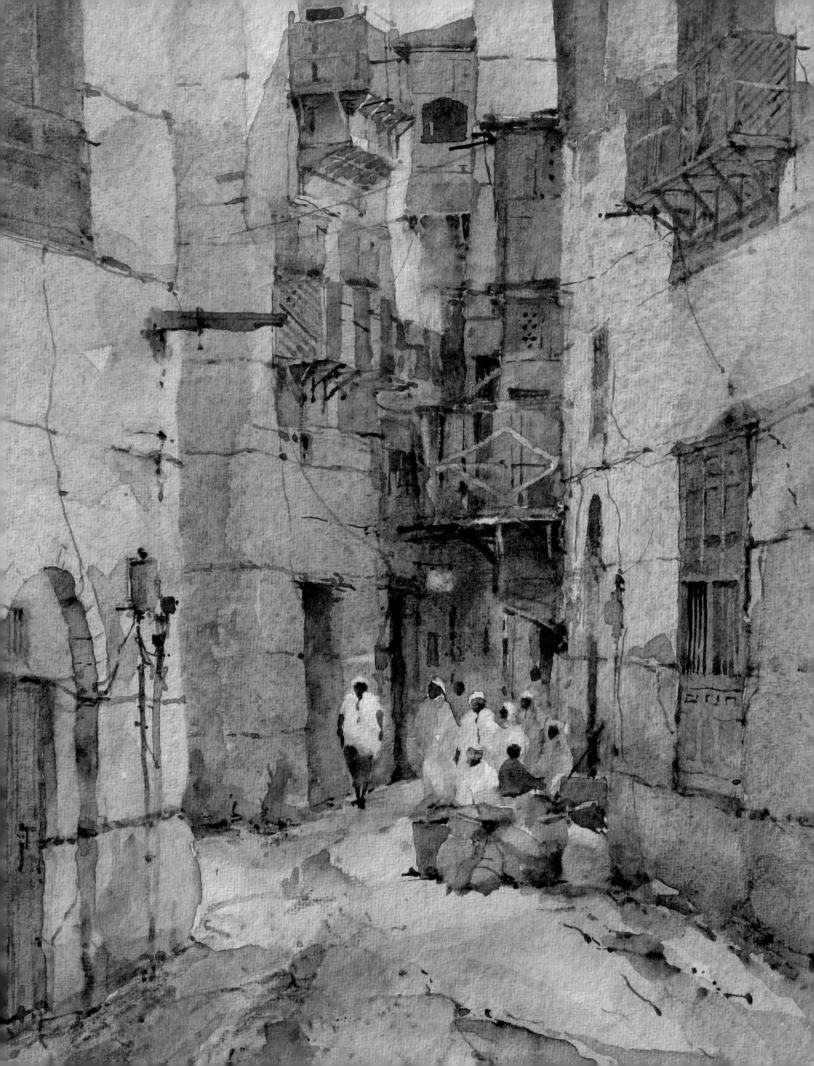

Introduction

Of all the painting mediums that have evolved over the centuries, it's a fairly safe bet that watercolour was the first. Colours may have been limited to browns, umbers or ochres depending on where your cave was located but at some stage our ancestors would have passed the occasional happy hour stirring around in a puddle with a stick and making marks on themselves and on nearby rocks and walls. All over the world there are examples of cave art that dates back to pre-historic times, where individuals have portrayed figures and animals in particular and in the process found different coloured pigments as well as charcoal from the fire to make their paintings more effective.

What is particularly apparent in most examples are the drawing skills that allowed the artists to portray the animals they hunted and lived amongst so superbly and whilst they may not have had access to brushes, they would have discovered that a bit of animal fur dipped in pigment worked pretty well and there is even evidence to suggest that they made stencils and sprayed 'paint' on. Bearing in mind most of this activity at the time would have been done in very dim lighting conditions and that the artists wouldn't have been able to hop outside with a camera to take a few pics to copy back in the cave, what we can see is a testament both to their artistic skills and their powers of observation and memory to create something, that in the best examples, is quite extraordinary.

In relatively more recent times other forms of painting have been developed, along with an ever-widening range of pigments and today's painters are spoilt for choice but despite this, watercolour has kept pace and is arguably the favourite and most convenient medium for most amateur painters and is highly regarded by many of today's professionals.

My own watercolour journey started when I was about five or six at a time when the wireless or a gramophone was the only form of electronic entertainment and that it was perfectly normal to find kids something to do to keep them occupied and out of the way and my first paint box was a standard example of the black metal variety with twelve half pans and mixing wells in the lid. My subjects at the time were in much the same genre as the cave dwellers thousands of years before, in that I painted what I saw outside which, rather than bison, wolves, jackals, and the odd elephant, were more likely to be Bedfords, Leylands, Fords, and Albions and anything else that might be driving past on a regular basis. As my painting developed over the years with oils and acrylics, watercolours were relegated to a supporting role as initial sketches for larger paintings but my wife often expressed a preference for the watercolours and later an ever increasing number of customers made the same choice. This book is based on seventy years of working with all the highs and lows of what is seen in some circles as a difficult medium. It's written by a painter of work that might be described as figurative or representational, who is most at home amongst landscape and marine subjects with occasional forays into other genre and the contents of this book reflect that, whilst accepting that there are other ways of tackling and using watercolour. Painting isn't meant to be easy and watercolour can offer more than a few challenges but it is deeply satisfying if you get it somewhere about right and this book offers practical ways of working with the medium and at the same time offers ideas and thoughts that can make your painting methods more exciting and adventurous and simply more painterly.

OPPOSITE *The Bedouin Souk, Jeddah.*

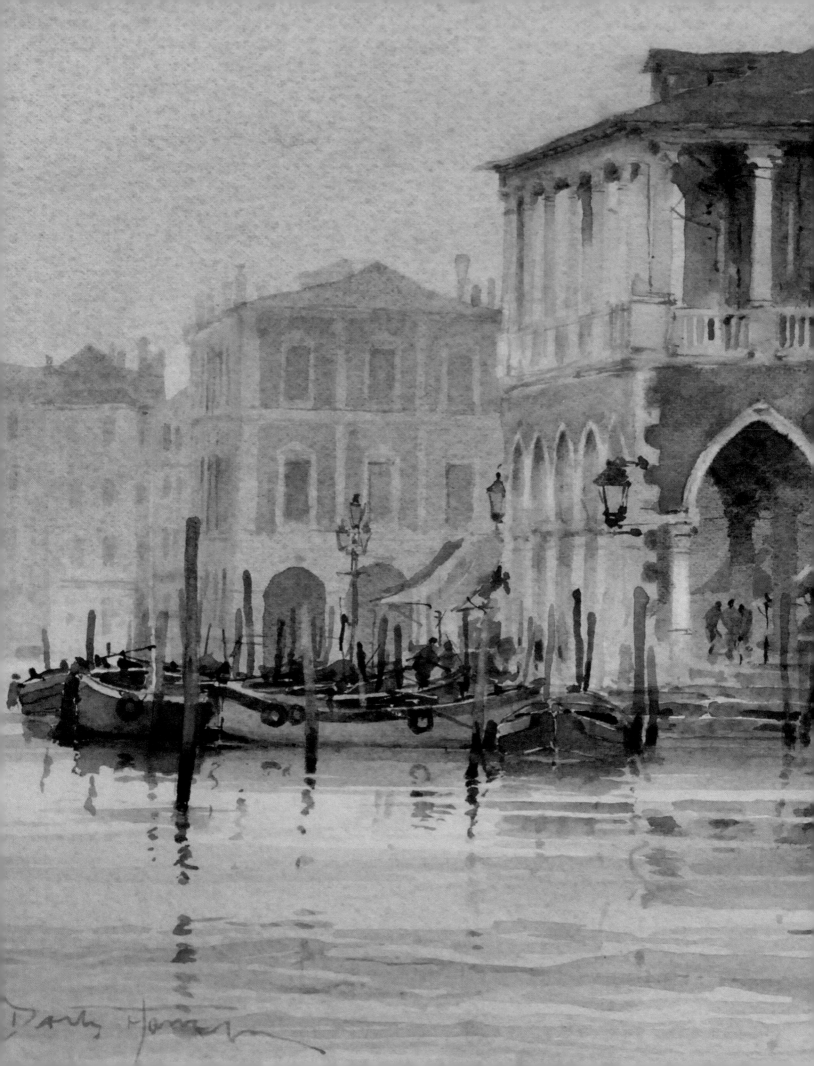

Materials and Equipment

One of the great attractions of watercolour is that you really don't need very much in the way of materials and equipment. In its simplest form all that is needed is a basic paint box, a brush, something to paint on and a supply of water. However, we live in a world where hardly a week goes by without new products and paints appearing on the market and where internet shopping gives us access to an ever widening range of goodies but it's still worth reiterating at this stage that, as watercolour painters, you really don't need a huge amount of stuff but investment in quality rather than quantity will pay dividends.

Paint

The major manufacturers of paint have a range of at least 100 colours on offer and at least a couple have well over 200. This is all very exciting and possibly confusing but it's up to us as painters to be selective and to find a range of pigments that suit our individual approach to the medium. The reality is that a carefully chosen range of the primary colours together with a selection of Earth pigments is sufficient to allow a painter to produce pretty well anything in terms of colour and hue that is needed, irrespective of location or subject matter, whereas buying paint just because it looks interesting on a colour chart or the name sounds different and exciting, might just be a way of making things rather expensive and unnecessarily complicated. We will all be tempted at some point to try something different but apart from botanical painters or illustrators who might spend ages looking for just the right colour straight out of the tube, the rest of us should get used to a tried and tested range of colours that

Fig. 1.0 *Il Pescheria, Venice.*

Fig. 1.1 Primary colours from left to right: Cobalt Blue, Ultramarine, Alizarin Crimson, Cadmium Red, Cadmium Yellow and Cadmium Lemon.

works for us in any situation and can be mixed to produce any tone, colour or tint required. It's so easy with spontaneous buying of this and that to end up with a selection of tubes or pans that rarely see the light of day and just take up storage space. The other argument for sticking with a limited palette is that you get used to the paints involved, their tinting power and how they mix and you will have a pretty good idea of what they will look like, both when they hit the paper and when they have dried. Remember watercolour dries a paler shade than when it's wet and familiarity with colours allows you to concentrate on the subject, rather than wondering what's going to happen next.

The primary colours for a painter are blue, yellow and red – in other words they are colours that cannot be created by mixing other pigments – but any examination of manufacturers' colour charts will reveal a wide choice and raises the rather obvious question of which blue, yellow and red? My answer is to have a 'double primary' cool and warm version, that effectively straddles what might be considered pure; Fig. 1.1 shows my selection. Starting with blue, my choices are Cobalt as the cool version and Ultramarine as the warm. Cobalt Blue is getting close to as pure as cool blue can get, while Ultramarine has a distinctly warmer shade, and French Ultramarine is usually a little bit warmer still. With reds, I opt for Alizarin Crimson as the cool one and Cadmium Red as the warm; for the yellows, I have Cadmium

Fig. 1.2 Earth colours from left to right: Yellow Ochre, Raw Sienna, Raw Umber, Burnt Sienna, Burnt Umber and Light Red.

Lemon on the cool side and Cadmium Yellow on the warm. If you look at these primaries on a colour wheel, they are roughly equally spaced, and having a cool and warm version is helpful in moving towards secondary colours, i.e. a mix of two primary colours, and helping to ensure that the mixes are clear and vibrant. This colour mixing principle is covered in more detail in Chapter 5, but what this double primary selection will give you is the ability to produce any colour you want in your paintings.

Earth colours (see Fig 1.2 for my selection) originate from clay earth and give the painter a range of ochres and umbers that can be mixed with primary colours where appropriate, to give modulated tones and deeper shades or just be used in washes on their own.

These twelve colours make up my basic limited palette and are all that I carry in my smallest paint box. A lot of larger boxes, of course, have more capacity and my larger palette-style field boxes have space for sixteen and give me the opportunity to add four more. As a landscape and marine painter I will invariably have even cooler blues on board – Cerulean Blue is a beautiful cool blue for winter skies, snow shadows, and water, while Prussian is an even colder blue and is handy for mixing dark greens and blues but it requires careful handling as it has very strong staining characteristics and if used injudiciously can ruin a painting. With reds I add Brown Madder which for me is a subtle alternative to Alizarin and when mixed with blues makes warm greys in much the same way as Light Red does. Although more recently I've been using Old Holland's Red Umber as an alternative, which helps create another range of cooler greys without making them too wintery. If you do want cold greys then either of the main blues mixed with Burnt Sienna or Burnt Umber will do the job. Finally, Sepia sometimes makes it to the start line, as it's handy for serious dark areas on harbour walls and mud, but again should be used sparingly.

All of these colours might be labelled as traditional and apart from Red Umber are available from all manufacturers as part of their standard ranges of paint. In manufacturing and marketing nothing stands still and in recent years there have

been new colours appearing, many of which owe their origins to more industrial applications like painting vehicles, and some use a synthetic binder as distinct from the traditional Gum Arabic which claims to allow a higher pigment loading leading to stronger tones. This all sounds very exciting but there are practical considerations to introducing colours that were originally designed to add sparkle and desire in a car showroom. What is most important for a painter is to have a range of colours that work well in harmony with each other and introducing a few colours that are excessively bright or dominant can be a disruptive factor. Ultimately it depends on what you are trying to achieve with your painting but beware of ending up with pictures that are unrealistically garish.

Paint Boxes and Palettes

If your painting is confined to home or studio, you can keep a stock of paint in tubes and squeeze out paint on to a palette when needed, or you can raid the kitchen for the odd plate or saucer. However, if you plan to venture further afield or even if you just want to keep things organized, you need a decent paint box. Fellow painters and tutors alike will have experienced the problems that come with an individual student who turns up to a painting session and proceeds to spread out Tupperware containers, the odd butcher's tray, kitchen rolls, carrier bags etc., and who generally takes up too much space and they will invariably be the ones who keep the rest of the group waiting on field trips or need help with carrying all the gear. If you're serious about your painting, leave this sort of muddle and messing about to others, not least because it's totally impractical if you want to work *en plein air*. A paint box doesn't have to be expensive but what a good one will have is sufficient space for around twelve to sixteen colours with plenty of mixing area and be equally suitable for studio use or for carrying to a group painting session or working outside. It should have a lid that keeps the contents protected and equally helps to protect the environment from stray paint and will also help to keep pans or squeezed out paint moist. Finally, some way of holding the box like a thumb ring is always helpful, particularly if you're working on location.

Most watercolour paint comes in two forms, either as pans or in tubes and as far as boxes go you have to decide which works best for you. The good news is that there are often 'deals' to be had on equipped paint boxes, where if you work out the normal cost of the paint contained, the box itself is effectively free. The downside of this approach is that you will end up with the manufacturer's choice of colours which may well include things that you're never going to use. Nevertheless even allowing

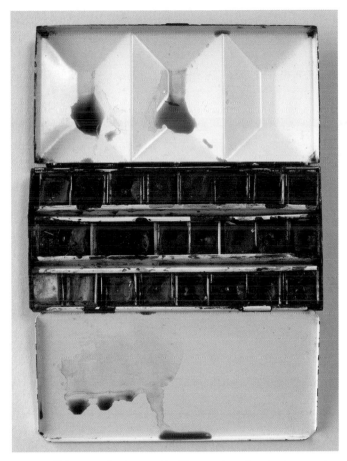

Fig. 1.4 This is a Holbein folding palette. Handmade in Japan, these boxes come in various sizes and this relatively compact 4 × 8in (10 × 21cm) version has space for sixteen colours, plenty of mixing area and folds over and shuts when not in use. It's very practical in that it's more robust than plastic and doesn't require such a commitment in terms of either amounts of paint or the expense of the larger top of the range handmade brass boxes. It's also much lighter in weight than a brass box which is an important consideration if you are working for long periods on location – repetitive strain injury is not unknown if you spend hours with a heavy paint box fixed to one arm! Inevitably at some point with a steel box, corrosion will rear its head but this one has lasted around twenty years and is only just starting to get a little tatty.

Fig. 1.3 This somewhat battered looking specimen is a classic example of the ubiquitous black metal paint box that's very similar to the sort that many of us started out with as kids. Measuring slightly less than 3 × 6in (7.5 × 15cm) it's very practical and compact enough to slip into a pocket. This one started life as a Winsor & Newton 16 × half pan box but the centre section allows the addition of more pans and in this case the frequently used Cobalt and Ultramarine are in whole pan form. There is a reasonable amount of mixing space with the flap and three wells and it has a thumb ring on the bottom which allows it to be fixed to one hand, leaving the other free to hold a brush. There are a few more colours than the sixteen suggested earlier but even a professional has to do a little experimenting.

for dumping some of the colours from an equipped box and replacing them with something more appropriate, they are still frequently a better buy than starting with an empty box and filling it yourself.

Boxes come in either plastic or metal and in a myriad of shapes, sizes and layouts. Metal ones are arguably more robust than plastic and for that matter some metal examples are stronger than others. They will get a fair amount of wear and tear in the hands of an enthusiastic painter, particularly if they are being used on location and toted around in rucksacks and bags. What is important is to have sufficient space for a basic range of colours and proper mixing areas. The traditional black metal box still takes some beating and is widely available in versions that will

allow anything from twelve to forty-eight half pans, whole pans or tubes. Bearing in mind that you probably don't need more than around sixteen colours it's more important to find one that has a good balance between space for paint and places to mix it. Three decent sized mixing wells and perhaps a flat mixing flap are more practical than having a large selection of colours and nowhere to mix them and don't get too excited with boxes that include brushes as they are invariably so tiny as to be fairly useless.

Smaller half pan boxes have the advantage of being compact enough to stuff in a pocket, which is very handy when travelling light and working outside but the downside is that the pans themselves are a bit small for use with big brushes. However, many boxes, particularly those with a clip system to hold the pans, will allow you to install both half and whole pans so that the colours that are more in demand with big brushes can be larger. Having a box containing tubes rather than pans of paint may look neat and tidy but tubes take up a lot of the available space and the colour has to be squeezed out somewhere and that invariably takes up most of the remaining mixing area.

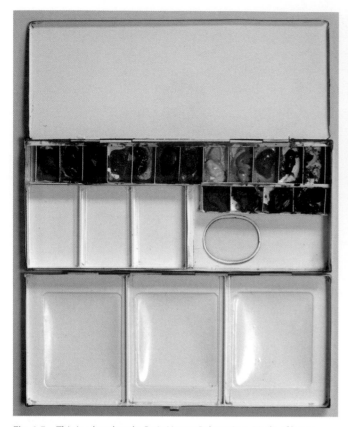

Fig. 1.5 This is a handmade Craig Young Palette Box. Made of brass, it has divisions for the usual sixteen colours but the sections contain enough paint for days of painting and whilst the dimensions of 4 × 9.5in (10 × 24cm) and the weight mean that it's hardly compact, it nevertheless is extremely practical for use with larger works and big brushes. It has six large mixing wells plus the flap and the thumb hole provides a means of securing it to the hand. Whether in terms of cost or in use, this box isn't for the faint hearted but its brass construction means that it won't rust like conventional tin boxes and should stand up to a lifetime of professional work and even be a collector's item in years to come. Boxes like this are available in other designs and capacities from one or two sources but be warned, delivery times are long.

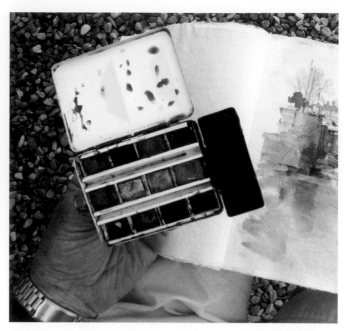

Fig. 1.6 Going to the other extreme this is about as small as a sensible working box can be. This little gem holds twelve half pans and has its own water supply built in with the lid hooked on the side acting as a water reservoir. It's equipped with a thumb ring and when closed measures only 2.5 × 3in (6 × 9cm). It's obviously a bit short of mixing space but this one is in constant use. It's so easy to slip in a pocket along with a retractable brush and a small watercolour pad. This one is from Winsor & Newton but other manufacturers offer what appears to be essentially the same box and there are alternative types of travel boxes.

Pans will dry out if they're not used for some time and even crack or shrink so that bits start dropping out, particularly as they get towards the end of their life. They are easily replaced and it's worth doing that sooner rather than later. It's all too easy to turn up at a painting venue and then find that the last vestiges of Burnt Umber or Cadmium Yellow have dropped out *en-route* and there's also the problem that flaking paint is likely to appear as pure undiluted pigment in washes with fairly disastrous results.

One way of overcoming the limitations of a conventional black box containing tubes is to move the whole process up a gear or two and go for a palette style box that allows for paint to be squeezed out and used in the studio as well as on location. Larger versions of them definitely won't easily fit in a pocket but they can contain sufficient paint for days away, have plenty of large mixing areas and work fine with big brushes. Plastic ones are the cheapest option but there are handmade steel and aluminium versions available at reasonable prices and the ultimate are handmade brass ones.

If you do opt for this type of box or for that matter use a lot of paint in the studio with palettes, it's more economical to buy paint in larger tubes. The ones found in off-the-shelf paint boxes are invariably 5ml but larger tubes are available containing 15/20ml – three to four times the amount of paint at roughly double the price of a small tube. Winsor & Newton even produce a limited number of colours in 37ml tubes which represent a serious saving if you use that much paint. Do be aware however that if large quantities of paint are squeezed out and only used occasionally, as with pans, it will start to dry out and break up.

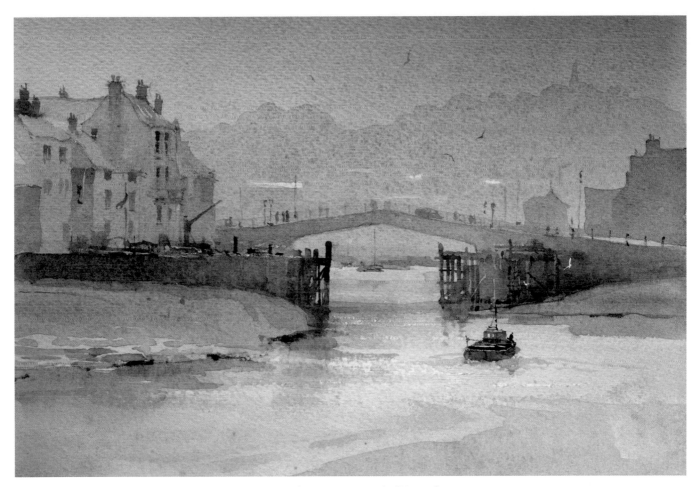

Fig. 1.7 This is a watercolour sketch of Whitby Harbour. Painted on 300gsm Waterford Not surface paper in a 19 × 28cm RKB Fatpad, using my Winsor & Newton Bottle Box illustrated in Fig. 1.6 and a size 12 Escoda retractable sable brush. No fuss, no clutter, just basic good quality kit.

Brushes

Brushes for watercolour tend to fall into two categories, those that will release their load of paint fairly quickly and those that will hold a quantity of paint but will release it in a controlled manner so that the painter can decide where the paint is going and how much. The ultimate hair for this sort of control is sable and whilst sable brushes are an expensive item, all watercolour painters should aim to have at least one or two. Sables have an extraordinary ability to hang onto a load of paint and it is this characteristic that makes them so essential for the serious painter. A good sized sable brush will 'point' to allow relatively fine detail yet be able to work over larger areas and will have the sort of spring that allows the painter to regulate the flow of paint by increasing or decreasing pressure.

A top quality sable will give years of service, although eventually it will lose its fine point but it then becomes ideal for areas where loose brushwork is required and I have sables like

this that have been around for decades. For those on a budget something like a size 12 and perhaps a 6 or 7 for finer work is about right but prices do escalate for larger sizes. However, do be aware that buying online has made the process a lot more competitive and there are companies like Rosemary Brushes that only supply directly to the customer. Investing in a size 14 or 16 would encourage bolder work but there is a point where even bigger brushes need to be made of something that will allow more flow. This is usually provided with other animal hair brushes or synthetics or even a mix of the two.

Applying smooth big even washes requires a brush that covers the paper quickly and this is usually achieved by using brushes that are frequently known as mops or wash brushes. Arguably the best of animal hair versions are those made with squirrel which, apart from holding a large amount of paint, have a softness that helps to ensure smooth washes and will release it quickly when required onto the paper. Sizing on these brushes is different to sables which does slightly confuse things but the best thing when

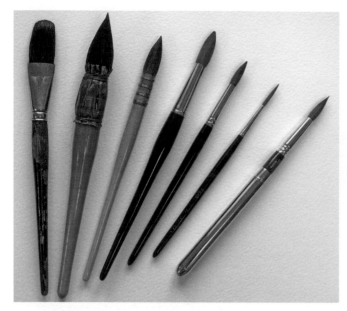

Fig. 1.8 A selection of my brushes that are in use all the time. They are from left to right – an ancient 1in squirrel flat wash brush which still produces wonderful skies and clouds, size 10 (Isabey) and size 6 (Rosemary) squirrel *petit gris* mops, size 20 and 12 round sables and a sable rigger (all Rosemary Brushes) and finally a size 12 Escoda retractable sable. These are all conventional in shape apart from possibly the rigger, which is ideal for producing long thin lines for mooring ropes, telegraph wires etc. but there is a variety of specialist shape brushes available designed for specific tasks.

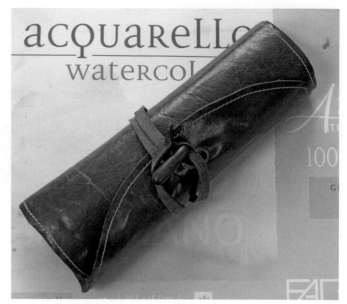

Fig. 1.9 My leather brush wrap which is hand made by Rosemary Brushes. This might be considered the ultimate brush wrap but similar designs can be obtained made of canvas or other materials that will cope with a collection of brushes and ensures that they travel safely. Other brush containers range from zip up cases to wooden boxes but be wary of any that allow the brushes to rattle around inside.

considering them is to either see the real thing or get hold of a catalogue that shows them life size. The two main configurations are either flat or *petit gris*. Flats are normally sized by their width and a typical wash brush will be somewhere between ½in and 1in wide. The *petit gris* round type are readily identifiable by their wired on quills round the hair which invariably comes to a decent point but with a bulky profile which allows a big paint load to be carried. They are very versatile in that they can be used for wash areas and at the same time enable the painter to get basic shapes painted in. They encourage bold and fast work and every painter will probably benefit from taking one of these on and going for it. Sizes range from around 5.5mm wide to over 20mm and whilst the larger sizes can be somewhat intimidating to use, working with one on a large sheet of paper can be liberating and certainly won't allow you to get bogged down with too much detail. There is a downside to these brushes in that they are not generally very robust. The thin wires holding the quill break and it's not unknown for the head of the brush to come off altogether. I've resorted to fishing line, superglue and sticky tape from time to time to hold things together.

There are alternatives in that there are more conventionally constructed round squirrel hair brushes and bearing in mind the primary role of this sort of brush is to get paint onto paper quickly, some of the brushes that use synthetic hair are worth a second look. Early versions of synthetic brushes were cheap and cheerful and fairly hopeless but brush manufacturers have developed new materials that claim to offer the possibility of performing nearly as well as animal hair and wash brushes that combine a mix of synthetic with animal hair may well be fine for fast loose work where control is not so important. However, it follows that as the quality of synthetic brushes improves, the nearer the price gets to the real thing!

It's important to look after your brushes. Make sure that they're clean after every painting session and don't leave them standing head down in the water pot which will quickly ruin them. Take care of them and they will last for a long time. If you are travelling to paint with a group or *en plein air*, you should find something to keep them in, either a case, box or a wrap so that they are protected from jostling around with the other contents of your bag or rucksack.

Paper

The manufacturing process of watercolour paper has been developed over hundreds of years with the object of creating a surface that will stand up to having water and paint applied to it without soaking it up like blotting paper or falling apart. In addition, it has to be acid free to ensure that with care it doesn't eventually turn yellow or develop brown spots (known as foxing) or even disintegrate like ordinary everyday paper and in the process destroy the painting on it. There are numerous inexpensive cartridge papers and pads that claim to be able to cope with watercolour but if you're serious about your painting you need to be investing in proper watercolour paper designed for the job. There must be many would-be watercolour painters who started with inexpensive paper to save money whilst getting the hang of it and have given up, because mastering the medium with inferior paper is just about impossible for the beginner and those of you who are learning to cope with this fantastic medium should at least invest in something decent to paint on.

As an individual painter, even as a professional, it isn't really practical to try everything that's on the market as painting is liable to turn into an expensive and time consuming experiment. However you should at least try some different papers until you find something that really suits your approach. As ever, the old adage of 'you get what you pay for' applies and the premium price papers made of 100 per cent cotton or linen rag are undoubtedly the best to work on for most watercolour painters and actually make the task of mastering the medium easier than some of the less expensive ones.

100 per cent cotton watercolour papers are usually described as either mould made or handmade. Mould made papers are manufactured with the aid of a mechanized mould process which ensures the consistency of the finished product and produces a finished paper with an ideal surface to work on and all the major watercolour paper manufacturers use this method of production to ensure that their products are consistent and reliable – in other words the paper handles and reacts to being worked on in much the same way each time you use it and production controls ensure that there are minimal variations from one batch to the next. Handmade papers however are often more unpredictable and frequently slightly challenging and are capable of beautiful results as well as the occasional disaster. Their attraction is in the variety of surface which has a less regular appearance with occasional lumps and bumps and the odd mark and there can be irregularities in the surface sizing that results in odd patches of darker colour in the finished painting. Some are better than others but inevitably with a handmade product, there can also be variations from one batch to the next.

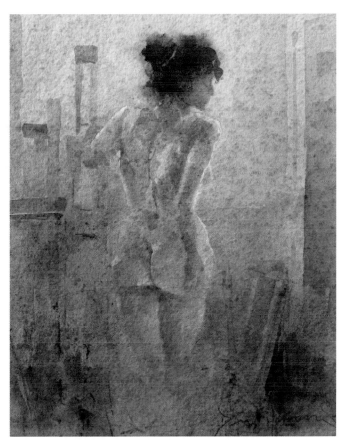

Fig. 1.10　This nude study was painted on Two Rivers handmade paper from a small converted watermill in Somerset. With no preliminary drawing, the painting has used wet in wet technique and large brushes and the paper has enhanced the picture with both its ability to allow brilliant colour along with granulation and odd blotches. Perhaps a paper not for the faint hearted but one to occasionally let your hair down with.

The choice ultimately depends on whether you want a predictable paper that allows you to concentrate on the painting or whether you want to walk on the wild side and enjoy the excitement of not quite being sure of what is going to happen next. For the more adventurous and possibly experienced painters working with handmade paper is a way of developing your painting and its imperfections can help to add a looseness and sparkle to the final result that isn't apparent in a carefully worked picture on mould made paper. Do be warned though, like grabbing a tiger by the tail, it can go horribly wrong.

There are less expensive papers than the 100 per cent cotton variety, either made of wood pulp cellulose or sometimes a mixture of cellulose with cotton or linen. This type of paper has to be treated to eliminate the acid content in the cellulose and won't have the archival qualities of the 100 per cent cotton papers although the better ones, like Bockingford, claim to be of an archival standard and are mould made in the same way as

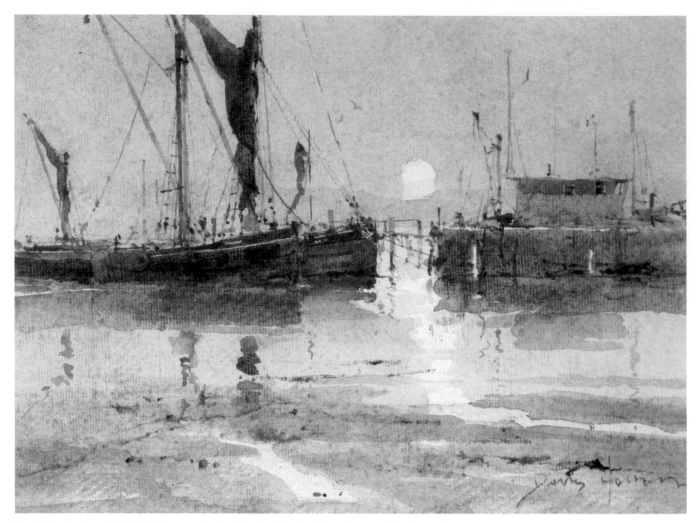

Fig. 1.11 *Sunrise at Pin Mill*. This is painted on Bockingford 'Eggshell' tinted paper with a Not surface and illustrates how loose watercolour, without too many fine adjustments, works well on this surface. In general, Bockingford tends to produce better results for the more confident painters among us and is available in a range of five tints as well as white.

the more expensive cotton papers. There are differences however. Cotton papers are usually gelatine sized internally and externally. Without sizing, water and paint would just soak into the paper and the purpose is to create a support that allows paint be applied but controls its penetration into the surface of the paper and allows further washes of colour without disturbing the initial layers, whilst at the same time retaining the luminosity and transparency of the medium. Internal sizing allows a certain amount of robust treatment of the surface without allowing the affected area to become too absorbent. Cellulose based papers are more usually starch sized and the surface isn't as robust as a good cotton paper. In practice they are fine for the confident painter but they don't work so well for a more tentative approach and most don't stand up well to clumsy additional washes or over-working. Once

you understand its limitations in this respect, using a paper like this can actually be of great benefit by encouraging a faster, looser and more painterly approach and discourage the temptation to fiddle about.

The weight of a paper is directly linked to the thickness and is specified in either gsm (grams per square metre) or in lbs (pounds). The metric measurement is self-explanatory but the latter measurement is arrived at by the weight in pounds of a ream (500 sheets) but whichever measurement is preferred, you need to get used to them and what they represent in terms of a painting surface. There is a convenient correlation between the two because purely in terms of numbers the gsm figure is roughly double that of the lbs – a 300lb paper would be 620 gsm.

As a guide:

The lightest watercolour papers are 70 to 90lbs (150 to 190gsm)
These can cope with really small paintings and watercolour sketches but are in reality a bit too flimsy for general use.

Medium weight 140lbs (300gsm)
This is a good all round watercolour paper weight and is normally the preferred specification for watercolour blocks and pads as well as being widely available in sheets and even in rolls. This weight of paper can comfortably handle paintings up to half sheet size (38 × 57cm or 15 × 22in) but loose sheets will need stretching on a board.

Medium weight plus 200lbs (425gsm)
A small number of paper makers offer this heavier mid-weight – Waterford, Two Rivers and Bockingford spring to mind and the latter also makes a 250lb (535gsm). The additional weight makes it that bit more substantial than the more familiar 140lb and capable of working with larger sheets but there does come a point where the heavy papers are desirable.

Heavy weight 300lbs (640gsm)
You only have to pick up a piece of this weight of paper to feel the difference. It feels more like a board and is ideal for large whole sheet paintings or even larger works. For whole sheet or half sheet paintings it's still advisable to soak and stretch it but I usually carry loose sheets when I'm working outside in quarter-sheet size (28 × 38cm or 11 × 15in) and paint on them without any stretching. It saves having to carry a drawing board. There are even heavier papers available – Arches certainly produce a 400lb (850gsm) paper but there are also others, although you will have to talk to a specialist to find them and unsurprisingly they are somewhat expensive.

The other significant variation in paper is the surface which is either Rough, Not and HP. Rough is self-explanatory and predictably the degree of roughness depends on the manufacturer. From a painting point of view rough works well for general landscape, larger scale work and loose free brushwork but can prove to be a little too much to handle if you're working on a small scale or with relatively exact work involving architecture or a lot of fine detail. HP means Hot Pressed. HP paper has a smooth surface which lends itself to fine detail and things like botanical exactness but I wouldn't recommend it for general work as it can be difficult to handle with washes and large brushes. Not surface paper is cold pressed – that is 'not' hot pressed. Think of it as a halfway stage between rough and HP. It's a nice surface to work on, in that it

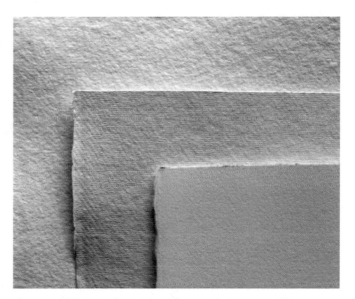

Fig. 1.12 This shows three sheets of watercolour paper and it's immediately apparent that apart from specifically tinted papers, the whiteness of paper varies. The bottom one and whitest in this instance, is Two Rivers 425gsm Not surface. The middle one is Khadi 600gsm rough. Both of these are handmade papers with their distinctive decal edges and whilst the Khadi is described as rough in surface terms they each have their individual random texture and if anything the Two Rivers is rougher than the Khadi. What is also noticeable is the Khadi has a creamier colour than the Two Rivers whilst the top one is an even warmer cream and this is Arches 300gsm Not surface.

has enough texture to 'hold' the paint without getting into the ups and downs of a rough paper. It's ideal for smaller works and subjects that need a little more detail.

A question that is often raised is whether there is a right or wrong side to a paper. Normally either side can be a painted on but the optimum surface will be the one that the manufacturer aimed to achieve in the manufacturing process. This specific surface is created by the felt that is applied during the drying of the paper and varies from manufacturer to manufacturer. The other side of the paper will normally show less of a created surface as this is the side in contact with the mesh of the mould. Most of the better cotton papers carry a watermark or an embossed stamp and this usually is a guide to the 'right' side but there can be exceptions. My own approach is to mark the 'right' side of a paper when it's cut because the clue of the watermark will not be available on all of the cut sheets.

What do I use? I always keep a stock of loose sheets of Arches in both Not and Rough surfaces and in 300gsm weight and also Rough in 640gsm. Similarly, Waterford is in the plan chest in 200lb Not surface and 300lb Rough and there is generally some Fabriano in Not surface 300gsm and 600gsm. Arches will stand

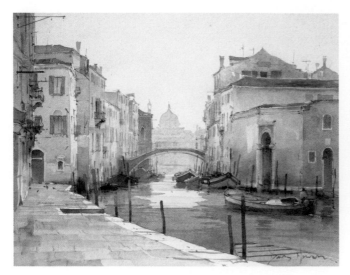

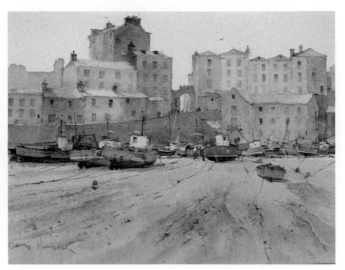

Fig. 1.13 *Rio della Sensa*. This is a painting of a Venice canal with a lot of architectural content. It's important with this sort of picture that it doesn't become too detailed but even with the detail being suggested you need sufficient control on the paper surface to make it work. This is painted on 600gsm Fabriano Not surface and developed with multiple washes to get the depth of colour and that requires a paper that will stand up to that sort of treatment and retain the luminosity of transparent washes of watercolour.

Fig. 1.14 *Tenby Harbour at Low Water* shows another detailed subject but this time it's painted on Khadi 600gsm Rough. Khadi is handmade and more absorbent and the effect is softer and the detail slightly less defined than with the Fabriano. Which is better? That depends on you and what you are trying to achieve but do be prepared to realize that there are no specific answers. Good painters will always be searching for the holy grail!

up to repeated washes and still allow crisp edges and detail, whereas Waterford is slightly 'softer' but will still cope with multiple washes and is a lovely landscape paper where boldness and freedom are required. Fabriano is a good general 'all rounder' and I also have a stock of Two Rivers 200lb and Khadi in both 300gsm and 600gsm. Finally, there's a supply of 300gsm tinted Bockingford in various colours. That's a lot of paper to keep in stock but I deliberately try not to get too comfortable with just one sort.

Fig 1.15 shows the start of a painting on hand-made Khadi 300gsm paper. The sheet has been soaked and taped to a board to stretch it and the initial washes have been applied with a size 7 *petit gris* squirrel hair brush, with tree shapes suggested and the composition loosely built up without any pencil drawing. One of the great attractions of the 300gsm Khadi is that the sizing allows for this sort of loose wet-in-wet work with a minimal amount of bleeding from one wash to another. This is a huge advantage when working in conditions where paint isn't drying very quickly because it allows progress. Note how the paper has cockled as a reaction to the wet onslaught, but it will dry flat again provided it's securely taped down. It's also apparent at this stage that the paper has variations in the surface that suggest a striped effect in places. Just accept it as one of those random effects of a hand-made paper. Fig 1.16 shows the finished picture.

For those starting out with watercolour this variety of papers

can seem daunting but a little experimentation is well worth the effort to find those that suit your approach to the medium. Trying to avoid spending too much money and opting for less expensive cellulose-based papers might just be a recipe for disappointing results. Many of these cheaper options come in attractively packaged and well-presented pads, but you might just be better off by buying a couple of sheets of not so glossy but good quality paper instead. If you cut a 22 × 30in sheet into quarters, you end up with four roughly A3 sized sheets or halved again, gives you eight approximately A4 sheets, and if using decent paper means that the quality of your work improves accordingly, the additional outlay will be worth it. Like a top athlete, you need the right kit to improve your chances of success. Try not to be intimidated by expensive sheets of paper. Worrying about every stage of a painting is an effective way to over-worked mediocrity. All paintings have a life of their own and you must learn to accept that. Using smaller sheets of good quality paper can lessen the risk factor and encourage a freer and more painterly approach.

You can buy paper in loose sheets, pads, or glued blocks. The loose sheets are usually sold as 57 × 76cm (22 × 30in) size and the lighter weights in particular will usually require soaking and stretching before you start painting. This is done either by the simple expedient of holding the paper by the edges under a running tap or filling a jug and pouring it over the surface and making sure that both sides are thoroughly wet. If necessary larger

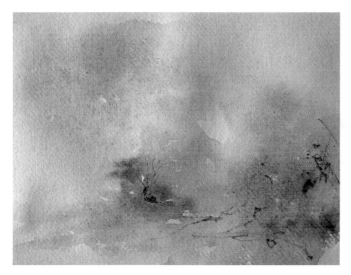

Fig. 1.15 Start point for a picture on Khadi 300gsm rough. Painting this way allows me to 'set the scene' and to put the composition together and to achieve a luminous mix of colour and tone with the random texture of the paper helping to create an interesting surface.

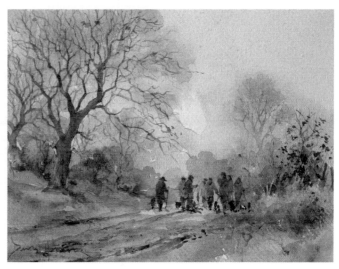

Fig. 1.16 The completed watercolour – *Beaters at Stearsby*. The finished work of beaters and their dogs retains the winter atmosphere created by the original washes and has been developed by adding more detail, trees and figures to the foreground, with stronger tones and colours where appropriate, to create recession in the picture.

Fig. 1.17 *Steady as She Goes* is another painting on Two Rivers hand-made paper. Its surface texture is varied and you have to get used to the idea that there will be random variations in the depth of colour and unexpected effects. If you feel the need for exactness and control, you may find a paper like this difficult to cope with and, perhaps unusually for a 100 per cent cotton and linen rag paper, it doesn't react too well to being overworked. For a confident painter who recognizes that it's the overall effect of a painting that matters, this can be quite an adventure.

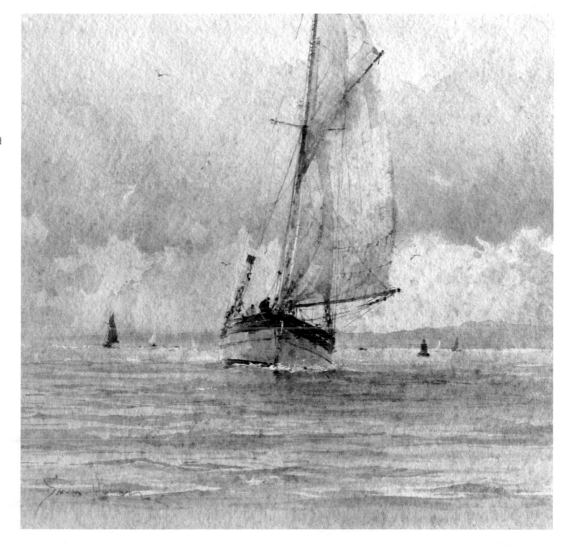

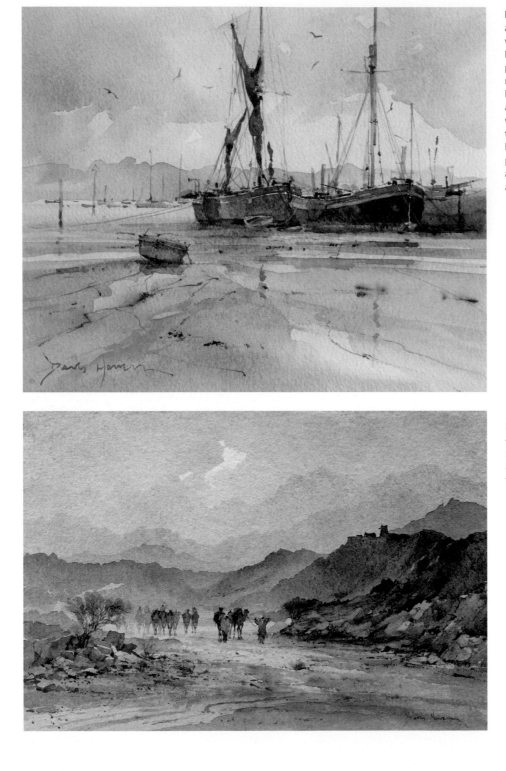

Fig. 1.18 *Pin Mill Barges.* This approximately 8 × 8in watercolour was painted on Bockingford 300gsm Not surface, cream tinted paper. It was painted quickly with a minimal amount of re-working and fine detail, using a fairly large size 7 *petit gris* squirrel hair brush and a Size 16 sable, apart from the rigging which was added with a sable rigger. The tinted paper adds a certain amount of harmony to the colours and tones and the paper's requirement of not being messed about has undoubtedly aided the loose and free approach.

Fig. 1.19 *Travellers at Qadda, Hijaz* 47 × 70cm This large watercolour is painted on 640gsm Arches rough – a superbly reliable paper and a joy to work on.

sheets that are too big to be held over a sink can be floated in a bath. Use cold water and in particular when holding paper under the tap, don't allow too much pressure to hit the paper surface or it could affect the sizing of the paper which in turn can lead to patchy results when painted. Don't overdo it. Holding a paper under the tap for around thirty seconds or so, making sure that both sides are evenly soaked is fine and then lay it on a flat surface with a tea towel or similar under it and apply another over it to gently dry excess water. Note the word gentle. When soaked the surface is vulnerable to harsh treatment and if it does get rubbed or handled clumsily it will affect the surface leading to unpredictable and sometimes fatal results when paint is applied.

Fig. 1.20 *HMS Queen Elizabeth, Rosyth Dockyard.* Very much an industrial marine picture, this was painted on an Arches 36 × 51cm (14 × 20in) block from the top of an adjoining office block with appropriate permissions from the Royal Navy and Babcock International as part of an ongoing link between the Royal Society of Marine Artists and the RN.

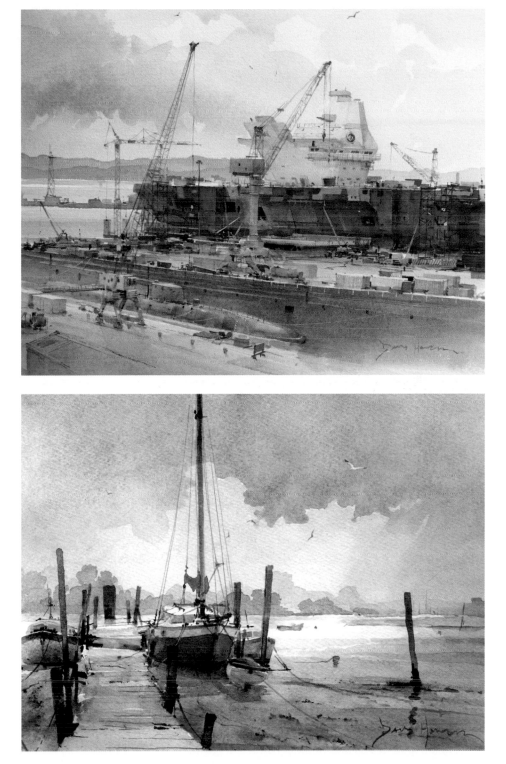

Fig. 1.21 *On the mud, St Osyth.* Another painting produced on a modest size 23 × 30cm (9 × 12in) watercolour block. This is Fabriano, a mould made reliable paper. This a very handy size for outside work – easy to carry and small enough to get something finished relatively quickly.

Once the excess water is mopped by the tea towel treatment the paper needs to be taped down on a board. The power of drying paper is something of a revelation and you need to tape it down with old fashioned gummed tape – sometimes known as craft tape. Masking tape and self-adhesive tapes simply aren't strong enough and equally the board has to be sufficiently robust as otherwise the paper will bend it. I use 7mm (½in) MDF boards

which work fine and are easy to replace when they get to the tatty stage. Leave the paper to dry naturally, which it will do quite quickly in most circumstances and you will have a perfectly flat surface to work on. It may well cockle again when initial washes are applied but will return to a flat surface.

Stretching paper on boards is fine in the studio or home location and is essential on larger works but it creates problems for

the *plein air* painter in that carrying paper on a board or boards adds to the weight and isn't exactly convenient. There is an answer in the form of pads or blocks. The latter are particularly suitable for painting on location but are equally handy if you don't have the space to store loose sheets. The blocks are glued on the edges meaning that you are painting on paper that keeps reasonably flat when being worked on and dries even flatter. They come in various sizes and the normal options on surfaces and are usually 300gsm weight although heavier weights are available if you hunt around. In practical terms 300gsm is fine because usually blocks are not so big that you need to think about using a heavier paper. I use them all the time and have a varied collection from Arches, Fabriano, Waterford and Sennelier. I also love the spiral bound RKB Fatpads with Waterford 140lb paper for on-site work. Do take the time to compare prices on pads and blocks and take into account the number of sheets of paper they contain. A lot of the cheaper pads with less expensive paper have only twelve sheets whereas those with 100 per cent cotton rag papers might have twenty or twenty-five sheets and the price per sheet of the top quality paper might not be nearly at such a premium as first appears.

Don't be too precious about paper. Being conscious of the price of the expensive papers may well encourage what is known as 'white fright' where a painter is intimidated by this expanse of expensive material and scared of ruining it and this in turn can lead to your painting being too careful rather than just getting on with the picture. Just accept that all paper will work best when you paint with freedom and a creative approach.

Other Equipment

There isn't an awful lot more needed to paint watercolours but like any other activity, art shops and online catalogues offer all sorts of accessories and devices that you didn't know you needed. Some are more practical than others and it's very much up to the individual both in terms of budget and space as to what is worth having a go at. Indoor or studio painters are able to work on an ordinary table, either sitting down or standing up with the painting lying flat. Standing up is better because it allows you to work at a reasonable distance from the picture but if standing isn't for you then you can get table easels or slopes that will tilt the picture at a slight angle towards you. The only problem with these is that watercolour, when wet, runs downhill and you have to be aware that with washes in particular that a certain amount of juggling is necessary to avoid the mixture running off the paper altogether or puddling at the bottom of the painted section. An alternative is to try and find a lower flat surface or support so

that you can sit and still look down on the work when working or even work with the painting on your knees.

There are indoor easels that are designed to allow the painting surface to be horizontal or as near horizontal as you want but the main problem with a lot of 'studio' watercolour easels is that they can be a bit wobbly, especially so if you have a reasonably heavy drawing board mounted on them. Easels designed for outdoor use obviously need to be as lightweight and portable as is practical and because of this they can be forgiven if things move about a bit but if you opt for an indoor easel, it does need to offer a steady platform for you to work on.

Lighting is something that needs consideration and even those who have north facing windows alongside them will almost certainly need a bit of help at some point, particularly in the winter months. The desirability of north facing windows or fanlights is that light from them is relatively constant and they don't allow direct sunlight to come streaming in to create massive contrasts between the light and shadow areas of the workspace, but for help on winter days and working at night a daylight lamp is a sensible investment or if you have fluorescent lights, you can get daylight colour corrected tubes. Jam jars make excellent water pots for home and studio use but if you're out and about then something lighter and unbreakable is a better idea. Any plastic mug, jar or beaker will do but there are ones specifically made for the travelling painter that collapse to take up less space. For carrying water, I use a plastic cycling drink bottle. They are tougher than the normal bottled water variety and most importantly they don't go brittle after a time and start to leak. Tissues are a must but good quality ones work best. Toilet roll, budget cheap tissues and kitchen wipes from the bargain end of the supermarket tend to lack decent absorption characteristics and disintegrate fairly easily.

For the *plein air* painter, something to sit on is required. A folding three-legged camping stool is easy to carry and most are pretty light but some painters prefer a little more luxury and opt for an aluminium folding chair with a backrest. They're not so convenient for carrying but they do offer a more comfortable perch and there are stools available that have an integral bag for your bits and pieces. The latter are especially made for painters but a visit to your local fishing tackle shop might find something just as good for less money. The biggest problem with many stools in general is that they are on the low side and for those in particular, who aren't in the first flush of youth, getting up again after sitting on one for a few hours concentrating on a painting can be difficult and possibly entertaining for onlookers. It's worth spending a bit more to get one that is well made and has a seat that offers at least a modicum of comfort rather than go for the cheapest – too often on the latter the stitching gives way at some

Fig 1.22 I don't bother a lot of the time to use an easel when working outside and will normally sit on a stool with the painting on my knees, water pot within reach on the ground and the paint box held in my left hand with brushes in my right. That works fine but if I do need to stand up and use an easel I have a Manfrotto photographic travel tripod as the base, with a homemade drawing board that is fitted with a threaded base plate that fits to the tripod and has a hook for a water pot. This shows the tripod and drawing board in use on a very steep hill in an Umbrian village. The tripod itself folds down to around 12in in length and is very sturdy and stable in this sort of location. This quest for compact equipment is largely driven in my case by the need for things that will fit on the back of a motorbike but for outdoor painters in general, things that take up less space or that will fit in a bag or rucksack are always good news.

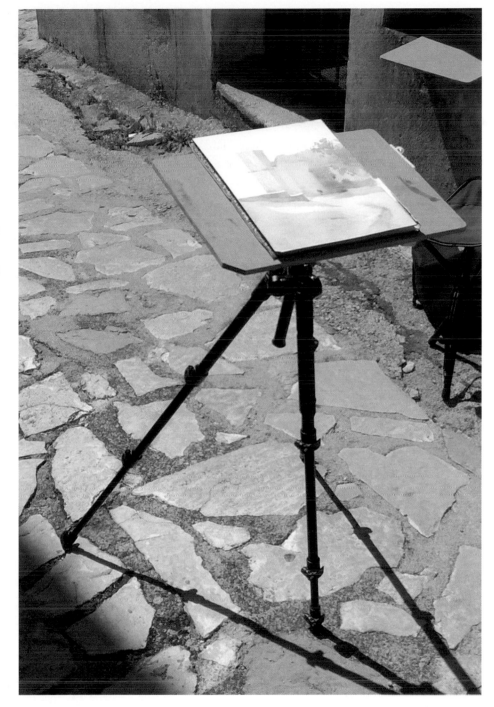

point. Worth a second look is a product called Walkstool, which is a three-legged stool with telescopic legs which when extended, allow a higher seat but when collapsed, is actually shorter and more compact than the more conventional variety. It makes a huge difference to comfort when working on location.

It's always worth keeping abreast of developments in other sports and activities. The Walkstool and compact photographic tripod are but two examples but there is an endless development process going on related to other outdoor sports and hobbies that can be equally of advantage to outdoor painters. Clothing in particular has moved on with base layers and lightweight windproof materials designed for skiers, golfers, mountaineers and bikers working equally well for painters, and a decent quality hiking rucksack is always a good investment. The one I use is designed for climbers with attachment straps for a snowboard and ice axe which happen to work just fine with a stool or easel and means that I can take off on foot with all the equipment I need for a painting session on my back.

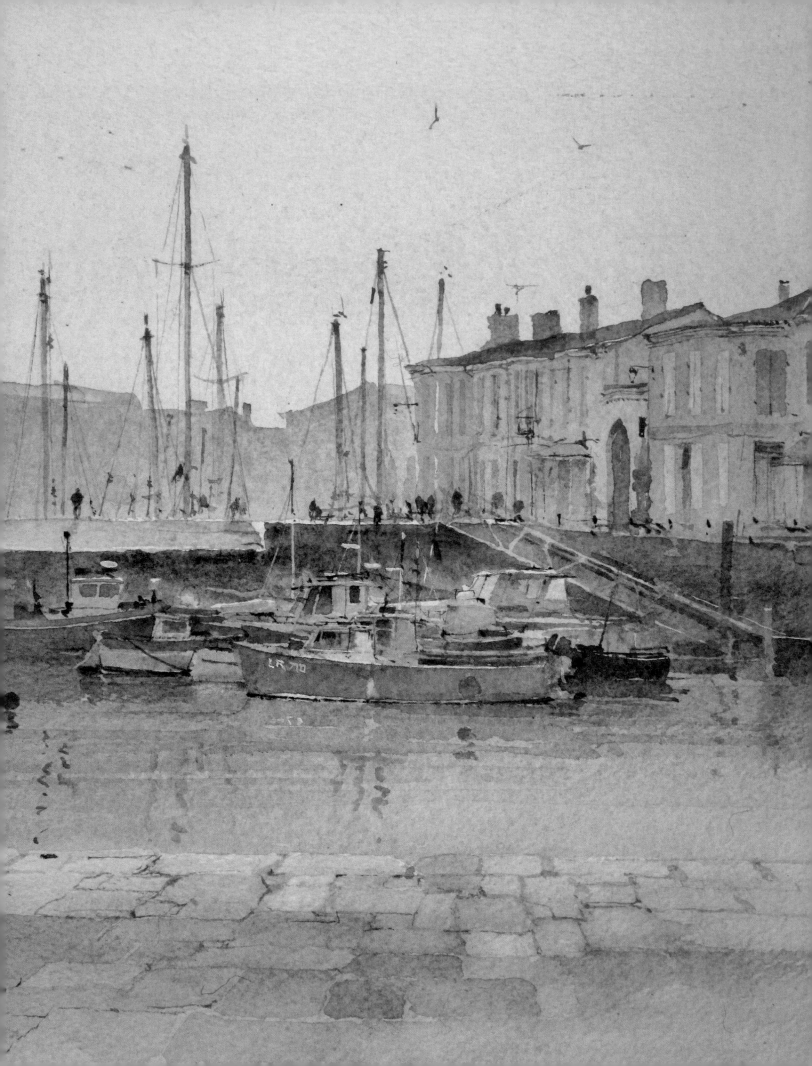

Working with Watercolour

On first examination, watercolour has a lot of things going for it. There's none of the problems associated with oil paints, like the smell of turpentine and solvents or the risk of paint travelling round the house on clothing, pets, door knobs and small children, or for having to find somewhere suitable for wet sticky paintings to dry for days at a time. There's none of the multi-coloured fallout and dust associated with pastels either. Watercolour is a cleaner, more environmentally friendly medium that allows equipment and materials to be kept to a minimum and able to be packed quietly away without taking up too much space when not in use. In comparison with other mediums, there is also generally less expense involved and it's probably because of these advantages that watercolour is the first choice for so many painters.

Having said all that, it also has the reputation in some quarters as being the most difficult medium to master. The clue to that comment may well be in the word 'master'. It is perfectly possible to have a lot of fun painting watercolours on a relatively small scale, working from photographs, using small brushes and keeping everything neat and tidy and the results of these endeavours can be seen at local art clubs and exhibitions and on the walls of friends and family. If you get pleasure from painting like this that's fine but this book is about raising your sights and taking things on to the next level and it's then that the question of 'mastering' watercolours comes into play.

Claude Monet is reputed to have once said 'I wish I could paint as easily as a bird sings' and if you ask most amateur painters how they feel they could improve their work, they will talk about the need to loosen up, to paint with freedom and to move away from the temptation for accuracy, tidying up and general

Fig. 2.0 *Sundown, St-Martin-de-Ré.*

Fig. 2.1 *Brancaster.* Watercolour can be as bold and colourful as any other medium if painted with freedom and verve as this painting of Brancaster in Norfolk shows. It doesn't have to be the preserve of careful delicate painters.

fiddling. Even non-painters can get very excited about paintings that allow the viewer to use a little imagination – the popularity of the French Impressionists is a case in point and on a personal level I'm well aware of the occasional enthusiasm by buyers for a sketch that has taken twenty minutes over a finished painting that has taken days. So if we know all this, why oh why, do so many painters end up agonizing over small details and worrying about accuracy, whilst at the same time miss the point that the last thing French Impressionists and many of the best known contemporary painters were or are worried about, is excessive detail?

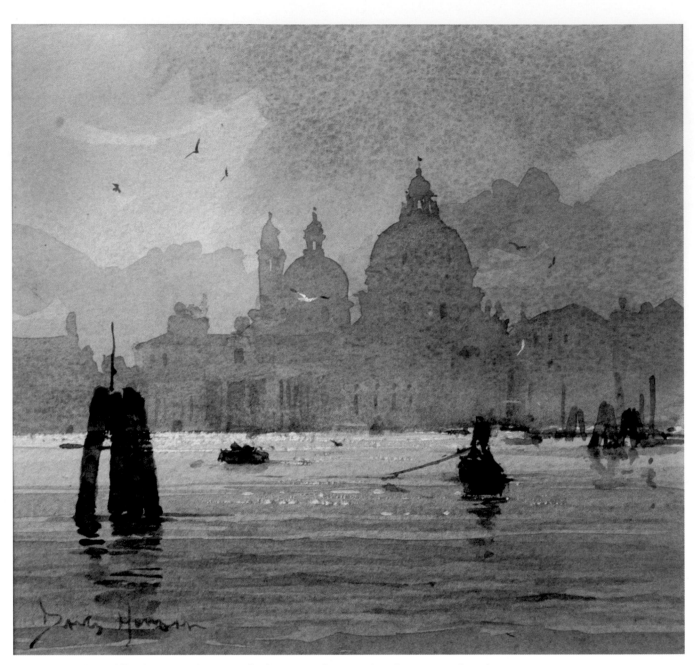

Fig. 2.2 *Santa Maria della Salute, Venice.* Santa Maria has been painted so many times by so many painters but an individual approach can always come up with something different. Painted on a winter's afternoon, this makes the most of the winter sky, with the distant church just a silhouette against the lighter background and crucially the gondolier is painted as a dark shape against the light. Neither have any real detail incorporated and the mooring posts on the left have been 'moved' to make a better composition. That's the advantage of the painter over a photographer or a painter copying photographs.

We might get a clue from the fact that whilst some of the Impressionists had access to and used photographs in their work, the photographs were monochrome and not necessarily of very good quality and much of the information they used to paint from was obtained by going outside and painting and sketching on the spot. This freedom was helped considerably by the development of paint in tubes, which were relatively easy to carry, rather than pig bladders and all the mixing clutter and containers that preceded tubed paint. The Impressionists accepted that painting was about creating a colourful overall impression

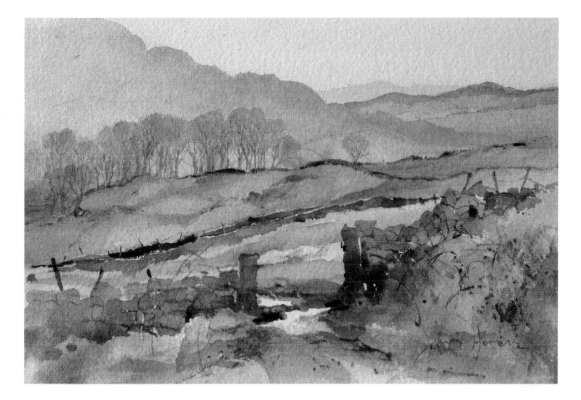

Fig. 2.3 *Above Trollers Gill.* This shows how effective watercolour can be for working on the spot. Painted up in the Yorkshire Dales, with a little 'tidying' back in the studio, it's a simple winter landscape that doesn't rely on fine detail to make it work.

rather than a need for super accuracy and revelled in the freedom that the more portable materials of the nineteenth century gave them and that allowed them to work outside the studio. Our generation is surrounded by recorded images, both photographic and in the medium of video and TV and certainly over the recent half century or more, there has been a constant improvement of image quality. Not only that but the majority of the population and particularly painters have the ability to record their own high quality images with a mobile device or digital camera and whilst at times this may be very convenient, it can also be a curse. We need to occasionally sit down and ask the fundamental question 'what exactly are we trying to achieve with our painting' and perhaps we should start by deciding whether we are looking for an accurate illustration of a particular subject, that looks as close as possible to the photographic images that are so much part of our lives, or whether we want to produce a picture that uses colour, shapes and tones to depict the motif in a way that evokes a response in those who view it and is interesting enough to have hanging on a wall.

Of all the mediums available to painters, watercolour does lend itself to exactness. With oils or acrylics, paint is applied with long handled brushes or a palette knife and whilst a degree of accuracy can be achieved with smaller brushes, in general it isn't that easy. Pastels are similar in that they come in thick sticks and it's difficult to be too careful with them unless the painter is using pastel pencils, or is deliberately sharpening them with a sandpaper block or something similar. Watercolour on the other hand can be painted with precision. All decent quality brushes come to a fine point and there's a wide selection of very fine thin brushes available. That might be okay for botanical painters or someone specializing in illustration or architectural studies but for the rest of us detailed photographic accuracy isn't nearly as important as the prime objective to produce good paintings.

Ultimately of course, it doesn't matter how you get your information to paint from, because all that really matters is what the finished painting looks like. There are times when a camera is essential, either because the weather or the particular circumstances means that sitting or standing around long enough to produce a half decent sketch is impossible but ideally it shouldn't be an automatic process that saves messing around, or taking the time to look at the subject properly, because eventually you will only see subjects through a viewfinder. The world is full of tourists who when they aren't taking selfies, walk around with one arm extended, taking endless pictures and video clips with their phones or tablets but never actually looking properly at anything. Painters need to take a little more time to see and understand what they're looking at and to be able to visualize how the subject that has attracted their attention can be turned into a painting. It takes practice but the more you do it the more readily painting opportunities appear.

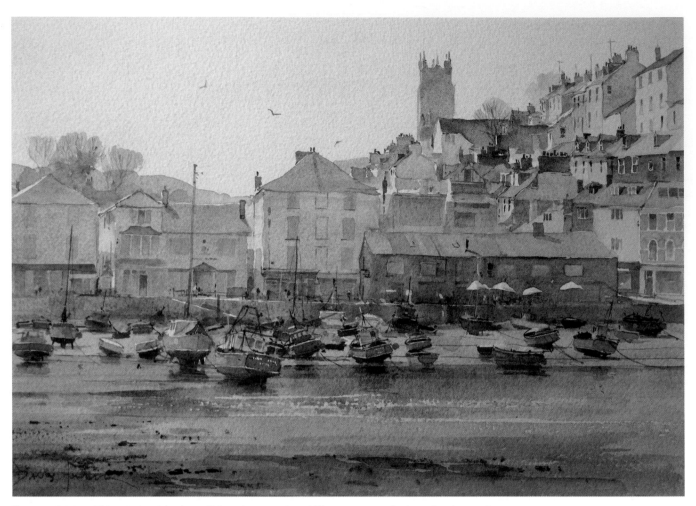

Fig. 2.4 *Brixham*. This painting ticks three of the points mentioned. There was no preliminary drawing on the paper and it was painted on the spot as part of filming 'Just Watercolour' for APV films, using predominately a large *petit gris* mop and a size 20 sable brush. Most importantly it hasn't become an architect's drawing. Buildings and boats alike aren't too detailed and, in parts, are suggested rather than meticulously painted in. There's also some serious thought given to the composition and the placing of the church (*see* Chapter 4).

The following points may offer some ways of overcoming inhibitions and getting away from tight careful watercolour.

1. Painting *en plein air* – For some prominent and professional painters it's considered the only sensible way to work and amongst those are individuals that often don't bother with a camera or photographic material at all. In all probability most do to some extent but they have learnt over the years to use it as a back-up rather than for their main source of information. It's not always quite that easy for part-time painters and the situation may be further confused by those who claim to work this way, whilst it's frequently evident in the finished work that they don't. However, for the serious painter, whatever level, it is the way to get away from copying photographs and there are ways of getting into this challenging approach in a relatively gradual manner.

Just sitting on a stool sketching on location for a short time could change your life!

2. Painting without preliminary drawing on the painting surface – this is the painting equivalent of the moment a para-glider jumps off a high mountain. You know you can do it but you feel you need the comfort of your feet on the ground. The trouble is that this preliminary drawing process, for many painters, is far too careful and they frequently get bogged down with excessive exactness at this stage. Painting without drawing allows a measure of freedom that allows the painting to have a life of its own. Carefully painting over a precise drawing is a bit like the colouring books of our childhood and similarly restrictive. Be bold, take risks.

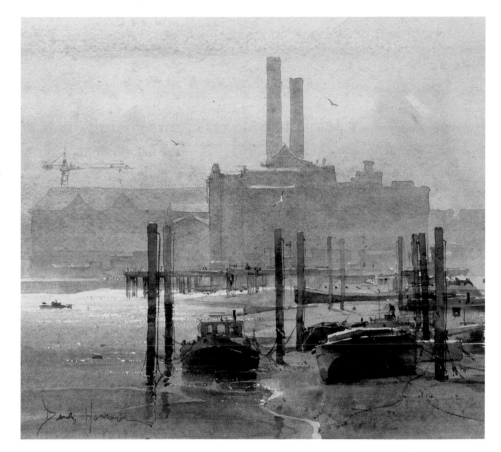

Fig. 2.5 *Afternoon Light – Chelsea Wharf, London*. This is a good example of a painting that needed at least some areas left blank. The reflection off the water in the mid-distance is achieved by leaving bare paper and highlights have been left on the superstructure of the barges in the same way. Roofs are indicated on the power station in the background by leaving them the same colour as the sky and the glint where the water meets the mud in the foreground has been carefully preserved. The sparkle of sunshine off the water closer in is achieved by scratching out – where a blade has been scratched across the surface of the paper to leave flecks of white.

3. Use big brushes! The bigger the brush you use, the more difficult it is to be super accurate as to where it goes. Fiddling about with small brushes leads to fiddly paintings and it's worth having a go at painting with nothing smaller than a size 10 or 12 round or even one of the smaller *petit gris* mops. Be prepared to experiment and to live dangerously.

4. Study painters past and present. Going to exhibitions and galleries can be very helpful, whilst books and magazines can be equally informative, particularly those by or about successful painters with a track record of success. Be both open minded and critical. You don't have to like everything you see and sometimes the emphasis on trendy can get in the way, but when you find a painting or paintings that you really like, ask yourself why and spend time analysing why they appeal to you.

Getting Started

One of the worst things you can do is sit looking at a blank sheet of white paper for too long but before you actually apply watercolour to the paper, you have to have a pretty shrewd idea of what you want and where you want it. You have to be able to see the painting in your own mind and with watercolour you need to know more or less where the components will fit because once committed, it isn't that easy to make too many adjustments and major changes are impossible. Watercolour is very much a case of working from light to dark, and preserving the lighter sections, where required, is crucial and often these will be unpainted areas of paper. Leaving these in the correct shapes and in the right places needs a lot of thought and whilst some painters use frisket or masking fluid to blank out areas, you still need to know where your bright spots are going to be. If you plan out your painting with careful drawing, both the application of masking fluid or leaving bare paper will be easier but you then run into the problems of being too careful. It's better to be brave!

I always start with making some sort of sketch on a separate piece of paper or sketch book, whether on location or in the studio. It settles the composition in my mind and is an invaluable aid to determining where everything fits in. I don't use masking

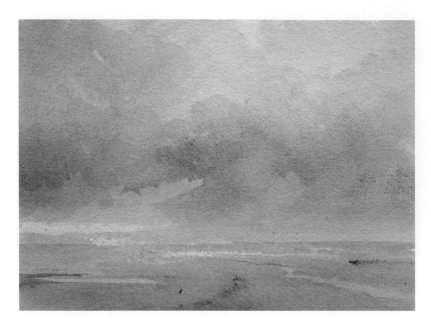

Fig. 2.6 First washes – *Pin Mill*. This is an example of what can be achieved with the first washes of a painting. The concentration is on getting the feeling of the weather and the location and the original background wash is a mix of Cobalt Blue greyed with a little Light Red and then tinted with Raw Umber whilst the whole thing is wet. More cloud shapes have been introduced wet-in-wet in some places and in others to deliberately achieve hard and soft edges in both the mud and clouds. Note how some areas have been left as plain paper.

fluid because the chances are I probably won't have it in quite the right place and my bare paper areas will also get forgotten in places or won't be quite where I thought they ought to be. That's fine because I accept that once a painting gets under way that it will have a life of its own and will never come out in quite the same way as envisaged.

Once you have a good idea of what wants leaving blank there's a lot to be said for getting a wash on the rest of the paper and using a big brush to ensure that paint is applied quickly and in quantity. It's also essential that you have enough colour mixed so that you don't start running out halfway through. The size of the wash brush needs to be sensible for the size of the paper – don't get too carried away but do be bold. I would use a size 10 *petit gris* or 1in wide flat for washes on a half sheet (15 × 22in) of paper but I might just gear things down a bit on a 11 × 15in quarter sheet but the object of the exercise at this stage is to set the scene and get down as much as possible on one go before stepping back and taking stock.

The first washes of *Pin Mill* (Fig. 2.6) is on a half sheet of Arches 640gsm (approximately 15 × 22in) rough paper and is a good example of working over the whole area of the sheet and getting the painting off to a flying start. The initial attack would have been with a maximum size *petit gris* squirrel hair mop, which would have allowed the whole area of the paper to be painted in probably no more than two or three minutes. Colours used are Cobalt Blue with a little Light Red to achieve a coolish grey and little tinting with Raw Umber. You must work quickly at this stage and the puddle of mixed paint would have been more than sufficient to avoid stopping to mix some more and allowing any area to dry too quickly. If you don't have enough paint mixed, there's no guarantee that mixing another lot will be of the same

tone and colour, so if you're working on a large scale you will need more than you think. If you don't have a paint box with big mixing wells you might need to borrow something from the crockery cupboard. The same brush would have been used to create the softer cloud shapes and to define the water channels through the mud and the critical thing, when adding extra colour, is to ensure that at no point do you allow wet paint into an area that is damp rather than wet. If you do, you will get unsightly cauliflowers and tide marks and so great care has to be taken to ensure that wet areas are not bleeding back into adjoining areas of the painting. In the example above, when adding additional colour in cloud and mud areas, it was critical that the mix being added wasn't wetter than the area it was being applied to. This judgement of how quickly a picture is drying only comes with experience, but holding up the painting to eye level to allow you to look across the surface will tell you how wet or dry it is by assessing the amount of sheen – the shinier it is, the wetter the surface. Tissues should be at hand at this stage, particularly for mopping excess paint from around the edges as this can bleed back into the main painting if not dealt with. However, do avoid the temptation to start mopping on the main body of the picture. It can sometimes work if you have painted over a bit that should be left as plain paper, like the reflections of light on the water in this example, or if there's a need for more specific light patches where there might be a mooring buoy or people – wrapping a tissue round the end of a brush works nicely for this but don't get into the habit of having a tissue or cloth in one hand, wiping and mopping out bits here and there or trying to define clouds. If you do your paintings will look messed around and tentative.

The process of working wet paint into wet colour already on the paper, unsurprisingly is known as wet-in-wet and it can be

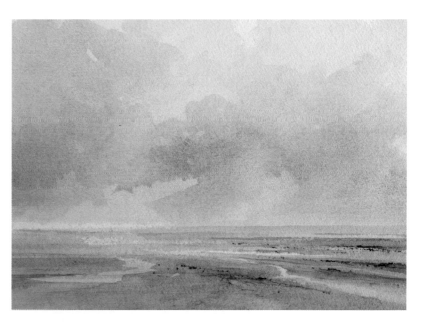

Fig. 2.7 *Pin Mill* – moving on. This shows the initial washes developed even further. Because much of the original layer would have been drying at this stage, further colour has been introduced using a sable brush which allows more control and doesn't dump too large a quantity of wet paint into a damp surface. Raw Umber has been introduced into the mud along with more Cobalt and Light Red and texture and marks have been added by dragging a piece of stick dipped in Sepia.

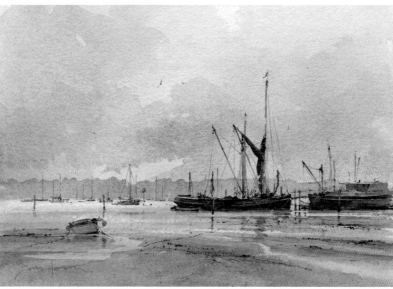

Fig. 2.8 *Pin Mill*. This shows the finished picture where the boats and barges have been painted over the original washes. This now shows the completed picture but those initial washes set the scene. Note how the developed cloud pattern on the left balances the main subject and the dinghy in the foreground leads the eye into the picture and across to the barges.

just as effective on smaller areas of a picture as it is when working over the whole area, as in the *Pin Mill* example. The gradual and blended changes of colour created add tone and colour interest and can be used to indicate shapes and reflections and a harmony with adjacent colours which are far more interesting than plain flat areas of colour. The key to success is to follow the simple rule that the colour being introduced must not be of a wetter mix than the colour already on the paper. Brush control is essential to ensure that a colour mix being introduced doesn't swamp what's already there and apart from bigger wash areas where squirrel hair might work perfectly well, sable brushes really do show their advantages in allowing the amount of paint to be controlled by pressure. Letting the added colour or colours bleed in rather than

overworking them is necessary to retain the special luminosity of watercolour. Too much brushwork and mixing on the paper will make the colours dull.

If it all goes haywire and you do get cauliflowers or tide marks, there still might be a way out. Don't try and rescue the situation by trying to mop out the developing tide line. All that will happen is that you will accentuate it by lifting colour from the wetter side and generally make things worse. Go away and have a cup of coffee and let the painting dry completely and then take your courage in both hands and make the whole thing wet again. This can be done by brushing clean water all over the surface with a suitably large brush or even putting the whole thing under a tap. Whichever you choose, don't overdo it or you will start to wash

all the paint off. What you are trying to achieve is a uniform level of wetness all over the painting and in the process softening the paint sufficiently to allow a little modification. Working on the wet surface prevents more unwanted hard edges and with a bit of luck, might allow the easing of a cauliflower edge or alternatively for it to be adapted as an additional cloud or other appropriate feature. This sort of handling of paint does require a delicate touch and practice and it also depends on what colours you use. My own choice as defined in Chapter 1 allows this sort of manipulation, whereas some of the more strident and staining pigments on the market will make it very difficult to rescue a painting in these circumstances.

Starting a picture with washes like this certainly requires a certain amount of courage and you don't want to be interrupted halfway through by someone at the door or having to answer the telephone. What you get however, is the whole surface of the picture covered in paint (as well as the floor and surrounding surfaces) and in this specific instance the sky, river and the mud at low tide are already complete, setting the scene in terms of the conditions, wind and weather. You must work quickly but in the space of fifteen or twenty minutes of sloshing about with water, paint and big brushes, you can effectively have a fair amount of the painting finished.

Where you work is also important – with washes like this you don't want to have them running down the paper and effectively running off it and in the process taking colour off already painted areas. This *Pin Mill* picture was painted on a half sheet of 650gsm paper, stretched on a board and the board was laid flat on a table, rather than being propped at an angle on an easel. This means that when colour washes are introduced to the surface or an existing wash, they vaguely stay where they are placed, rather than running across the paper and contaminating other areas or causing cauliflowers in adjacent drying paint. However, do be ready to tilt the board in an appropriate direction if you do want to move a wash around in a specific direction – that just means that you're in charge!

If you stand whilst working flat on a table, it crucially allows you to work further away from the painting, allowing more freedom with handling brushes and a better view of the proceedings. It's the nearest watercolour painters can get to the recommended stance for oil painters, that allows them to stand back from the easel, to better judge the effectiveness of what they're doing. In this particular example, there is a nice loose impressionist feel to the painting and apart from the introduction of Cerulean Blue in the river in the mid-distance and Sepia for the dark bits in the mud, up to this point, it is painted mainly in three colours. That approach gives it colour harmony and note how the clouds are

more defined to the left of the picture – there's a reason!

A few more colours have been used to paint the vessels. Really dark greys and blacks have been created by mixing Ultramarine Blue with Burnt Sienna and Alizarin Crimson, Burnt Umber and Raw Sienna would have come into play and the distinctive coloured sails might have had some Red Umber added. In all no more than about a dozen colours.

When it comes to painting more detailed shapes over smaller areas you will need brushes that offer more control than the big wash variety. Sables are the ideal and again, it's always a good idea to use one bigger than you think you need. In the picture above, the rigging lines and mooring ropes will have been painted with a size 6 sable rigger but note that they're suggested rather than painted in accurate detail. Much of the rest of the picture will have been completed with normal size 12 and 16 round sables, including masts, sails and mooring posts and as ever, the whole approach is to have a painterly painting without getting bogged down with too much detail. If you are too careful, straight and accurate with masts and rigging, the picture will start to lose its painterly feeling and instead become a stiff illustration. Unless you are working on a very small scale or have an overwhelming need to paint the whiskers on a mouse's ear you don't really need anything smaller than a size 6 or 8 round brush and investing in something of a decent size will help your painting to improve.

By now you will probably appreciate that watercolour needn't or perhaps shouldn't be handled with kid gloves. Whilst it's easy to appreciate its suitability in comparison with other mediums for a delicate, careful approach, your painting will actually become far more interesting and painterly if it's tackled with a certain amount of verve and by taking a few risks. As with most paint, the worst thing you can do with watercolour is mess it about. Whether painting washes or more detailed parts of a painting, it is essential if possible to keep the clarity and luminosity of the medium alive. Try to get used to the idea of putting it where you think it should go and then leave it alone. It won't always end up exactly where you want it but paintings have a life of their own as they progress and it's all too easy to become obsessed with something that you think isn't right and start to add a bit here and brush out something there. In the process the paint will lose its vibrancy and if you carry on fiddling around, it will start lifting in the wrong places and generally look overworked and do far more harm to the picture than the original perceived mistake. Perceived being the operative word, because more often than not, the mistake that you consider a problem will not be apparent to others. They see and judge the final result and messing about with the part that you consider wrong will only emphasize that there's something amiss. There's no such thing as a perfect picture for

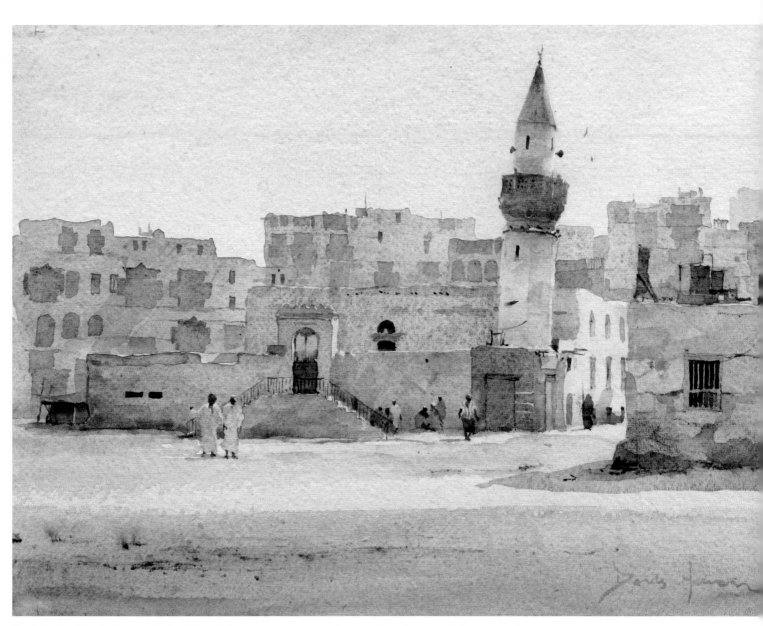

Fig. 2.9 *The Al Basha Mosque, Jeddah.* This painting is a good example of the use of wet-in-wet technique on smaller areas. These buildings in the old city of Jeddah are largely constructed with coral stone of various shades and the intense sunlight reflects off both them and the surrounding flat surfaces. If it was painted in flat washes of ochres and umbers it wouldn't look nearly so interesting but by using wet- in-wet, the walls and buildings have a constantly varied colouring like they do in real life. In addition to colour introduced to existing washes, further colour has been added when the appropriate area is dry, to create more variation.

a serious painter and we all, to a greater or lesser extent, worry about what we're doing. Think of it as faith, hope and clarity. Have faith in your ability, hope you get it about right and above all maintain the clarity and luminosity of the medium.

Whilst carefully constructed watercolours on a largely white background can be effective, developing your technique to give paintings colour and tonal harmony as well as depth and strength through good composition, can take the medium up a gear or

two. Working on a large scale on a big and expensive piece of paper can be somewhat nerve racking, and you might want to hone your technique and boost confidence on smaller sizes to start with, but watercolour needn't be the preserve of the meek and gentle amongst us but has the capacity to favour the brave and produce works that make a serious impression with enthusiasts, potential buyers and fellow artists.

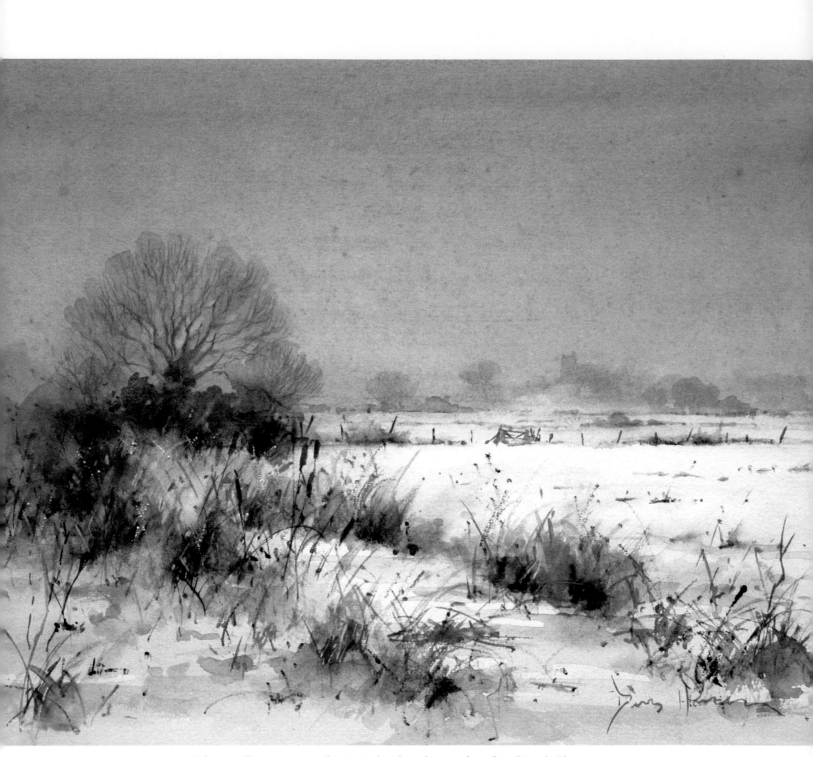

Fig. 2.10 *Snow on Kings Sedgemoor.* This is quite a simple painting but shows how much can be achieved with minimum content. Colours used would have been Cobalt Blue and Prussian in the sky to get the depth of colour, Ultramarine and Burnt Sienna to get the black of the winter bushes and Raw Sienna for the winter grass and vegetation. There's a bit of Burnt Sienna in the left hand vegetation as well and the cold shadows in the snow would have again used Burnt Sienna and possibly a smidgeon of Alizarin Crimson here and there. The treatment of everything from the distant church to the foreground grasses and bull rushes is loose and impressionistic. Fence posts are at various heights and angles and about the only area that shows a little more accuracy are the branches in the willow trees. It was too cold to paint this on the spot and the picture was completed from memory and a very quick sketch.

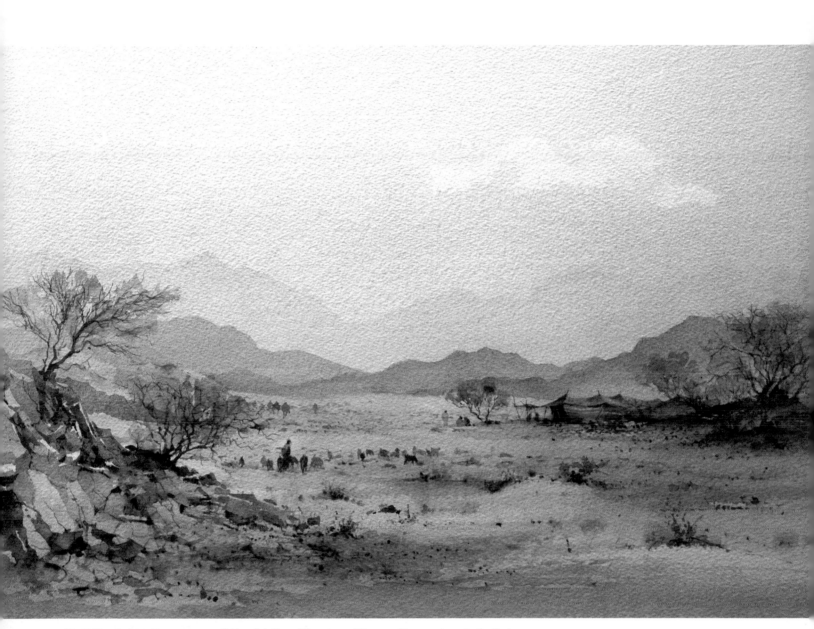

Fig. 2.11 *Bedouin Encampment – Al Mutullah*. Very different conditions and temperatures to the Sedgemoor picture above, this half-sheet watercolour is painted on Arches 640gsm rough with exactly the same palette that I invariably use. The warmer blues and greys would have been painted with Ultramarine and Light Red but the same earth colours of Raw Sienna, Yellow Ochre, Raw Umber and Burnt Umber are in evidence and there's a hint of Cadmium Red to warm up the sky.

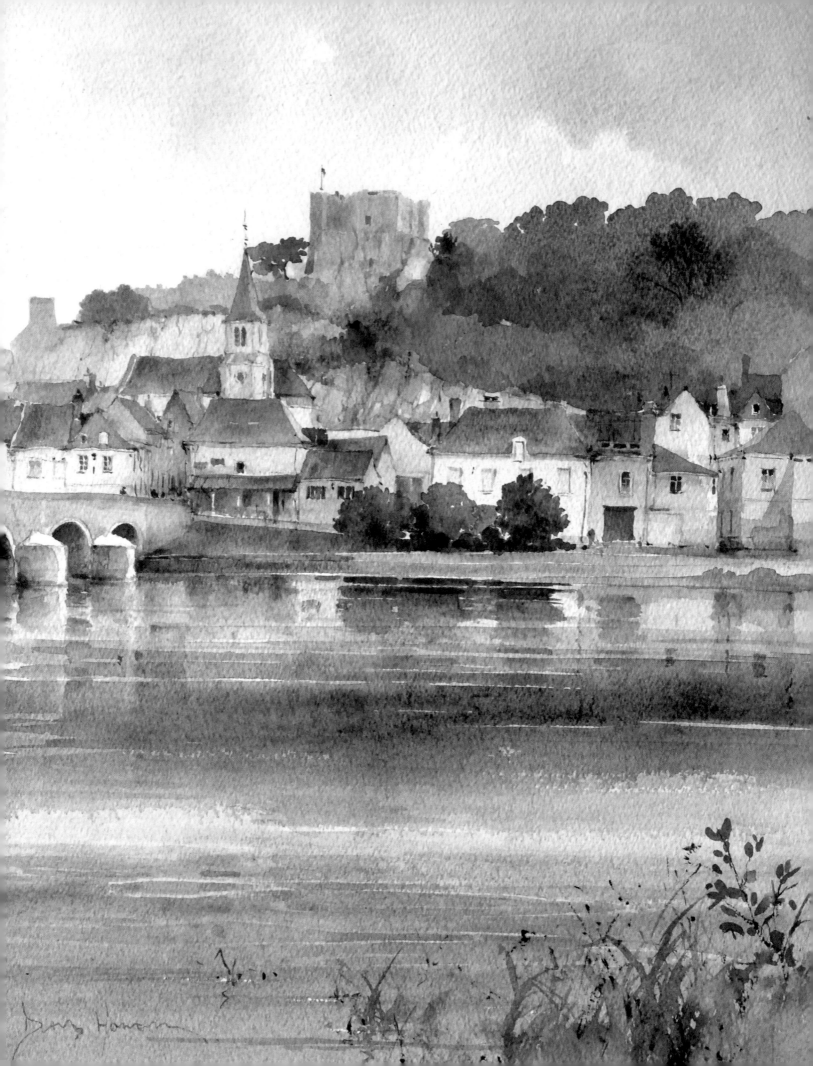

The Importance of Drawing and Sketching

This book is essentially about figurative or representational paint-ing, that is painting that uses references and objects in the real world as the subject matter, and an ability to draw is one of the fundamental requirements for being a figurative painter. If you can't produce a half decent drawing of any particular subject, then you're unlikely to be able to do much with it in paint. Mastering the art of being able to make quick drawings and sketches is an invaluable skill that offers a delightful way of recording whatever interests you, as well as being part of the preparation and devel-opment work for good paintings and I am frequently surprised that so many painters in this day and age don't seem to bother.

Undoubtedly cameras and the images generated by them are largely to blame and there's a whole generation of painters cop-ying photographs and images on various electronic gizmos and rarely picking up a pencil, apart from using a nicely sharpened one to carefully copy what's on the photograph or screen in front of them onto watercolour paper, ready for applying paint. This might be effective to a limited extent with experience but more often it's likely to lead to paintings that are stiff and lacking in imagination and fluency. Being constrained by the limitations of the average photographic image and the compulsion to get the finished result as close to what you are using as a source of information is effectively very restrictive and there are many aspiring painters who never actually look at anything properly or try and draw or paint it as it actually is in the real world. If you hand out an identical photograph to a dozen painters working in this way, you will get a dozen similar paintings with only marginal individuality and if you ask those same painters how they would like to develop their painting, most are likely to say that they would like to loosen up and use their imagination a bit more. Sketching offers the way out.

Fig. 3.0 *Montrachet.*

Fig. 3.1 *Staithes from the Cowbar* – sketched with a mix of graphite and coloured pencils.

Apart from being an ideal introduction to working in front of the actual motif without having to spend hours actually painting there and then on the spot, sketching is equally important as pre-liminary work in the studio, as a way of finding your way around the subject and to developing a composition. Good sketches are infinitely more effective as a source of information when actually painting and if you must work from photographs, using them to produce a sketch is far preferable to working directly from the camera image. As a tip, if you do work this way, make sure that when you get to the painting stage, you put the photograph

Fig. 3.2 Soft pencils. You really don't need very much for sketching and you certainly don't need a whole selection of different grade pencils and I rarely use anything other than either the softest 8B or 9B. You will need a method of sharpening them. A really sharp knife or blade is best because they tend to make the lead into more interesting shapes which in turn leads to a variety of marks but a conventional pencil sharpener is OK and tends to cause less excitement at airport security checks. You can see the difference in lead shapes in the illustration with the blade sharpened one on the right.

away or out of range and just work from the sketch because if both are beside you whilst you're working, your subconscious will almost certainly drive you back to just using the photograph as a reference because instinctively most of us think that somehow it's more accurate and reliable. The whole point is that painting in general isn't about being accurate or reliable but is about producing something that attracts attention, is aesthetically pleasing to others and allows your own individual interpretation of the subject. The interest shown in sketchbooks, not only by fellow painters but by non-painters and collectors alike probably says it all. Loose expressive sketches are something special and can often have more appeal than the carefully finished final paintings developed from them and that might just be a lesson for all of us to take on board.

Ideally painters should have a sketchbook handy all of the time. It doesn't have to be big – something around A5 size that will slip into a pocket or handbag is a start and an A4 sized book is a good all rounder. Larger books are available of course and might be considered a must for more complex subjects and of course you can buy cartridge paper in large sheets to pin on a board. There is a huge variety of sketchbooks available on the market and

they range from the cheap and cheerful that you might buy for a child to scribble in, to stylishly bound hardback versions. The problem with the latter is that they are so nice that whilst they might be fine for a journal with odd carefully drawn sketches, they are not ideal as an everyday working sketchbook, because there is a tendency to be wary of spoiling them. A sketchbook can have a fairly hard life and a few scuff marks, smudges and splashes of paint are all par for the course. My own preference is for the ring bound variety which lend themselves to being folded over to allow a flat surface to work on, but I know other painters who prefer the hardback bound variety because they allow the book to be opened up so that both sides can be used in an extended landscape format when required.

Probably more important is the paper and as ever that depends on what you want to do with it. For pencil and crayon something with a little texture or tooth is ideal with a weight around 150gsm. Many sketchbooks will claim that they can be used for watercolour as well as dry technique – that might be true on a relatively small scale but nevertheless slightly heavier paper of 200gsm or more is advisable if using watercolour, soluble crayons, and suchlike. One of the major attractions of sketching as distinct from precise drawing is that it doesn't matter too much. It doesn't matter if you make a mess of it because you can just turn over the page and have another go. It's not like drawing with a fine pencil on watercolour paper and being frightened in case you make a mistake. It doesn't matter if a line has a bit of a wiggle in it or needs to be re-drawn because it's only a sketch. It doesn't matter if the pencil you use is a bit blunt or that some of it gets smudged. In fact, because it doesn't matter, the whole sketch is improved by the working marks and smudges as it's put together and if done well will have vibrancy and immediacy that is exciting. A 4 × 6 photo or the screen of an ipad isn't in the same league.

Soft pencils aren't intended to work with very fine points. They lend themselves to a variety of line thickness and shading depending on the pressure on them and the angle the pencil is applied to the paper. What is needed is to develop a light and loose touch, particularly in the early stages of a sketch. Letting a really soft pencil wander across the page without any real pressure will allow the drawing to develop without too much commitment in the beginning and where there needs to be changes they can just be gently re-drawn. Harder pencils don't allow this sort of flexibility of line and tend to encourage tight accurate drawing which might be fine in an architect's office or design studio but not for painterly work. Don't bother with an eraser. Allow exploratory lines to build up the drawing and become part of it and at the later stages a moderate increase in pressure on a soft pencil will allow important elements to be more defined, leading to a combination of thick and thin lines and shading.

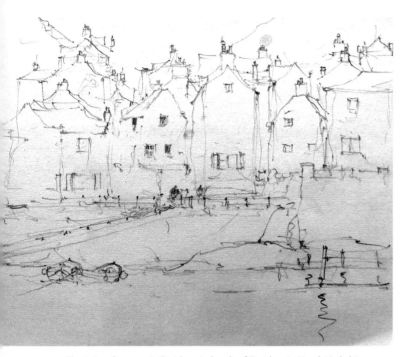

Fig. 3.3 *Cottages in Staithes*. A sketch of Staithes in North Yorkshire drawn in a ring bound A4 sized Aboreta sketchbook with 160gsm off-white cartridge paper. Using an 8B pencil, lines have been kept loose, redrawn where necessary, nothing is set in stone and everything is an exploration of the subject in line. Above all, the lines are allowed to flow rather than be carefully accurate with a view to capturing the feel of the village cottages, rather than turn it into an architect's drawing, with the whole picture being worked on rather than concentrating in any one area.

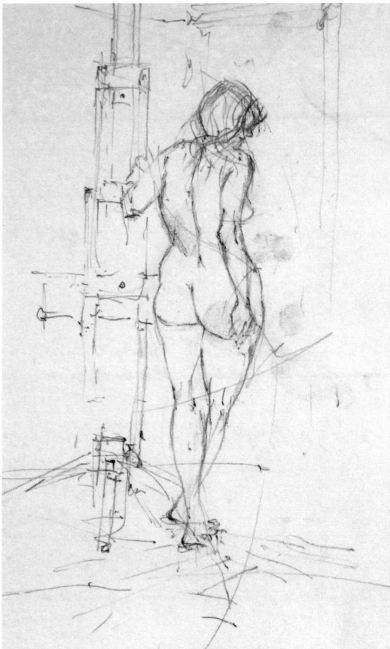

Fig. 3.4 Figure sketch. This figure study again uses mainly line drawing and the lines have been modified where necessary to get the proportions and angles of the model somewhere about right. One of the major attraction of life drawing is that you don't have too much time to allow exactness and it's vitally important not to make too much of a commitment in drawing terms until you know you have proportions and angles about right.

This rapid line drawing was produced as the initial stage for the painting of a watercolour. Working like this lets me develop the composition, work out angles and proportions and make sure that it will fit on the paper. This enables me to go straight into painting without any preliminary drawing or working things out on the watercolour paper itself which helps to keep the painting fresh and spontaneous and avoids damage to the surface and of course is a reference if wind and weather mean that the actual painting can't be completed there and then.

Once you get used to the idea that sketching isn't about neat, carefully drawn lines it's a fairly natural progression to the use of thicker implements like graphic sticks and clutch pencils. Whilst the latter occasionally come with a sharpener built into the cap, the whole idea is to have a thick graphite instrument that can be used for everything from light and dark lines to a tonal drawing where the blocks of tone are shaded in. Again, pressure and the way the instrument is held largely determines the result, but they are brilliant for rapid sketching with a wide variety of marks and tone.

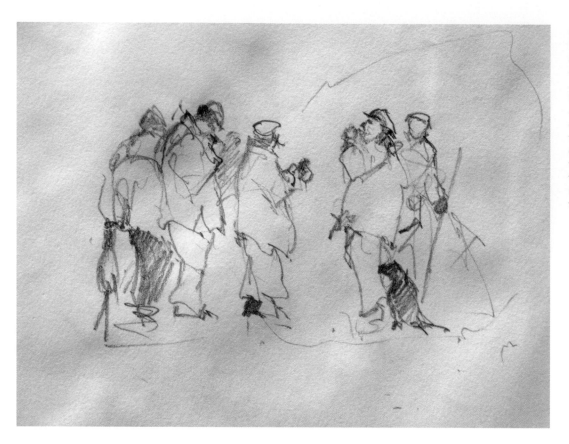

Fig. 3.5 *The Beaters.* Nothing works as well as a quick sketch in circumstances like this. A group of beaters, lighting up and taking a swig, along with the odd dog waiting for the next drive. Speed is essential – a group like this will only be there for a few minutes at the most. Note the wrinkled paper from the rain!

Fig. 3.6 Clutch pencils. A couple of examples of clutch pencils. The graphite lead is replaceable like a propelling pencil and is released or retracted by pressing the button on the end which protects it from breakage when clambering over fences and under barbed wire. They may appear clumsy at first but they're very versatile.

Fig. 3.7 *Pen-y-Ghent.* This shows the use of a clutch pencil with a 5.6 mm thick lead to produce a tonal sketch. Rather than the fine lines of a conventional pencil, a graphite stick or a clutch pencil lends itself to a wide variety of marks and shaded blocks of tone and once you get used to what might appear initially as a somewhat clumsy instrument to cope with, you will find them very effective for fast loose sketching and they encourage working across the whole picture rather than getting bogged down in too much fine detail.

Fig. 3.8 *Cottages at Clapham.* Another example of a monochrome tonal sketch. This one of Clapham took a little more time than usual but I wanted to get the tree shapes right as well as the detail on the cottages. Again most of this was created with a clutch pencil along with a more conventional 8B for the more detailed passages. Both this and *Pen-y-Ghent* above are in effect completed monochrome pictures. The composition is sorted together with tonal relationships and they could be framed and put on the wall.

Fig. 3.9 *Meadows at Dedham.* In contrast this landscape sketch at Dedham took no more than a couple of minutes but the group of trees on the left that effectively become the point of interest have sufficient shape and tonal contrast to be effective. This was actually a demonstration to show how you can develop a composition from very little and use a pencil sketch to illustrate what's in your head before the original idea and concept is lost or overcome by other events.

Fig. 3.10 *Old Jeddah.* Developing an ability to get enough information down quickly is a great asset. Apart from time pressures in general or the weather being unkind, there are places where the ideal viewpoint is either somewhat hazardous or where waving a camera around might cause a few problems. The prevalence of camera phones has probably eased the latter difficulty but the ability to quietly produce a quick sketch pays dividends. This is a sketch made in a street in the old city of Jeddah. Although many of the locals were intrigued with the idea, not everyone appreciated the presence of a painter in this environment and therefore the ability to find a quiet corner and get enough done before things got out of hand, with arguments and objections, was paramount and the degree of concentration required committed much of it to memory.

Fig. 3.11 *Working Horses.* These sketches were produced at a ploughing match. Once again speed was essential, although in this instance it was helped by the fact that the horses and ploughman went up and down a few times. In these circumstances you might just have to rely on a camera for back up but the movement and fluidity of sketches like this makes these my first choice to work from.

Fig. 3.12 *Barns at Westonzoyland.* This is a quick pencil and crayon sketch, where the tonal value of the sky was important and contrasted with the lighter and brighter colour of the winter grasses in front of the barn. A camera may well not have been able to get this right and might have reduced the silhouette of the distant church to almost nothing.

Once you get used to the idea that pencil sketching is enjoyable and extremely effective it's a small step to getting into colour. The humble coloured crayons of our childhood may prove a bit too waxy but there's a huge selection of other means for drawing with colour. Coloured pencils are the obvious choice and come in conventional dry pigment or in water-soluble versions. My own choice is for the dry variety not least because if I'm going to introduce water into the mix then I might as well be painting in conventional watercolour but there are brush pens with their own water reservoir designed to work with soluble pencils and even versions with their own colour supply. Part of the fun of painting can be trying different things and in general most of those related to sketching aren't too expensive if you want have a go with something different.

Fig. 3.13 *Workum.* Another pencil and crayon sketch, this time in Frieseland in Holland. The sky in this sketch conveys the flat pale greeny grey of a cold winter. It's very subtle but sets the tone for the painting.

Fig. 3.14 *Quai du Port, Le Croisic, Brittany.* Part of the attraction of this picture was the colour of the boat moored at the quayside but it's also a good example of a complicated subject developed in colour. This took an hour or so to finish.

Once you get used to the idea of producing coloured sketches *in situ*, it doesn't take a lot of imagination to extend the sketching process to using watercolour itself. Working on a relatively small scale allows minimal equipment and often surprisingly effective results and once you accept that sketching is not about accuracy and that fluidity of line and shapes is an advantage, using watercolour and brushes just takes the process a little further and starts to blur the lines between producing a sketch or a finished painting.

Fig. 3.15 *Stormy Skies at Paull, River Humber.* This is a good example of what can be achieved relatively quickly without too much finesse or detail. It's primarily a 'sky' picture on a windy stormy day, painted with freedom and a certain amount of bravado. It's painted on an A4 size loose sheet of Khadi 300gsm rough held down with clips on a drawing board fitted on a camera tripod. It may only be a sketch but it has a vitality and sparkle that many carefully considered works might lack.

Fig3.16 *Moorland Landscape, Keasden.* Here is another example of a watercolour sketch. There wasn't enough time to paint a proper watercolour but the sketch captures the feeling of distance towards the Lake District mountains that I wanted. This was painted in an RKB Fatpad on 300gsm Waterford Not surface paper.

Both the sketch of Paull and the one of Keasden are examples of what can happen when you get out of a cosy indoor environment and work *en plein air*. They were produced as sketches rather than as 'proper' paintings and were painted quickly because of time constraints and they bear little resemblance to a detailed copy of a photograph. What they do have however, is a loose free immediacy that is worth a second look.

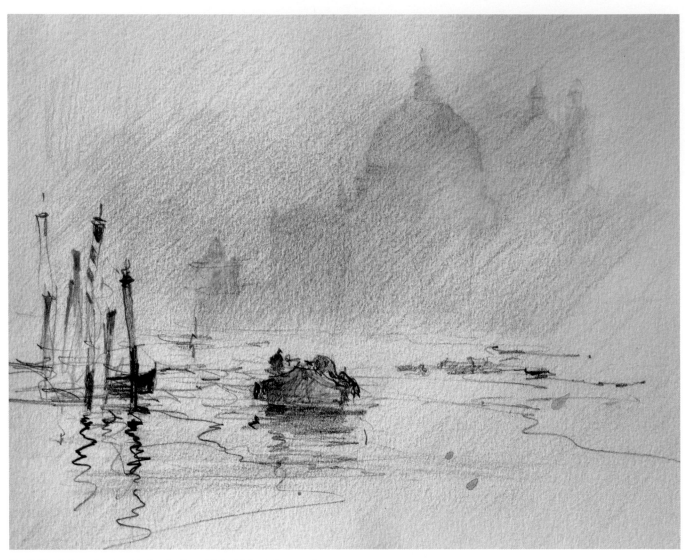

Fig. 3.17 It doesn't get much simpler than this but this winter morning sketch with the fog clearing has just enough information and atmosphere to create a painting. Santa Maria looms out of the murk with a workboat coming up to the moorings and just the hint of sun breaking through.

Venice is a favourite spot for painters but a great deal of the architecture is complex and can be a bit overwhelming to paint there and then. Sketching is an excellent way to get used to the city and to sort the wheat out from the chaff to produce material that can be worked on later. It encourages rapid work without too much detail which in turn leads to paintings with life and atmosphere rather than producing architect's colour drawings from a photograph. Take the brakes off, learn to live!

You might have noticed that many of the sketches in this chapter are not exactly in pristine condition. That's because they have been subjected to wind and weather, splashed with paint, dropped in the mud, smudged and generally given a hard time. They're not supposed to be pristine and precious but they can become an amazing record of where you were and what has appealed to you and if you constantly work this way you will eventually build a library of information in the form of filled sketchbooks that is always interesting to look back on and of course, when going out to find new material isn't an option, individual sketches can be used to have another go at any particular subject.

Understanding the difference between accuracy and painterly pictures is an absolute requirement for any painter who aspires to make the leap from being just a copyist to being a painter in

Fig. 3.18 *Fondamenta dei Mori, Venice.*

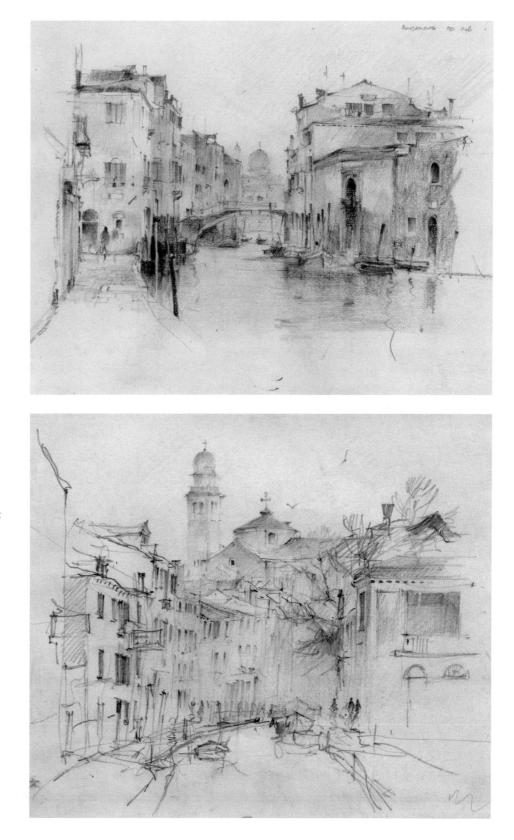

Fig. 3.19 *Rio dei Tolentini, Venice.* Two more complex drawings of Venice that have everything needed to work from back in the studio. I like the city in the winter. The changing light is more interesting with occasional mist and fog but the shorter winter days mean that time is limited and I can produce at least four or five sketches like these during a day, whilst a fully-fledged *plein air* painting in damp conditions might take most of the day on its own.

their own right and developing sketching skills is a great help in understanding what makes good pictures. Learning to develop a way of thinking that tells you that it's only a sketch will help to get rid of those inhibitions that encourage excessive care and emulating photographic accuracy and instead helps to encourage the freedom and painterly approach that most of us aspire to in our pictures.

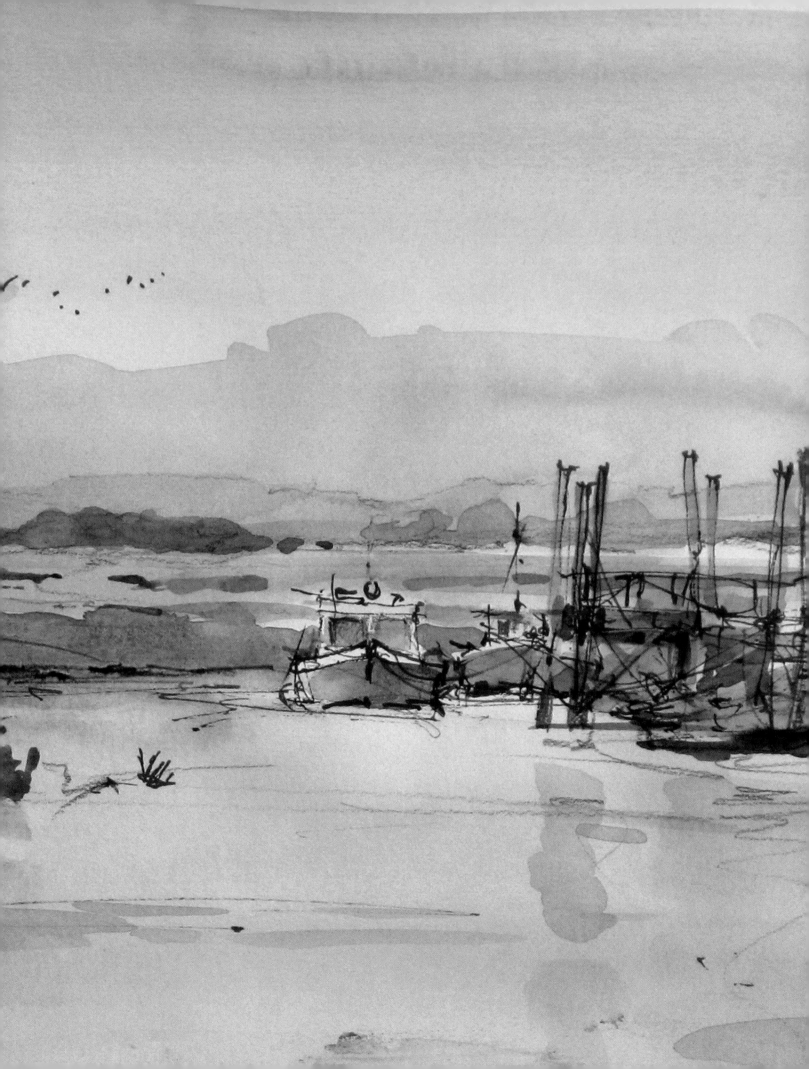

Composition and Construction

How to Make Paintings Work

Painting watercolour on a piece of paper is a doddle. Painting the right colour and tone in the shape you want is considerably more difficult but with practice, application and perseverance, it can be mastered. However, there's another hurdle that has to be overcome and that is possibly the most important – composition. Composition makes the difference between a painting that is competent but somehow not quite right and the sort of painting that has pulling power from across the other side of the room. It's about constructing a painting, so that the viewer can look into it and understand what it's about, to know what's important and what isn't and, to put it in the simplest terms, a painting that is good to look at.

The start point for a painter should always be the question 'Why do you want to paint it?' What is the main point or are the main points of interest? It can be an easily identified factor like a church tower in a landscape, a boat in a seascape or a group of people standing in the street or whilst less obvious, contrasts between colours, groups of trees, changing light, skies or even cloud formations can be used, either to build a picture around, or become a significant factor in the overall construction. The sketchbook, as always, is arguably your greatest asset. Whether *en plein air*, the studio or the kitchen table, it gives you the chance to push the painting concept around and to decide what goes where and how to fit it all in.

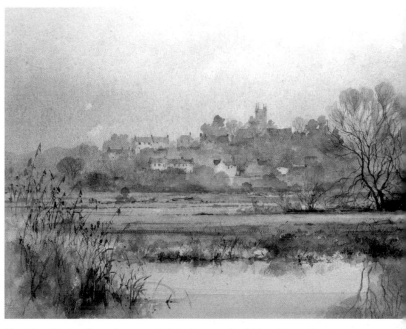

Fig. 4.1 *Clearing Fog at Langport.* This is the sort of painting that works. The eye flows through it from the reeds on the left hand side, across the water towards the town and the church in particular up on the hill and the willows on the right stop the eye drifting out of the picture. The way these elements are placed is not accidental and may not be where they actually were at the time!

Many of you will have heard of the Golden Mean or Golden Section. For those who haven't and for those who have but could never quite see the point, you'll probably be pleased to hear that I'm not going to get into the relatively detailed mathematics associated with it. However, we are told that Pythagoras was an enthusiast, as were learned mathematicians in general and architects in particular, including those responsible for some of the architectural wonders of the ancient world. Their understanding and use of this proportional theory was that buildings or objects that were specifically designed to comply with it were pleasing to the eye – they looked right in aesthetic terms. That's not a bad

Fig. 4.0 *Thornham* sketch.

Fig. 4.2 *Near Horsey, Norfolk.* This sketch was produced in a matter of a few minutes on a stormy Spring day with the wind getting up and serious amounts of rain on the way. The main subject is obviously the ruined windmill which has been placed at roughly one third from the left hand edge and one third from the bottom and is balanced by the poles and the storm clouds on the right. Although very much a basic sketch it ticks a lot of boxes from a compositional and construction angle.

place to start when considering proportions and composition in paintings and certainly by the sixteenth century, painters, including Leonardo da Vinci, were applying some of the principles to their work.

In terms of scale and from a practical angle, buildings are somewhat different to paintings and if we applied the 'ideal' rectangular form as espoused by the Golden Mean it would mean that we would be painting in a somewhat excessively wide landscape format. That might be fine for the occasional picture but as we would normally be using a less extended rectangle as typified by a half sheet or quarter sheet of watercolour paper, or even at times moving towards a square format, the good news is that we can still utilize the Golden Mean idea by using a simplified form for painting without the use of mathematical calculations. The bit that really matters is the one third principle. Actually if you apply the Golden Mean more accurately it would be the one third and a bit principle but for a painter, one third is about right. This concept is not set in stone but as a start point, if you take the trouble to think about your composition in its most basic form, placing the main subject or point of interest roughly one third from an edge of the paper will give the painting a certain aesthetic quality that will emphasize the point of interest but allow a balanced composition and if you really want to hit all the buttons putting it one third from two edges will be even better. It doesn't matter which two edges – if you think about it there will be four optimum points in any rectangle.

The placing of the main subject in Fig. 4.2 is very much in line with the Golden Mean thinking. Rather than putting the subject bang in the middle of the picture, putting it off to one side allows room for the balancing elements and helps the overall feel of the picture. The Golden Mean principle doesn't just stop with the overall composition. The telegraph poles might well have been more regularly spaced in real life but my drawing has again gone for the one third principle in the placing the middle of the three poles immediately to the right of the windmill. This is not accidental but because of an awareness that a too regularly spaced row of vertical poles becomes an ugly intrusion. Deliberately modifying the spacing and exaggerating the amount of lean here and there adds to the composition and with the ominous clouds behind them reflecting the stormy conditions.

Overall this is a classic example of the advantages of using a sketch book. Even in the limited time available I've been able to create a lively sketched composition by the placing of the main subject and the supporting clouds and poles. If you think about composition and construction at this very early stage of a painting, you create the basis for a picture rather than an exact reproduction of what is actually there and the more you work like this the more instinctive it becomes. You don't get that sort of flexibility from using a camera.

There is another issue to be considered with this sketch. The horizon line effectively cuts the picture from the vibrant sky and the main subject of the windmill and leaves a blank area one

Fig. 4.3 This is the sketch with the foreground developed. The reeds have been kept loose and varied to avoid a barrier across the bottom of the picture and they have more height and detail on the right hand side which encourages the viewer's eye to travel through the picture via the reeds and the telegraph poles to the main subject, the windmill. It's a simple picture but it ticks a lot of boxes and sometimes a simple picture can have a lot more appeal and impact than something fussy and excessively detailed.

Fig. 4.4 *Storm Clouds Near Horsey.* This watercolour was painted in the studio from the sketches. I've concentrated on retaining the stormy threatening sky and kept the foreground as simple as possible. From a compositional viewpoint it might be argued that the horizon should have been a bit higher in the painting as the major point of interest is a little too low but it's nicely balanced by the cloud formations and you can't win them all!

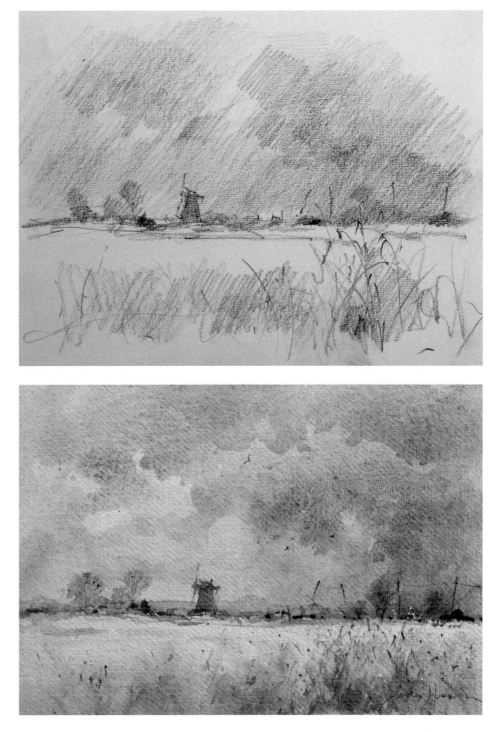

third below it. At the time the priority was the windmill and the sky and the fact that I didn't put anything below the horizon suggests I wasn't too bothered about what was there. The divide has been eased to a certain extent in the sketch by using a large clutch pencil with a little help from a more conventional 8B, which has created the freedom of loose soft marks rather than hard lines but the foreground can't be ignored altogether when it comes to the actual painting. In reality it consisted of marshy reed beds but any attempt to convey their presence has to avoid the trap of creating a horizontal barrier across the picture between the viewer and the point of interest.

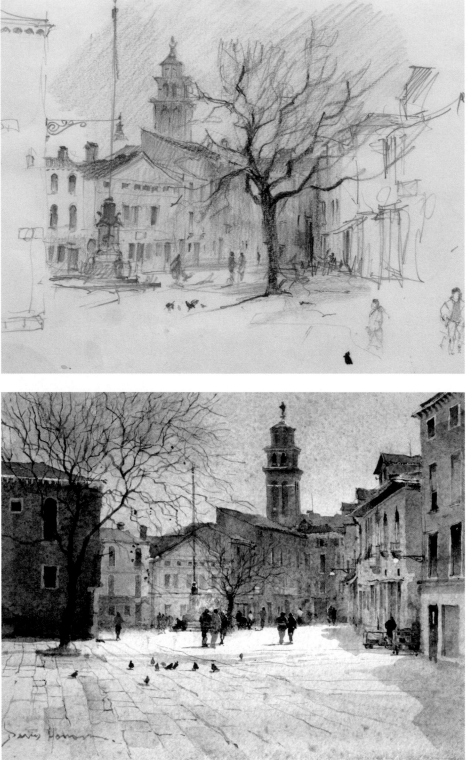

Fig. 4.5 *Campo Santa Margherita, Venice.* This sketch was produced sitting on a stool in Campo Santa Margherita and is a fairly classic example of how not to do it. The church campanile is actually in a Golden Section ideal spot – i.e. one third from the top edge and one third from the left side and therefore was probably seen as the main point of interest to start with. However, there are other dominant features, not least the tree, that have confused things, leaving the viewer similarly unsure of what it's all about.

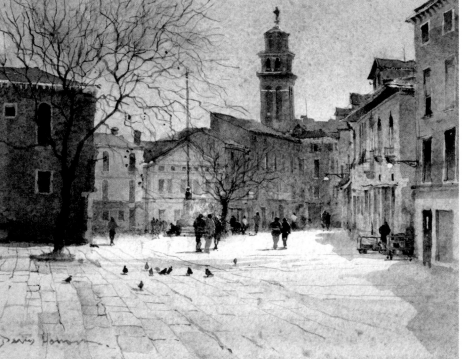

Fig. 4.6 This is better. This watercolour is painted from a little further back in the square but there is still a lack of focus on what are the most important elements and what is the main point of interest. The far end of the square with the campanile and supporting buildings are an interesting set of shapes and in the right place compositionally but the eye tends get caught up between the groups of people and a tree.

How not to do it!

The sketch of Campo Santa Margherita is undoubtedly busy and full of content but if painted into a watercolour literally as it is in the sketch, would lead to a fussy painting that wouldn't look right. From a viewing angle it's unclear what the main subject is.

Almost certainly this is how it looked from where I was sitting but the tree takes over in the foreground and the eye is drawn towards the people standing just beyond it and then round to the right into the dark end of the square. The figures in the bottom right hand corner incidentally are just quick sketches of people walking by – always handy for future paintings.

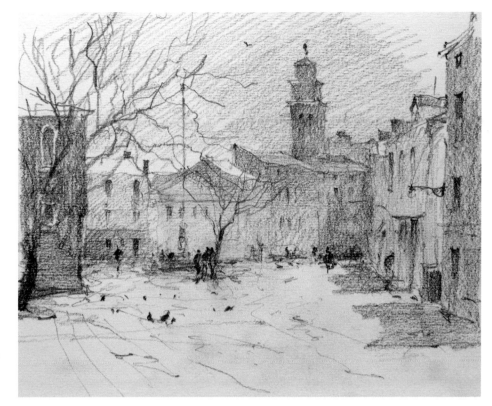

Fig. 4.7 This is a revised tonal graphite sketch of the square. The buildings still feature as the main attraction silhouetted against the strong sky and located as a group round the campanile at roughly one third from the right hand edge. The bright paving of the square swings round towards them and by moving the left hand group of figures back a bit, they don't get in the way and it allows the viewer's eye to find its way into the picture on the left side, via the pigeons and the group of figures and then down the square to the buildings and church at the far end. The right hand pair of figures in the watercolour have been removed and replaced by a more distant and less distinct figure which repeats the one third principle by being placed off centre in the gap between tree/figures/flagpole on the left and the buildings on the right, whereas in the watercolour they were bang in the middle of the gap. This is a loose rapid sketch largely produced by a clutch pencil but as a composition it has a better balance and works more effectively.

This watercolour in Fig. 4.6 isn't a bad painting but it could be improved. People or living things always draw the eye and therefore irrespective of where they are at the time, they have to be positioned with the overall composition in mind. The title of this painting gives the clue as to what it's about – *Campo Santa Margherita* – and my primary reason for painting the scene was the group of buildings silhouetted against a surprisingly strongly coloured afternoon sky and the way the sunlight was bouncing off the paving. The group of buildings and the tower are very much in the right place from a compositional point of view and the shape of the square leads the eye towards them. The problem is that the two groups of people are too central and get in the way and whilst they may well in reality have been precisely there at some point, it's important to make sure in this sort of situation that they are placed where they fit in with the composition rather than where they actually are. One of the attractions of Venice is the lack of vehicles which means that people have to walk or travel by water and therefore its squares, particularly away from the tourist hotspots, always have a mixture of pedestrians either going somewhere or meeting with friends for a chat and they are very much part of the townscape. If you leave them out, it isn't a Venetian square. You can't ignore them – just make sure they fit in the right place.

Another Venice picture, the sketch of Rio di San Vio was produced leaning against a bridge parapet over the canal. It's another winter afternoon picture with an interesting sky as the sun goes down but however right from an atmospheric and drawing angle it also has compositional issues, the primary one being that there's a hole down the middle with a distant chimney in the middle of the gap and the related perspective of the canal and buildings leads the eye towards it. Is the chimney the subject? Good question! There is a human interest in that there is at least one boat under way, coming towards the bridges but again it's all a bit central.

The answer in this instance is to reinforce a point of interest round a combination of the boats and the shapes of the bridges and to relieve the chimney of the responsibility of being the vague focus of the picture. That can be achieved by surprisingly little modification. Moving the boats/bridges a little more to the right and a little further up into the picture (back to the Golden Section) will help considerably and moving the chimney to the left or the right so that it's roughly one third from one side or the other and not bang in the middle of the gap, would improve things and balance the composition. Even just a modest cropping of the picture on the right immediately brings a slight improvement.

Consideration of compositional issues right at the beginning will always pay dividends with your paintings. You can buy ready-made small scale viewing frames, or even make your own, that are designed to be held out in front of the subject and there is at least

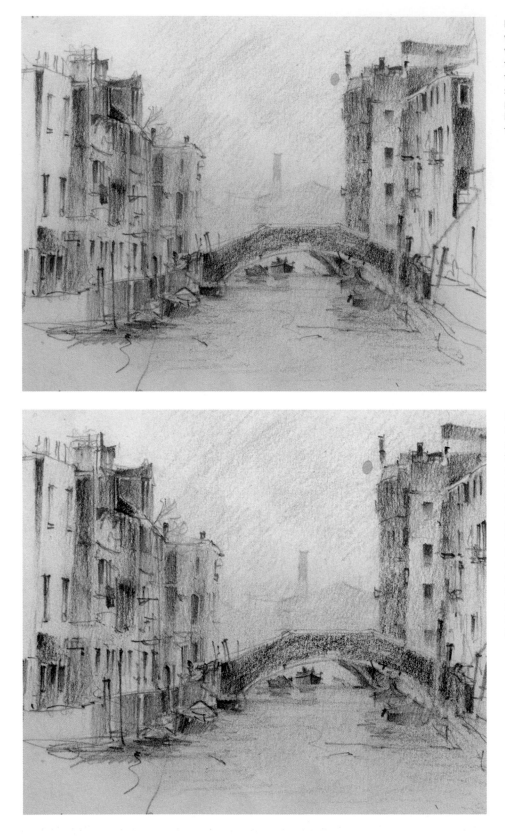

Fig. 4.8 *Rio di San Vio, Venice.* A late winter's afternoon in Venice. It can be wet and chilly in Venice in the winter but the light and the relative lack of summer tourists makes up for it. This coloured sketch produced with crayons and soft pencils captures that winter feeling but has compositional issues that need to be thought about.

Fig. 4.9 *Rio di San Vio* – cropped. The chimney over the water on the Giudecca still needs moving out of the middle and to the right or the left of the gap but otherwise the focus of the composition is more on the shapes of the boats and bridges. Note the sense of distance that is conveyed by both linear and aerial perspective. The chimney and buildings in the distance are a soft grey/blue, merging into the sky colour, whilst the closer buildings have much more colour strength and more detail. This is one of the distinct advantages of sketching in colour and although I use it as a rapid way of recording things the sketch is effectively a picture in its own right.

Fig. 4.10 This graphite sketch was produced high in the Yorkshire Dales near Settle on a damp and cold afternoon. Despite not having an obvious subject, the composition allows the eye into the picture via the sheep fence and stone wall on the right and then to the farmstead in the valley and then the lines of distant stone walls lead the eye to the contrast of the dark ridge in the distance, balanced by the even more distant high ground veiled in the threatening clouds.

one of these that is adjustable so that you can vary the format from rectangular to square. They can be helpful at the early stages of composing a picture or holding up both hands with the forefinger and thumb extended at right angles to form a rough rectangle film director style, works just as well, even if it looks a little pretentious. These sort of aids work equally well with life work, portraits, still life, and so on, all of which require compositional planning, as well as the more obvious application for the *plein air* painter and can be of assistance at the early stage of the painting process to determine just where the point of interest should be in the composition and in relation to its surroundings. They shouldn't be relied on to try and fix everything in the picture and once the initial decisions are made as to where the main element or elements will be placed, they can be put to one side. Sketching allows you the essential flexibility of changing things and developing a composition that makes a good painting rather than a super accurate representation of what's actually in front of you.

Try not to get distracted by subsequent events. For the outdoor painter it's all too easy to start a painting or drawing with an established point of interest and something else happens that demands your attention. A peaceful landscape might focus on a group of trees and farm buildings, but after an hour or two a herd of sheep might arrive on the scene or a harbour composition might suddenly be completely changed when a large fishing boat arrives with colourful floats and nets, which changes the whole appearance of the picture and you can't help yourself and the

new arrivals get included or even take over. Amongst my students these distractions are known as alligators. There is an American saying from the Florida Everglades that 'When you're up to your backside in alligators it's sometimes difficult to remember that the reason you originally came here was to drain the swamp'. If the 'alligators' enhance the existing composition, fine but more often than not they change the whole focus of the picture and frequently confuse things. Be prepared to ignore them and again having that all important initial sketch is a huge help to keeping things on track.

Finally, it's quite a good idea to have a couple of mounts handy that you can use in conjunction with one another to offer up round a finished work so that the picture area can be marginally adjusted and cropped to allow you to see how it might improve the composition. When you are absolutely happy, remember to put 'tick' marks in the corners as a guide to the framer for the dimensions of the final mount.

Perspective

Apart from the need to create pictures that are pleasing to the eye from a compositional view we are, as figurative painters, involved in the deception that what the viewer is looking at appears to be three dimensional, whereas in reality it's on a flat two-dimensional piece of paper. This illusion is achieved by the use of

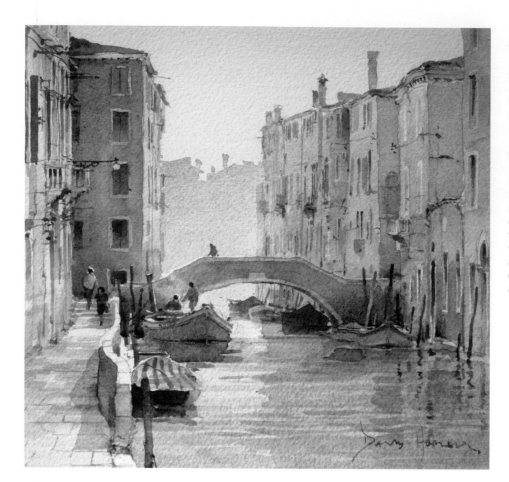

Fig. 4.11 *Rio di Santa Caterina, Venice.* This is an early morning picture in Venice and illustrates that however uneven they are (and after all that's part of the attraction), the buildings get smaller as they get further away down the canal and the sides of the canal itself converge as they go into the distance. The lines of perspective on the left side, particularly the canal side wall are almost vertical, indicating that I'm standing virtually in line with it, whilst the angles of the buildings on the opposite side are gentler, showing that they're further away. Two other points to note – the main interest is the men and the blue boat by the bridge, which are vaguely in about the right place, and also look at the lack of detail and cool colouring of the distant buildings. That's aerial perspective.

perspective which in turn can be linear or aerial or most likely a bit of both. Most painters will be familiar with the basics of linear perspective at least, and many may struggle with it from time to time. As always it's largely about observation and painting what you see rather than making assumptions or getting into excessively complex theory but at the root of linear perspective is the fact of life that things get smaller as they get further away. For instance, if you have a row of cottages, the ones nearer to you will be larger than the ones at the other end of the street and any related features like people, cars, lamp posts, and so on, will similarly reflect the diminishing effect of distance and on the same scale. There's no set formula and what you, as a painter, have to determine is what angles of pretty well anything in a picture are needed to create the appropriate level of recession and at the same time to tell the viewer whether they are looking up or down in relation to the subject.

It's surprising that so many painters struggle with linear perspective when all you really need to confirm angles and proportions is a pencil of a reasonable length. Starting with angles, the secret is careful observation. Don't assume anything but take the trouble to check horizontal angles against vertical ones. Taking buildings as an example, it can be assumed that all vertical walls are roughly just that, irrespective of how far away or near to you they are. They may vary slightly with older and more rustic structures but if they lean too much out of the vertical they tend to fall over. However, roofs, gutters, and the horizontal lines on windows and doors will all have an element of perspective in them unless you are viewing them from straight on. With experience you get used to judging these angles but even experienced painters will occasionally hold up a pencil vertically to check. Bearing in mind that the verticals in the buildings will be near enough as a guide to ensuring your pencil is about right, you can check the angle of any line against it. Does it go up, down or is it horizontal? As ever, don't assume anything and it's particularly important to check, if your viewpoint is higher or lower than the line or feature under consideration, because the basic theory of roof lines going downwards as they recede and base lines going upwards until they meet at some vanishing point may not apply in the real world. Paint and draw what you see!

Not making assumptions becomes critical if your subject is effectively below or above you because the only way of indicating your viewpoint is to get the perspective right and surprisingly strange things happen, depending on how high above or below you are.

Fig. 4.12 *Najac.* Najac is a medieval village in the Dordogne region of France where the main street drops down a steep hill towards a magnificent castle perched on an outcrop at the bottom end. A very paintable subject but it does require strict attention to perspective angles.

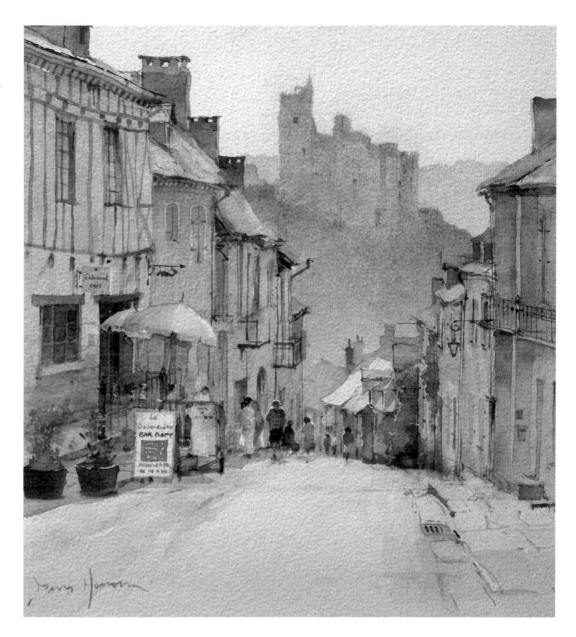

The picture of Najac illustrates how important it is to get perspective right and in particular what happens when you are at the top of a hill. All our instincts tell us that roof lines will slope downwards as they move away but that only applies if you are below them. If you are above them the lines whether high or low on the building itself, will tend to be angled upwards. The picture of Najac clearly shows this with gutters and roof lines angled upwards from the vertical and note that the horizontals of windows and doors follow suit. If you don't get that right, windows and doors will look decidedly odd and the lines of perspective on the buildings also change as the street bends round to the left halfway down. Always be aware that the size of people changes and they too must get smaller as they get further away and in scale with the buildings in the same vicinity. What the painting does convey is that you're looking down a very steep hill and it follows that if you were down at the bottom of the hill looking up there would be a similar re-arrangement of perspective angles. Check, check and check again before you get to the stage where paint is on the paper and it's too late.

Note the treatment of the distant castle in the Najac picture, particularly how it is painted with minimal detail and in soft cool bluey-grey tones. That's aerial perspective in action. Apart from things getting smaller as they are further away, they also tend to get a bit fuzzier and indistinct. The degree may well depend on the prevailing light and how good your eyesight is but most of us would need a pair of binoculars to see any detail on something more than a few hundred yards away. In addition to this, as objects get further away they not only lose definition,

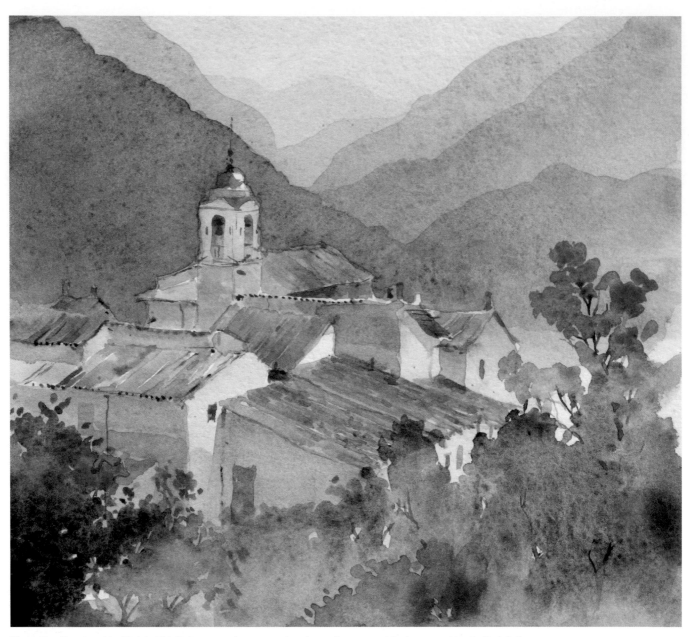

Fig. 4.13 *Castelvecchio, Umbria.* This little watercolour was painted one afternoon whilst I was teaching in Umbria from a position above the village with the sunlight reflecting off the church tower and the pantile roofs and this amazing view down the valley through the mountains towards Spoleto. The perspective lines on the buildings reflect the high viewpoint and the receding spurs of the landscape get paler with each stage as they get further away with progressively cooler less intensive colours, whilst the foreground vegetation colours are much stronger and warmer.

they also lose colour and painters should be prepared to reflect this and even exploit it in their paintings to further reinforce the impression of recession.

Even if you can see detail in a distant feature, simplifying the shapes and softening the outlines will help to make the picture more effective and leave something to the viewer's imagination. Using cooler colours will similarly give the impression of distance and there's nothing wrong in using your painting skills to exaggerate this. You will find a lot more on colour in the next chapter but one of the reasons for using warm and cool

versions of the primary colours is to enable colour mixes that help with depth in paintings. As always there will be exceptions but in general terms warmer more intense colours should feature in foregrounds, whilst cooler softer colours work better in the background and far distance.

As with most things with painting, composition and construction comes with practice and getting it right will result in paintings that catch the eye and look right. Isn't that what we're all trying to do?

Fig. 4.14 Same village – different angle. This is Castelvecchio from further down the hill and where all the buildings are at or above eye level and the resultant perspective has to reflect that.

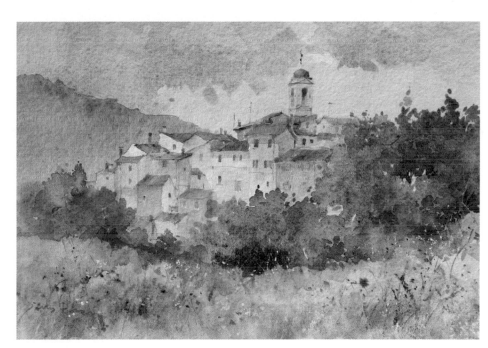

Fig. 4.15 *Brixham.* Square pictures tend to add a little something in comparison with the more relaxed landscape format but the same general composition principles apply. In this example the red/orange boats are warm coloured and immediately command attention, positioned as they are roughly one third from two edges but then the eye slides neatly up the street to the balancing effect of the bright gable ends of the cottages.

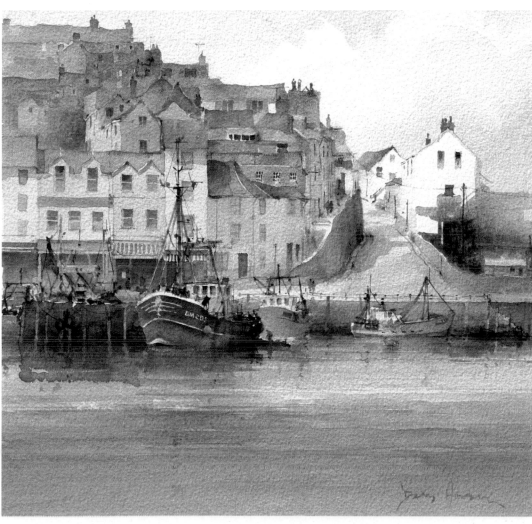

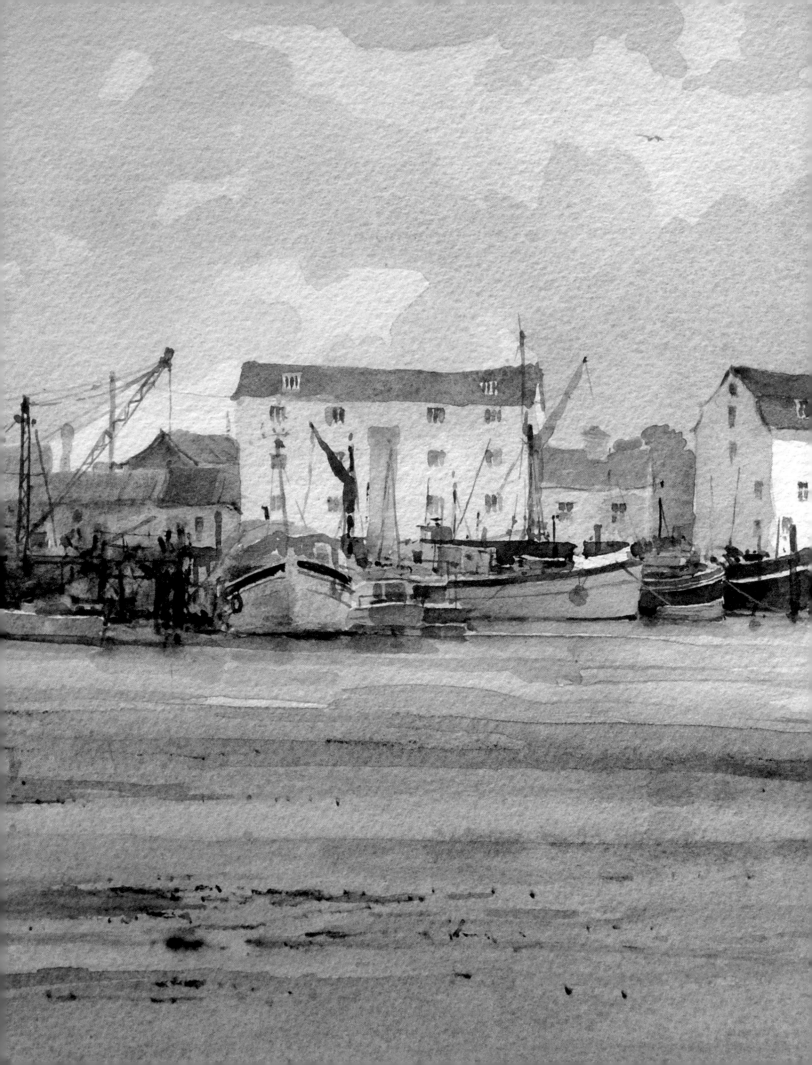

Understanding Colour

Apart from the basics of composition, shape and perspective, the overriding concern for most painters is mastering the skill of getting the tones and colours they want in their pictures and therefore the need for a range of colours and understanding what they will produce for you, is a primary requirement for successful painting. Things aren't exactly helped by the wide and ever increasing range of colours that are produced by manufacturers and any attempt to cover all your colour requirements by buying more and more tubes or pans will inevitably lead to confusion and not inconsiderable expense.

I've talked about the selection of colours that I use in Chapter 1 and this chapter is intended to develop this further in understanding how effective they can be. For painters, there are three primary colours, that is colours that in their purest form, can't be mixed from any other colours and they are Blue, Red and Yellow. Theoretically, these three colours can then be mixed with others to produce any colour required but it isn't quite that simple to define exactly what is a pure primary colour, not least because a glance at a paint manufacturer's colour chart will undoubtedly confuse things further by showing a selection of at least ten to fifteen different versions of blue, red and yellow. In most cases they will show a bias towards either the warm or cool side to the colour and if you try and work with just three pigments and get it slightly wrong, you won't necessarily get the clarity in secondary colour mixes that you might expect. If however, you deliberately choose a warm and cool version of the primary colours, you have effectively a double primary palette and the advantage of this is to ease the progression into clear intensive secondary colour mixes and to retain the luminosity of watercolour as much as

possible, as well as allowing the option of more subdued mixes where required.

The primary colours I use have been around a long, long time and have the advantage of being available everywhere, from all manufacturers. In comparison with some of the more exotic names dreamed up for new pigments they may sound a bit ordinary but the important thing is that they work. Starting with the blues; Cobalt is my cool blue and Ultramarine is the warm one. Cobalt Blue is just about as pure blue as you can get, whilst Ultramarine's warmer appearance is because there is a hint of red in it. This means that its bias towards red allows it to be readily mixed with the latter to make clear violets and purples. Similarly, the cooler Cobalt Blue leans more easily towards the yellows to allow clear greens.

With the reds my choice is Alizarin Crimson as the cool one and Cadmium Red as the warm. Adding a hint of blue to a red makes it cooler and Alizarin naturally gravitates to violets and purples, whereas Cadmium Red is warmer and makes bright intense oranges as it moves towards its warm yellow neighbour on the colour wheel. It's worth noting that there is always a slight question mark about the light fastness of Alizarin Crimson but traditionally most other cool reds like the Madders and Carmines are similarly rated as somewhere between permanent and less than permanent, rather than absolutely permanent. There are alternative cool reds. Many manufacturers produce a Permanent Alizarin Crimson, although it isn't quite the same colour but the reality is that all watercolour paint will deteriorate if continually subjected to bright light and it's a fact of life that a more fugitive pigment will fade faster than the others.

Fig. 5.0 *Woodbridge.*

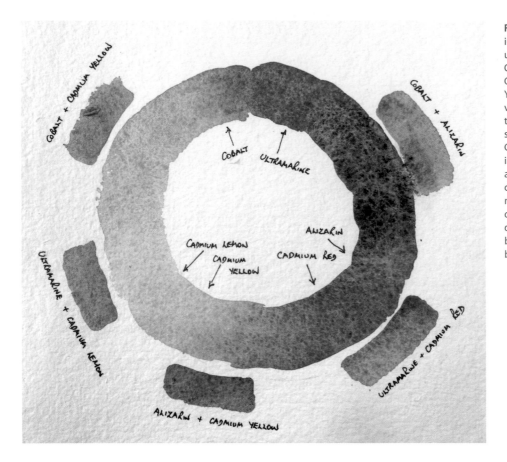

Fig. 5.1 This colour wheel (or slightly irregular colour doughnut) is painted using my warm and cool primaries of Cobalt and Ultramarine Blue, Alizarin Crimson and Cadmium Red and Cadmium Yellow and Cadmium Lemon and in the vaguely circular section, illustrates how they combine to make clear graduated secondary mixes of Purple, Orange and Green. This wheel was painted wet-in-wet in one go, on Two Rivers handmade paper and shows the clarity and intensity of the colours that can be achieved by minimal mixing and using warm and cool primary colours that work together. Your selection doesn't have to be the same as mine but a little thought about what makes a balanced palette will pay dividends.

The yellows I use are both Cadmiums – Cadmium Lemon is the cool one whilst Cadmium Yellow is the warm. Cadmium Lemon already has a slight green bias and mixing it with Cobalt will give a range of bright clear greens, whereas Cadmium Yellow is a strong pure yellow that easily joins forces with Cadmium Red on the warm side. The Cadmiums are opaque watercolours but if sufficiently diluted are transparent enough to work well in colour mixes but they also have the power of intense colour if needed.

You won't always want colours as clear and sparkling as those in the circle but awareness of how colour works will enable you to achieve less intense colours from the same selection, whilst retaining a level of clarity that will make your paintings more interesting. The key to this is understanding the complementary colour principle. Opposite, or complementary colours will, when mixed, subdue or neutralize each other and this technique comes in very handy when you want less intense hues without resorting to the deadening effect of proprietary greys and blacks out of a tube. They work particularly well for instance, with shady areas or where aerial perspective is bleeding the colour out of distant elements in a composition and it follows that if exact opposites have this effect on each other, then there is a partial de-saturating effect attainable by mixing colours that aren't quite opposite or alongside one another on the wheel. As examples I've painted just

some of these intermediate mixes round the outside. Working clockwise from the top, the mix of Cobalt Blue with Alizarin Crimson produces mauve rather than the violet/purple created by mixing the adjacent Ultramarine and Alizarin, whilst mixing Ultramarine with Cadmium Red generates a bluey grey. Down at the bottom you can see that mixing Alizarin Crimson with Cadmium Yellow produces a browny yellow rather than the clear orange produced by mixing Cadmium Yellow with Cadmium Red. By using a balanced selection of two blues, two reds and two yellows and understanding how they relate to each other and work together, it is possible to get to pretty well any colour that you want.

Finally, look at the variations of green created from both the primary and intermediate mixes. They range from a greeny blue to yellow on the main wheel along with the darker more intensive greens made with intermediate mixes. If you then take the complement of green – that is red and bring that into play as well, you will have a range of dark and light, bright and subdued greens that can replicate anything that exists in the real world. So many painters get nervous about greens but working this way makes it so much easier to get natural looking and varied greens rather than wrestling with some of the ready-made variety, like Hooker's and Viridian, which can be excessively dominant. Paint suppliers

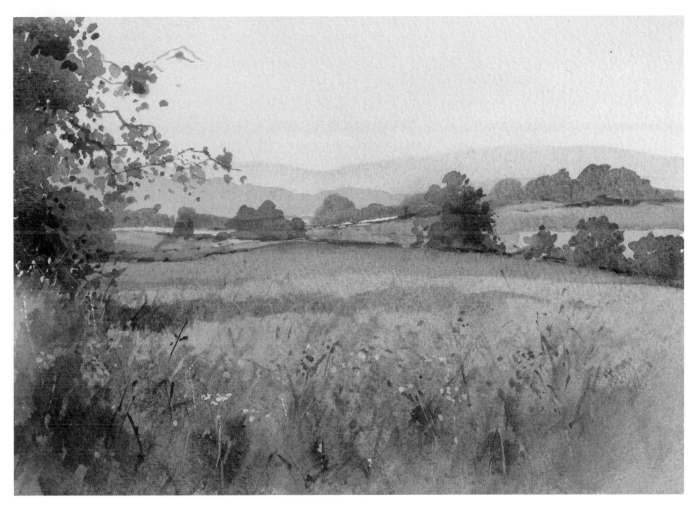

Fig. 5.2 This little early spring morning watercolour of a North Yorkshire landscape is painted on Waterford 300gsm Not surface paper in a ring bound 19 × 28cm RKB Fatpad. Despite the variation of greens involved they are all created, using the primary colours and a little help from Raw Sienna and Raw Umber.

offer a wide selection of greens but trying to match them with the range of greens in foliage in the real world, either requires mixing them with other colours, or risking creating paintings where something straight out of a tube takes over and imparts a totally unnatural colouring.

Figs 5.3 and 5.4 are examples of how the complementary colour principle works in practical terms. The first two show watercolour sketches of a Tunisian fishing boat at Hammamet. These boats are very colourful and make a lovely subject, sitting on the beach in the sun, with light and shade defining the shapes. If you use Black or something like Paynes Grey for the shaded areas, it deadens the colour in the shadow areas, whereas in real life these darker areas will still have loads of colour, albeit with darker tones and of course in this environment they will also have the influence of reflected light from the sand and surrounding boats. Every now and then this book will talk about the

advantages of working *en plein air* and one of the major advantages of painting on the spot is that you study the subject with so much more intensity and in such circumstances you will be aware of much more colour in these shadow areas than you would see in a photograph. Cameras are fine for the quick recording of a subject but they do have their limitations and one of them is that despite ever advancing technology, they don't necessarily get it quite right. Camera metering determines the best exposure for what it's being pointed at and if the subject is this fishing boat, it will come up with an exposure that is right for the boat, the sand around it, the sea and the sky above but it will almost certainly under expose the shadows, which means that they will appear darker than they actually are. We are so used to photographic images, that we just accept this as normal and for painters that rely totally on photos, that's how the world looks. The plein air painter will see it differently.

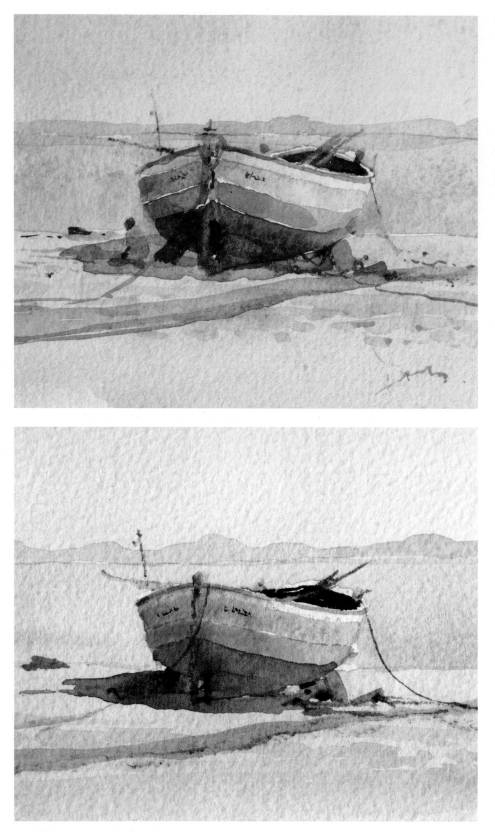

Fig. 5.3 *Tunisian Fishing Boat* – 1. In this instance the shadow side of the boat has been muted by using the various colours' complement. The blue strip on the boat was quite a light cold blue, slightly greeny and I've used Cobalt Blue as the base colour and I've deliberately used a little spectral mixing by thinning the wash and adding a smidgeon of Cadmium Lemon as the sun hits it, whilst the shady side has orange added. Similarly, the yellow band has purple added to the shady side and the red on the bottom of the boat has green added to de-saturate and darken the colour.

Fig. 5.4 *Tunisian Fishing Boat* – 2. This shows the same boat but instead of using the complementary colour principle for the shadow areas, the short cut approach has been used with Paynes Grey. The result is that, whilst on one level it achieves a light and shade effect perhaps more similar to a photograph, the shadow areas are darker and less interesting because the deadening effect of Paynes Grey has killed the colour.

The dark interior of the boat again uses complementary colours, in this instance a combination of Ultramarine and Burnt Sienna. The shape of this dark interior was painted in with a relatively concentrated puddle of Ultramarine and then a similarly concentrated mix of Burnt Sienna, which is effectively a deep orange, was dropped into the wet shape. It's important not over mix this combination and to allow it to create a vibrant dark mix, that is so superior to the deadening effect of just using black.

If you see things with a photographic mindset or work exclusively from photographs, you will be used to sharply defined shapes and deep shadows and these loose sketches will have a somewhat unfinished feel. What matters, however, is what makes a better picture? These are simple paintings in watercolour without any pre-drawing, not meticulous copies of a photograph and what a painting enthusiast sees is the colour and immediacy of a painter's work. They're not bothered whether the gunwale is too wide or the hull too deep, they just see a colourful painting of a fishing boat.

By using a balanced dual primary set of colours and understanding how they relate to each other and work together, it is possible to get to pretty well any colour that you want and this allows you to achieve that vital harmony in pictures where the colours all seem to work together. Once you are familiar and at ease with your own particular selection, it enables you to get what you want in terms of mixing and colour relatively easily and allows you to concentrate on the painting itself.

When you get to this point, do beware of introducing new colours that upset the balance. A number of manufacturers in recent years have introduced theoretically brighter and stronger pigments that have their origins in the industrial and automotive world and certainly in the case of one manufacturer, claim to have developed a synthetic binder that supposedly allows a higher pigment loading than the traditional Gum Arabic, thereby offering the prospect of deeper more intensive colour. That may be well and good but watercolour so often depends on a subtle approach and if new fancy colours are excessively dominant that could be bad news.

I indicated earlier there are alternatives to my suggested primary colours which you may prefer or in some cases might be less expensive. I accept that the Cadmiums and Cobalt Blue are at the top end of manufacturers' price lists and whilst they have superior tinting power they can be substituted if you feel the need to limit expenditure. As an example, Cadmium Yellow is a warm intense yellow and on the colour wheel it's leaning gently towards the orange/red side; most manufacturers produce charts that will show their yellows going from cool to warm and therefore it makes sense to look in the same area of the chart that contains the colour you're intending to substitute. Looking at a Winsor &

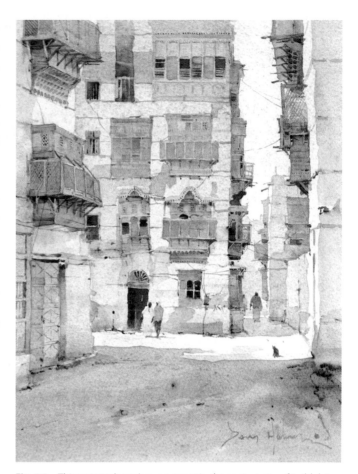

Fig. 5.5 This watercolour shows a street in the ancient city of Jeddah in Saudi Arabia. As you would expect the light is intensely bright and you might expect the shadows to be excessively dark in comparison. The reality however is that these shaded areas are full of colour and reflected light, rather than just dark grey, and using the complementary principle ensures that these areas retain their vibrancy and colour.

Newton colour chart for instance, Winsor Yellow Deep or New Gamboge appear either side of Cadmium Yellow, both of which are categorized as group one on pricing rather than the group four of Cadmium Yellow. Other manufacturers may have their own names for these alternatives – Old Holland for instance uses the name Scheveningen – and some produce 'Hues'. If a paint has 'Hue' after its name it indicates that it uses substitute and less expensive pigments.

The same principle applies to the other Cadmiums and Cobalt but is it worth it? You will save money but not necessarily a huge amount. The saving will be in the region of 35 per cent on the pigments in question and whilst this may be of significance to oil painters because they use more paint, as watercolourists it's unlikely that we would be getting through paint at anything like the rate that would make this sort of economy important. There are other considerations as well. I've never found anything that quite matches the intensity and clarity of Cadmium colours,

Fig. 5.6 *Sunrise – Île de Ré.* The power of the Cadmiums! This painting is all about the brilliance of a sunrise over the water and relies considerably on the power of Cadmium Yellow, muted where appropriate with Alizarin Crimson and drifting up into a light Cobalt Blue early morning sky. From a composition point of view, the eye is led from the old marker posts on the left along the channel to the boats and from there to the sun.

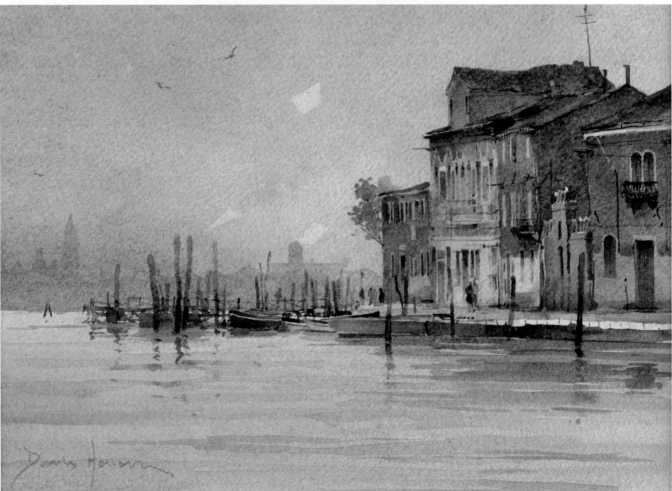

Fig. 5.7 *Fondamenta San Giovanni dei Battuti, Murano.* A good example of Earth colours in action. This is a winter afternoon picture where there is little evidence of bright colours, but instead there are soft greys, deep reds, ochres and umbers with just the occasional brighter colours on the boats. Raw Umber has been predominately used to depict the winter sky with the subdued silhouettes of Venice in the back ground painted with Cobalt Blue mixed with Light Red and the latter figures predominately in the rooftops and brickwork of the buildings.

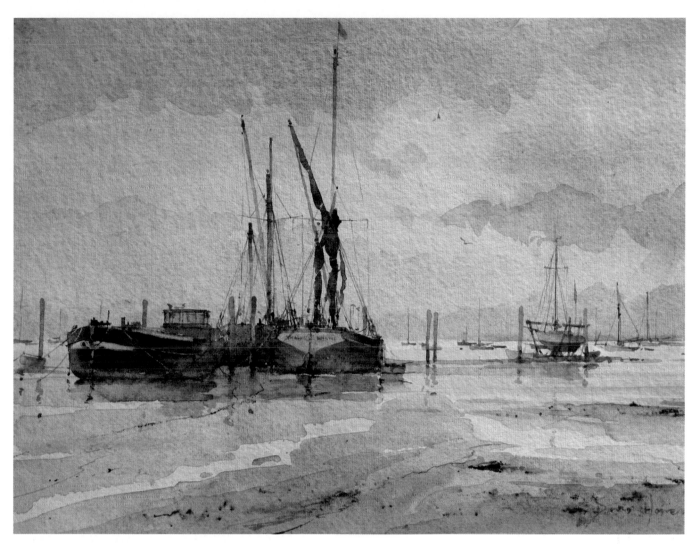

Fig. 5.8 This is another *Pin Mill* picture where the sky and reflections have been kept relatively clear and clean by using largely primary colours, but earth colours have been used on the moored vessels. In particular, using a mix of Ultramarine and Burnt Sienna has created nice dark blacks for the barges and note the way that at the waterlines, Raw Umber and Light Red have been used to depict anti-fouling paint and rust and to convey the sense of solidity of the barges.

particularly when mixed with other paints and because of this you arguably need less paint to achieve the result you're looking for. The same principle applies to 'Student' colours – they are cheaper and okay up to a point but they're simply not as good as the 'Artist' pigments.

That leaves the rest of my recommended colour range which consists of a number of 'Earth' pigments:

- Yellow Ochre / Raw Sienna/ Raw Umber / Light Red / Burnt Sienna / Burnt Umber.

Their choice is undoubtedly influenced by the fact that I paint a lot of marine and landscape pictures but I've found that over many years, they provide a range of paints that give me a base to build my colours on and are constantly in use.

None of the colours I use are excessively dominant, apart from possibly Burnt Sienna which needs a certain amount of care but it's strength allows it to be mixed with Ultramarine to make beautiful blacks. You won't always want clear bright colours and using de-saturated primary colours along with Ochres and Umbers provides a complete range of subdued colours for winter light, dull days or dark interiors, for instance. Light Red mixed with either of the blues makes soft greys, either on their own for their own sake or mixed wet-in-wet with Yellow Ochre, Raw Sienna or Raw Umber for shadow sides of buildings or with the main yellows to warm them and to create splashes of sunny brighter colour.

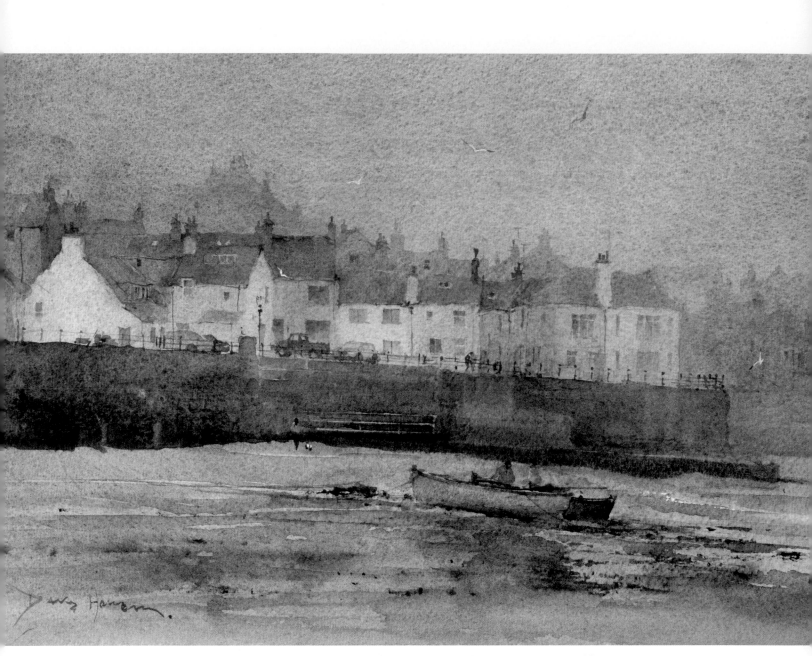

Fig. 5.9 *Sea Fret and Rain, Staithes.* The world isn't always bright and shining but atmospheric paintings in wet and foggy conditions can often be very effective. The aim here has been to let the colours of the cottages glow through the fog and drizzle, and they have been de-saturated by using the complementary colour principle to retain their harmony. The greys of the sky and vague silhouettes of distant cottages add to the atmosphere.

The picture of Staithes was painted on a day when it might have made a lot more sense to give up and go home. When watercolour is being washed off the paper as fast as you can get it on you've got a problem, but sometimes paintings produced in adverse conditions can be as equally effective as 'chocolate box' sunshine. The important point is that the same group of colours recommended produced both this and the brilliant colour of a Red Sea sunset in Jeddah in Fig. 5.10. You don't need a huge selection of paints and pigments – just a limited number of the right ones will do fine.

When tackling a sunset like this you have to accept that it won't be around for very long. The sun sets quickly in the tropics, so much so that you can actually see it moving and disappearing, and therefore memorizing colours is vitally important and making a few notes on the colours you are seeing may be of considerable help later on. A camera is a waste of time because the brightness of the setting sun will obliterate everything else. The boats of course weren't going anywhere so they could be painted or sketched at any time, either before the sun got to the final few minutes of its plunge to the horizon or even the next day.

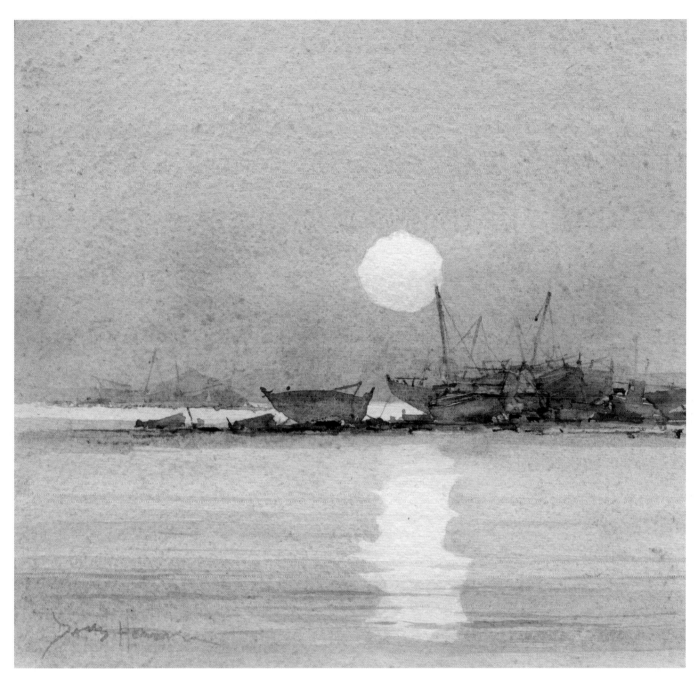

Fig. 5.10 *Red Sea Sunset – Jeddah*. This painting again shows the tinting power of Cadmium Yellow in particular but it's mixed in the sky with Alizarin Crimson, moving towards Ultramarine higher up and creating a purple, effectively working round the warm side of the colour wheel to get brilliant but harmonious colour. In contrast the use of Cobalt in the sea provides a fascinating balance of colour. We can never get it quite as bright and vivid as the real thing but we're only using paint rather than the power of the sun.

Ultimately the colours you choose depend on what you are trying to achieve with your painting and occasionally it's nice to have a go at something completely different. I've tried and even occasionally persevered with various colours over the years, including some that claim to be more brilliant or more intense, but I always eventually gravitate back to the tried and tested few that I know will work for me, irrespective of the subject and that means I can concentrate on all the other problems that painting in watercolours inevitably need solving.

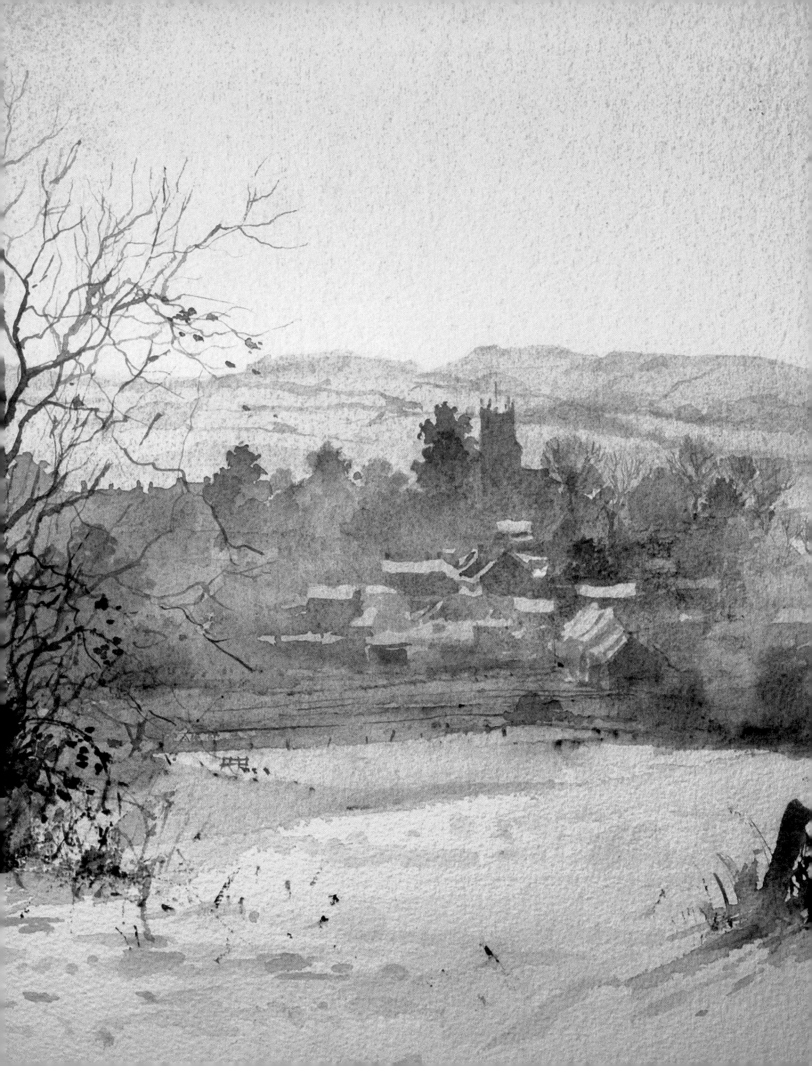

Landscape

Landscape is a fairly general term that covers much of what's outside the four walls of where we live and work and it goes without saying that to be good at painting landscape, you have to be prepared to get out there and experience it first-hand. Not just the fleeting moment of a glimpse through a car window but being out there in all weathers and seasons and at various times of the day. The more time you spend in absorbing what is around you, the more you see and you have to get used to coping with what the weather is handing out, not least because that is often when some of the more interesting landscape painting opportunities present themselves. An early summer morning may present a delightful panorama of blues and greens of various tones and hues with long shadows and the promise of another sunny day but you must be prepared to get up really early to see it as its best; likewise, tackling a winter subject in bitter cold conditions may well be even more rewarding in terms of visual impact, colour and atmosphere.

You don't necessarily have to go far. Living in a neighbourhood allows you to explore it and see it in all its variations and it may take some time, even a year or two, to become aware of its potential for paintings. Dog owners have a huge advantage. They have to be out every day, suitably clothed and protected from the elements, rain or shine, on foot and frequently over much of the same ground and if they have a painter's eye they will notice the way colour and light changes on a daily basis. I'm not suggesting that all budding landscape artists need to rush out and acquire a four-legged friend but whether you are a dog person or not, what above all is necessary, is learning the advantages of being out

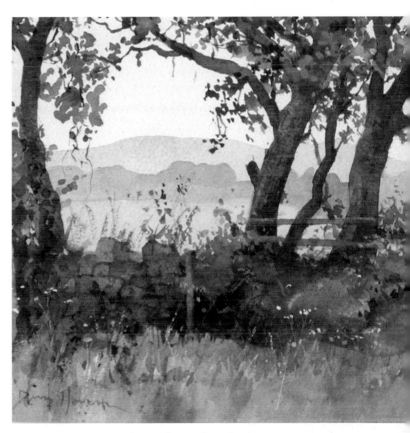

Fig. 6.1 *Devon Bank*. Landscape often works well with concentrating on a small area rather than a huge panorama. *Devon Bank* uses the shapes of the tree trunks and fence on the right as the main point of interest, with the tree on the left giving balance, and the grasses and flowers bringing a sparkle of contrast. The background hills and hedges are simply blocked in using cool blues and greys. It's so easy to walk straight past this sort of opportunity, unless you cultivate the essential skill of keeping your eyes open for anything that might make a painting

Fig. 6.0 *Langport in the Snow*.

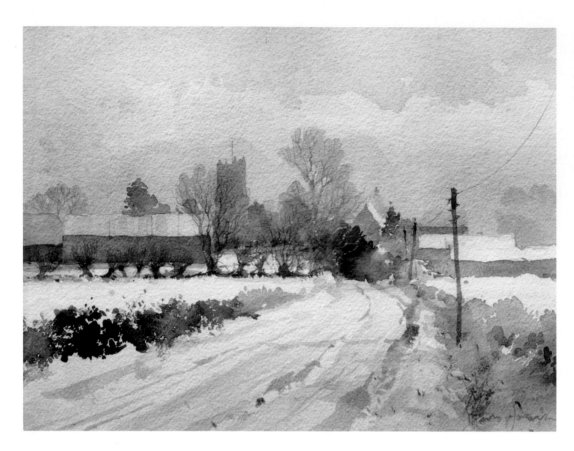

Fig. 6.2 *Snow at Muchelney*. A winter landscape – snow, sunlight and shadows, and though we associate snow with turning everything white, in reality there is a surprising amount of colour. The main subject is the church and the road and related perspective leads the eye towards it.

regularly and discovering the art of looking, standing and staring. The more you look the more you see and develop the ability to identify the components that will make a picture. It could be a wide vista across rolling countryside but often it is something that is of a particular moment much nearer to hand – the light on the side of a building, shadows rippling across the corner of a cornfield, a foggy sunrise or the juxtaposition of trees in the local park against buildings in the distance. It will look different every day and what it requires above all is a talent for observation. An experienced painter sees subjects everywhere and sometimes in the most unlikely places.

Any discussion about painting landscape pictures invariably raises at some point the question of whether, having identified a suitable subject, using photographic images is okay or whether we should be painting on the spot, *en plein air*. There is an awareness that many more experienced painters do tend to paint outside and even a view in other circles that working from photographs is somehow cheating. The issue is further complicated because not everyone is entirely honest on the subject of their working methods but the proliferation of cameras in various guises in this digital age means that in reality there are very few of us that don't use them to a greater or lesser extent. The crucial question for a landscape painter is whether there are any real benefits from subjecting yourself to the vagaries of wind and weather and the occasional intrusion of people and wildlife, or whether it's fine to take a few photos and head back to the studio.

Taking a photograph may indeed appear to be the easiest option but there are potential disadvantages of the mechanical recording process. Cameras are very handy for 'grabbing' a specific play of light or cloud formation or the shape of a group of trees but if that's all you rely on for your subsequent information, there is a distinct danger that the limitations of working from a photograph will result in a disappointing result. Landscape isn't about being photographically accurate or detailed and it needs the painter's own compositional skills to identify what is important and what isn't and what inspired the picture in the first place.

Working from a printed photograph or a digital screen may seem very convenient but it is dependent to a large extent on the camera and the skills of the operator, and often leads to a rather static reproduction of the image, which apart from too much detail, may well contain distortions of perspective, tones and colour. As an example, skies are very often an integral part of a landscape painting and have a great influence. They are a clue as to what the weather is doing, as well as being a guide to the season and time of day and can be used to create dramatic effects when required. They may well occupy at least 50 per cent or more of the picture area and therefore are very much part of the composition and can be used to balance and enhance it. A landscape painter

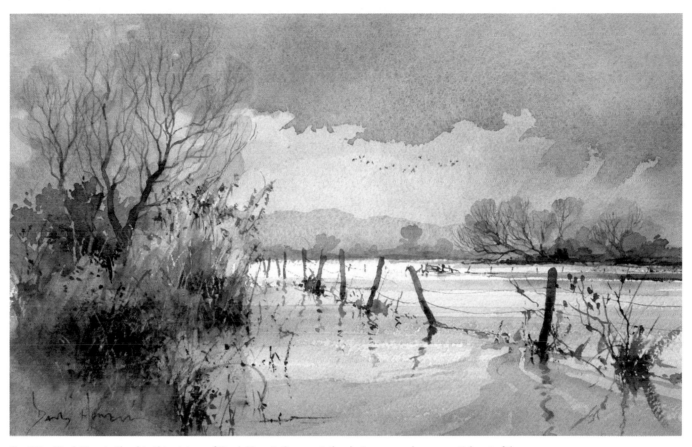

Fig. 6.3 *King's Moor in Flood*. In this picture of King's Moor in Somerset, the sky is very much an essential part of the composition, balancing the autumn colours of the reeds and bushes on the left. It's a winter sky with plenty of rain around and in tonal terms is actually darker than much of the flooded area. A camera may have been able to cope with the clouds to a certain extent but would certainly have lost the subtle colour in the lighter part of the sky. The fence posts mark the boundary of what in summer would be moorland pastures but odd angles and drooping wire add to this bleak but beautiful scene on the Somerset Levels.

should never take them for granted or treat them as some sort of neutral background but should always be aware of them.

Painters who rely on photography for their information may not realize that cameras, particularly of the point and shoot type, frequently can't cope with skies to any great extent and even more sophisticated and expensive examples need a certain amount of technical know-how to get the best out of them. The problem lies in the metering process, whereby a camera assesses the amount of light and adjusts the exposure accordingly. When aimed at a landscape, it will do the best it can for the overall scene but often the technology won't be able to cope with the range of exposure needed to allow for the brightness of the sky in comparison with the land below it. Focus the camera on a backlit vista and you probably won't get any sky at all because it is totally over-exposed and, even in less extreme contrast situations, there will still be a tendency for the sky to be re-produced lighter than it actually is with less detail and little of the subtle changes and beauty of cloud formations. If you always use photographs rather than sketching or painting on the spot, this distortion can be accepted as a norm

and is reflected in the paintings. Some cameras are better than others but if you do rely on photographs make sure that you take at least two shots – one of the general scene and one that concentrates solely on the sky. Point the camera well above the horizon line so that the light metering doesn't try and adjust for the land below it.

Similar exposure problems may exist in other circumstances. A photograph featuring a ripe cornfield for instance may well get the exposure right for the brightness of the field but as a consequence will under-expose surrounding trees and hedges and shadow areas might turn out to be virtually black with none of the variation of colour that is actually there. The same problem is often evident on a sunny day where buildings are involved and the camera gets it right for sunlit structures but the colour and interest in the shade areas is lost because they appear darker than they actually are. Paintings worked only from photographs frequently reflect these distortions and they lose some of the subtle colours and tonal balances that exist in real life.

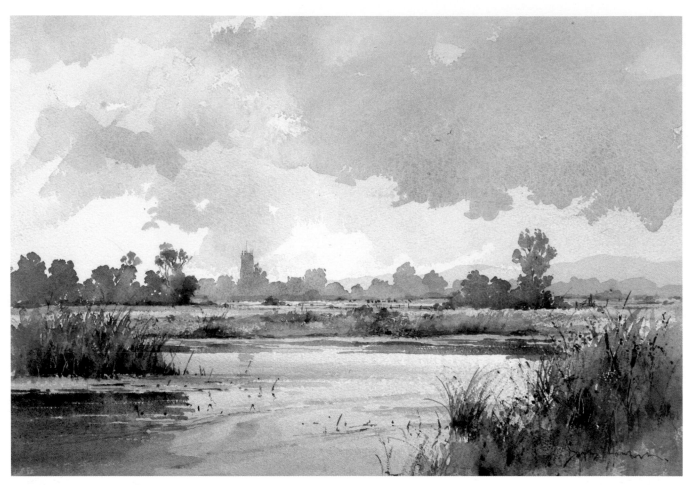

Fig. 6.4 *Muchelney from the River Parrett*. A favourite painting spot where the church tower becomes the point of interest. Because it's important there is a sub-conscious tendency to make it larger, whereas on a photograph it may barely register. That's the difference between a painter's view and a camera.

Perspective is another area where cameras can cause problems for the unwary. There are significant variations in lens specifications but cheaper digital cameras and phones or tablets may well have a fixed lens of a short focal length. They're fine for taking selfies, groups of friends on a night out, and so on, but can be a serious problem if used to record a landscape. Their wide angle, short focal length will tend to make elements in the mid-distance look farther away than they are and can create a situation where even more distant features virtually disappear and if you work exclusively from a photograph from one of these devices, you may well lose the very things that made it interesting in the first place. If you are using a more sophisticated camera with a zoom lens, try to keep the lens focal length around the old 35mm film camera equivalent of 50mm. Many cameras on the market have the most extraordinary telephoto ranges but be warned, if you are using these at their extreme maximum lengths you will get substantial distortion of perspective. Quite simply, things at a distance will look a lot closer and, perhaps more disturbingly for those copying photos, perspective lines will be totally wrong with even lines getting further apart as they recede rather than closer together as do in the real world. All this can be allowed for of course, but you might be surprised how many painters who rely on photographs exclusively get it wrong.

Genuine dedicated *plein air* painters are well aware of the advantages of working on site. You are much more in tune with the subject and will be more conscious of colour, tone and light and a perception of what is important and what isn't. There is an ongoing pressure to get on and not fiddle about. Things that don't appeal get left out and a good open air landscape painter won't be too fussy about pulling something into the composition that may be 'out of camera shot' to improve it. In other words you get to put your own particular stamp on the painting and it's this factor that is so important in producing top quality work. Standing or sitting for the amount of time that it takes to produce a painting

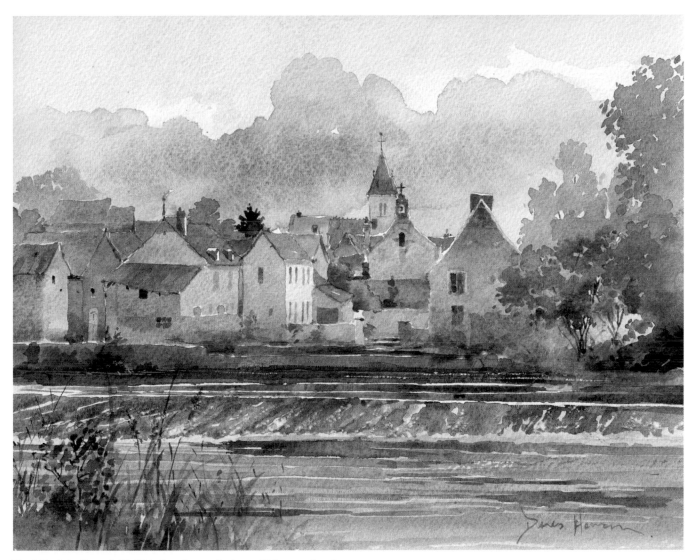

Fig. 6.5 *Saint Pierre de Maillé*. It doesn't get a lot better. This was painted on a warm day tucked into a quiet spot beside the weir at St Pierre in the Poitou-Charente area of Western France.

on the spot is not for everybody. It can be a pleasant experience in ideal conditions but can be equally somewhat arduous in more difficult circumstances, but these have to be taken in their stride or just considered part and parcel of what is ultimately one of the most rewarding forms of painting.

The biggest danger with working exclusively from photographs is that the painting can effectively become a copy of the image without any of the individuality or creativity of painting live and leads to static and uninspiring work. There are ways round this and for those who, for whatever reasons, rely on photographs for their information but want the finished work to have some of the dynamism of 'live' work, the following thoughts might help.

Sketching is covered in Chapter 3 and the use of a sketchbook in landscape painting can make a huge difference to your work. When I'm painting on site I still start by producing a quick

sketch. It focuses my mind in relation to what the composition is all about and it fixes things that are important and are going to change before the painting is finished, like light and shadows and I leave the sketch lying beside me as a reference whilst I'm working. There's no reason why the same approach can't be used when a camera is the primary tool. Even an extremely rapid pencil sketch, that doesn't require you to be hanging about for long, can be invaluable in creating more interesting work and the photograph is available for more information if necessary. However, don't fall into the trap of relying on it completely and forgetting about the sketch. It's remarkably easy to do!

The same creative process, of course, can be applied to actual printed photographs. If the only practical way for you to paint is using a photo for reference, try producing a sketch from it with all the nuances and creative input you think is appropriate and

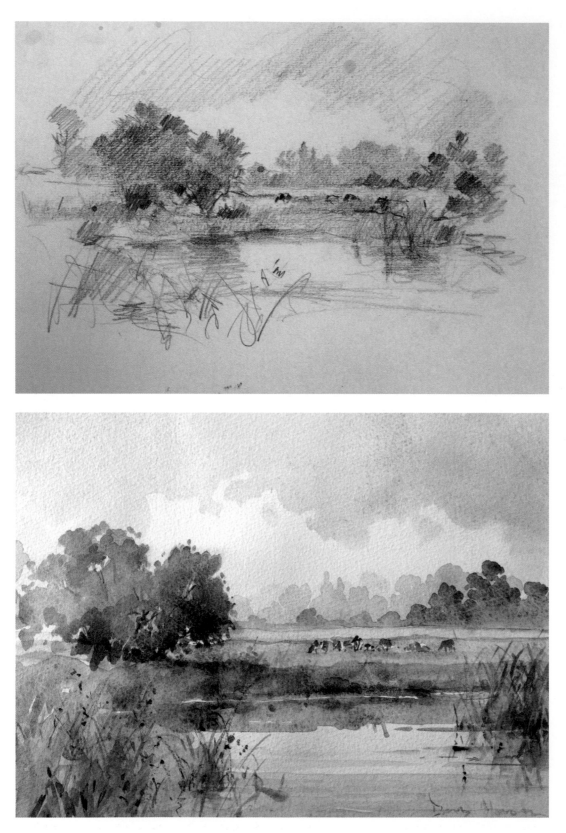

Fig. 6.6 *Dedham Vale.* This sketch was produced in about ten to fifteen minutes, early on a damp rainy morning using a clutch pencil with a 5.6mm thick lead on Arboreta off-white cartridge paper. Using a thick pencil encourages a tonal sketch with blocks of tone rather than just lines and it's too clumsy for fussy detail. The cattle were 'borrowed' from a field out of shot but they become the focus of the composition.

Fig. 6.7 This is the watercolour that was produced later in the day working exclusively from the sketch, without any photographic back-up. Interestingly, although this works okay as a small watercolour, the on the spot sketch possibly has a bit more verve and life about it.

work from that. Work quickly, don't try and be too careful and aim for the same sort of liveliness that comes from rapid work in the field rather than getting obsessed with irrelevant detail.

When you have your sketch, put the photograph away. Hide it, don't keep going back to it.

Working from a Photo Demo

Thorney Moor is a good example of a photograph taken with a phone camera when simply going for a walk. As a painter, two things caught my eye, the marsh gate on the right hand side and the church tower in the distance. This is a classic example of a photo with a wide angle lens. The distant church is there if you look carefully but it's so small as to have virtually vanished, whilst the marsh gate is barely visible against the background. Frankly it's not a very exciting photo and if copied into a painting would probably be even more boring.

Memory in landscape painting is very handy asset and I distinctly remembered what my painter's eye saw and using this, plus basic information from the photo and a little imagination, I created a sketch to work from. The sketch has brought back the church as I remember it and the marsh gate has been given a certain amount of rustic treatment with the hawthorn bush on the left to balance it, whilst the great expanse of uninteresting

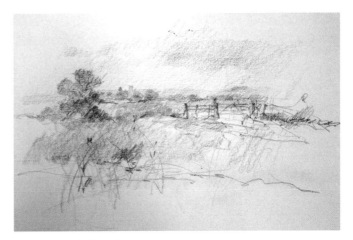

Fig. 6.8 *Thorney Moor.* The photograph shows the flat landscape of the Somerset Levels but not a lot else. It needs a landscape painter's eye and skills to make it interesting.

Fig. 6.9 *Thorney Moor* – the sketch. What I have now is an interesting composition that is much closer to what triggered my interest in the first place. Note the treatment of the sky. In this instance the camera shot made quite a good job of the sky but it's not very painterly, so again a certain amount of artist's licence has been employed to enhance the painting.

Fig. 6.10 *Thorney Moor* – starting point. With the sketch as a guide, the photo is consigned to history and it is time to get into paint. Painted on a quarter sheet of Waterford 640gsm Rough, the first brush marks are applied with a *petit gris* No 6 squirrel mop and determine some of the basic structure of the picture. There's no attempt or need to be super accurate and there's no pencil drawing on the paper. Just loose watercolour marks.

Fig. 6.11 *Thorney Moor* – moving on. This next stage shows the painting with the distant hills painted in a cool Cobalt Blue to help them recede into the distance and the sky largely completed along with a bit of the foreground. At this stage the composition is already developing with the posts delineating where the marsh gate will be and an unpainted shape for the church tower.

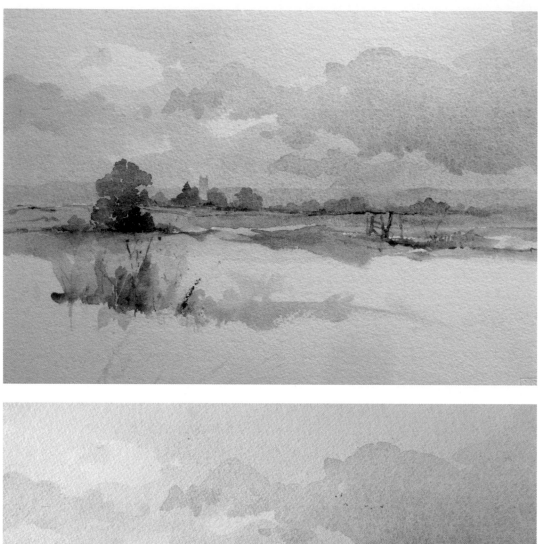

Fig. 6.12 *Thorney Moor* – on the way to completion. The sky has been developed further and the trees around the church painted in along with the field in the middle distance and the hawthorn bush on the left, plus a little more enhancement of the foreground with some stronger and warmer colour. Although this is pretty basic it has a nice feel to the composition and the biggest danger is doing too much and losing the spontaneous feeling.

Fig. 6.13 *Muchelney from Thorney Moor.* This is the final result with the gate painted in and the foreground reeds developed. I'm still not too sure of the treatment of the reeds. They have introduced a certain fussiness whereas the previous stage left a little more to the imagination. It's always difficult to know when to stop and walk away but this approach beats working directly from a photo any day.

foreground has been replaced by a loose suggestion of reeds and grasses. I know there's a fair amount of imagination involved but that's what painting is about.

An ability to identify what will make a good landscape painting is crucial. It doesn't have to involve driving for miles to a renowned beauty spot or distant vista and in fact approaching the whole exercise from that point of view is likely to lead to some pretty unsatisfying work. All paintings are essentially a combination of shapes, colours, tints and tones and what sorts the wheat out from the chaff above all is composition. All serious painters

Fig. 6.14 *Autumn at Othery*. The potential here was first spotted whilst driving past and the initial trigger was the scruffy gate and barbed wire along the water-filled ditch, with its glimpse of red paint, fence posts at odd angles and with the church in the distance. The only way to get at it involved parking the car a few hundred yards away and then walking along the side of a busy road with no pavement.

Fig. 6.15 *Sketch – Autumn at Othery*. This is the sketch done on the spot using pencil and coloured crayons. Produced quickly because of the somewhat precarious location, it nevertheless has everything necessary to work from.

eventually develop an eye for something that will make a picture. It might just be the blue grey of distant hills set against golden stubble fields, the reflection of a church tower in a ditch or even something as simple as grasses round a gatepost. What makes a good landscape painter is the ability to take something that initially fires the senses and turn it into a picture that others will want to look at. It frequently is a moment in time when the light, shadows, sky and atmosphere all combine to make something paintable and it is vitally important to recognize that it will never look quite the same again. Something that shouted out to be painted last week can look totally uninteresting a few days later and therefore the ability to get something down when inspiration strikes, in the form of a sketch or even a small watercolour, is a must. Strike whilst the iron is hot! Landscape painting works best when you have your equipment with you, the weather is right and you have sufficient time to work on the spot but the reality is that you will probably have to make do with your memory, a sketch if you're lucky or a photograph with all its potential pitfalls.

The ability to stand and look and remember what makes you want to paint a scene is a great advantage. I will often do this when walking the dogs – stand and stare (the dogs are used to it), make a scribbled sketch, take a phone photo and get the whole thing in my head, then I'll go straight to the studio to start the process.

Working on-site for the Othery picture posed even more problems, in that whilst the verge was wide enough to sit on a stool, concentration was somewhat difficult with trucks, cars and farm traffic whistling past just a yard or two away and the noise was more than a little distracting. I opted for getting what I needed in the form of a sketch rather than trying to paint *in situ* and concentrated on the composition and the factors that inspired me to take all this trouble in the first place – the fence and gate, the hazy afternoon light and the church in the distance.

In retrospect it would have been a lot safer to take a photo and get out of there but, despite the circumstances, being able to develop the composition on the spot has resulted in a painting that reflects everything I felt about the subject. From a compositional point of view note how, in the finished painting, the concentration of fence posts that started the whole process are placed roughly one third from the bottom and right hand edges of the painting with the distant church balancing the picture.

Do get used to accepting that a little manipulation of the various elements in a landscape can make all the difference and it is essential right from the word go to establish what is the point of interest and why you want to paint it. Possibly more than in any other genre, the golden section principal is very important. The painting should allow the viewer's eye to wander through it and to understand what made the painter want to paint it and

Fig. 6.16 *Dedham Water Meadows.* Another Dedham painting where the sky is an integral part of the painting and indicates a damp, unsettled showery day in early summer. Note the softer and less intense colour and cool greys of the distant trees.

Fig. 6.17 *Najran.* This picture of the Arabian Desert makes an interesting comparison with Dedham. Painted from sketches produced many years ago when I lived in Saudi Arabia, it's of a much harsher but nevertheless beautiful wilderness where you have to learn to cope with the heat and the dust and where watercolour dries almost as soon as it goes on the paper. The camels have largely been replaced by 4x4 vehicles and pickups and whilst most of the Arabian desert rarely sees any rainfall, the mountains in the south west create rain clouds, particularly in the winter, and in this picture they have been used to create a balancing effect to the main subject. The colours of the desert are predominately ochres and umbers although the distant silhouettes of mountains appear in shades of blue and grey and help to create recession. However, my palette in terms of colours remains unchanged.

if that means moving trees a little, introducing vegetation that wasn't actually there, that's fine. It isn't the job of a painter to record everything exactly as it is – all that matters is the picture. You will find that it's quite normal to subconsciously exaggerate the proportions of things that interest you when painting, because that's how you saw it at the time. This is part of putting your own interpretation on the finished work, and the painting skills required in using cooler softer colours and less-defined shapes in the background to increase recession and give the illusion of a three-dimensional work, all help to make the picture interesting to look at.

Dedham Vale is where the great landscape master John Constable lived and worked and in more recent times was also home to Sir Alfred Munnings. Very much a landscape of trees, fields and skies with occasional glimpses of the River Stour, it's sometimes difficult not to feel their ghosts looking over your shoulder. The composition was initially built around the distant barn, enhanced by the surrounding trees and bushes and the grasses in the foreground and balanced by the cloud formations. However what it needed was something in the slight emptiness on the right half of the picture and once again a herd of cattle came to the rescue, although on this occasion they actually put

Fig. 6.18 *Hill Farm at Keasden.* This moorland picture takes the composition process a little further. The dry stone walls, the lines in the landscape and the sedge have been used to take the eye up the hill to the farm and the telegraph poles along the high horizon against the dark sky help to emphasize the wild moorland country.

Fig. 6.19 *Les Limousines.* Another small opportunist watercolour. I had already taken a fancy to the sunlight through the leaves and the related contrasts with the bright sunlit field beyond when the cattle appeared and have become the focus of the picture.

in an appearance whilst I was painting. Working here on the same meadows where Constable painted makes you aware of how much the great man didn't flinch from moving things about and adding interest to improve the final result. One thing that is very apparent in an early summer landscape like this is the need to understand how to mix convincing greens. As indicated in chapter 5, I don't actually carry ready-made greens and the variety of greens in this painting are all created with the primary colours.

For the fitter painters amongst us, a bit of effort can bring rewards. I knew the view of Bredon that I wanted, with the river in the foreground, but actually getting there took serious amount of reconnaissance, an hour or two of tramping about, climbing over fences and wading through marshland. Travelling light with a rucksack containing all the gear is a great advantage in these circumstances.

Fig. 6.20 *Bredon.* This view of Bredon is clearly visible from the M5 motorway, except of course you can't stop. Getting to a painting position meant a lot of cross country work.

Fig. 6.21 *Landscape near Angles.* The concentration required for working on a painting ensures that you remember the occasion years later. This picture was painted sitting in the middle of a quiet backroad near Angles-sur-l'Anglin in Poitou-Charente, France. Occasionally I had to move to let a vehicle pass but it's a happy memory of working with students on a summer day in France.

Floods at Othery is an excellent example of the value of a sketchbook. a good memory and the ability to work standing up. Painting on the spot was obviously out of the question. A far bigger concern was trying to get to a point where I got a good view without the water going over the top of my boots. Be sensible in situations like this. Apart from the boots I had a stout stick to probe the ground and check the depth of the water and to make sure that I didn't fall in a ditch (it has been known) or the main channel of the Sowy River. I took a few photographs but they were fairly useless because the winter afternoon sun made everything else too black but memory and a scribbled pencil sketch provided sufficient information to complete this back in the studio. If you have to rely largely on memory like this, get painting quickly whilst the inspiration is still fresh.

Going home, Snargate is a good example of grabbing a moment in time. I had been beating on the local shoot along with Tally my Irish Setter and this was the view from the top of Snargate Hill as various beaters and dogs started to wend their way back down to the farm and home. The road was covered in ice and reflected the sky and the figures, whilst the huddle of cattle on the right watched the procession in the gathering gloom. I photographed the sky with a camera phone and scribbled a pencil sketch in a sketchbook that I usually carry on such outings, but the onset of darkness and the bitter cold meant that was it. I went back the next day with a view to developing the sketch but it looked completely different and in the end I worked from memory, a sky photograph and a scrubby sketch. These sort of opportunities do happen every now and then, for all of us but you have to be ready to do something about it.

Fig. 6.22 *Floods at Othery, Somerset.*
Another Othery picture on the Somerset
Levels. The village itself is on higher
ground, but the surrounding meadows
are invariably flooded at some point in
the winter; the willows are characteristic
and note how the sky colours are also
reflected in the water as well as the trees,
vegetation and odd bits of fencing.

Fig. 6.23 *Boussay.* A French landscape
painted in late summer on the side of the
road while propped on a stool against the
back wheel of my motorbike. The colours,
particularly the greens, reflect the time
of the year because they contain more
red and ochre.

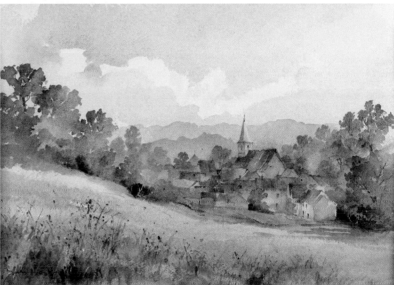

Fig. 6.24 *Going Home, Snargate.*

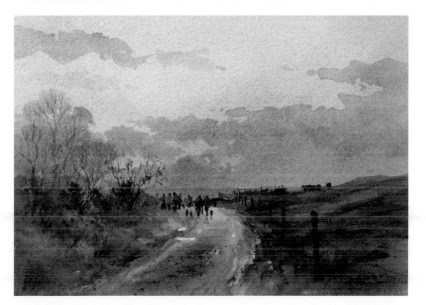

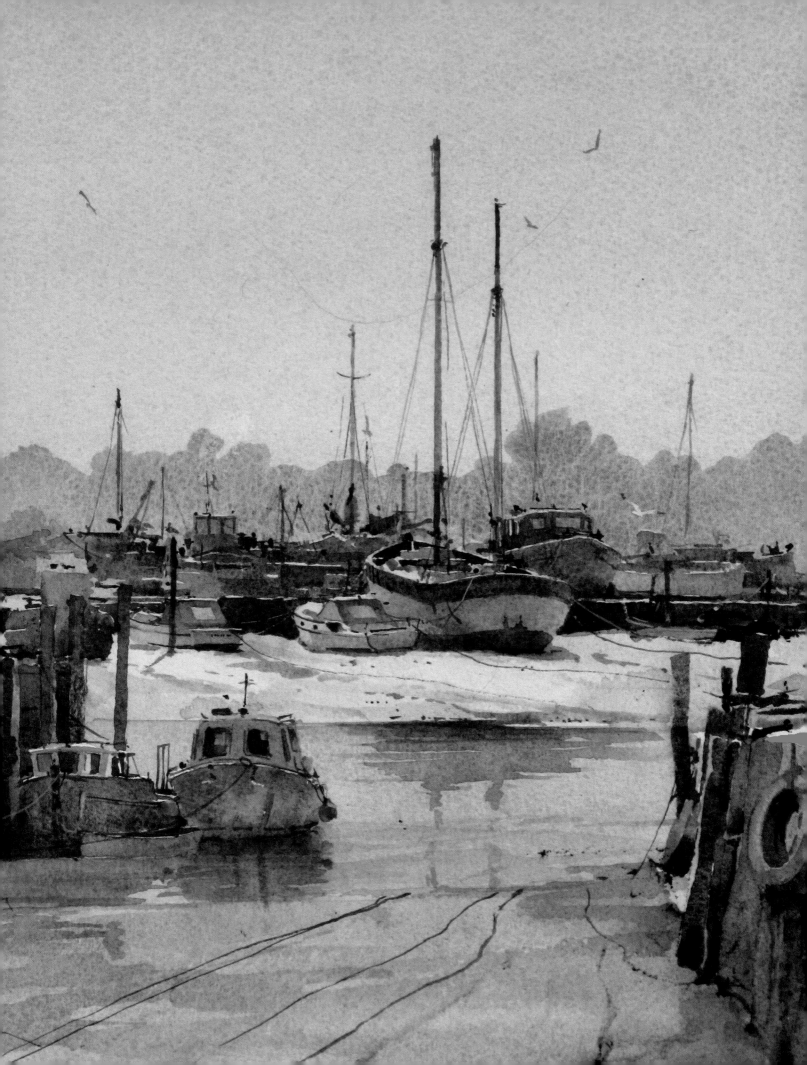

Marine

There are many similarities between painting landscape and marine subjects in that, unless you are fortunate enough to be living with a paintable view from your window or on a boat moored in a suitable spot, both involve getting out and about to find suitable material to paint and with marine that means heading off to the sea or at least to tidal waters. When you get there you have a whole collection of new challenges, not the least of which are access, lots of water, mud, reflections and so forth and of course the fact that nothing stays still for very long. Time and tide wait for no man and you have to get used to the idea that pretty well everything related to marine painting is on the move.

Jetties, steps, rocks and foreshores can be very slippery, whilst mooring lines, crab pots, nets and general fishing clutter are easy to trip over, and falling off piers or harbour walls is not a good idea. Always be aware of the state of the tide if you're located in a vulnerable spot and remember that mud can vary from the stuff that sticks to your shoes to the glutinous gunge that you can sink in up to your armpits. Working in a marine environment quickly establishes the need to be organized. Whether painting or sketching, you need to get used to the idea there will be times when you will have to stand to work, because using a seat is impossible due to soft mud, sand or even water and that will also mean that if you dump your bag on the ground it will almost certainly get wet. If your chosen location involves climbing down steps or gingerly working your way across wet rocks and mud, working on a relatively modest scale is easier to cope with rather than struggling with something like a half Imperial sheet stretched on a drawing board, and do make sure that you're wearing appropriate footwear.

Fig. 7.1 *Newton Ferrers, Devon.*

Most of the time it tends to be windier on the coast and you have to get used to working accordingly. Loose paper will flap about without proper clips to hold it down and even complete sketch books can catch a gust of wind and end up in the mud or water. Using moderate size watercolour blocks (something around 9 × 12in) is ideal because the weight and relative solidity of them helps to cope with breezy conditions and because you're not trying to work with something too big, they will give you a chance to get a fair amount done before conditions change.

It is possible to paint marine pictures without any boats in the painting but an ability to cope with their varied shapes and types is arguably essential. You don't have to be able to paint them in

Fig. 7.0 *Hairy Bob's Boat.*

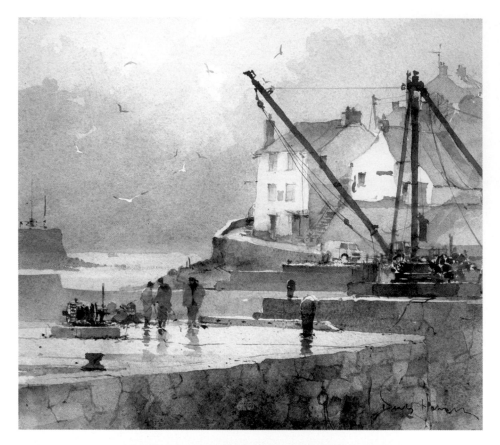

Fig. 7.2 *Stormy day in Porthleven.* It's necessary to be aware that apart from sitting on a sun kissed beach, the marine environment can often pose more risks to life and limb than most other forms of painting. Porthleven in Cornwall frequently features in television news footage of waves breaking over the breakwater by the clock tower in rough weather, with the serious risk of the unwary being washed away, and at low tide there is a serious drop from the outer quays. A somewhat complex composition, this watercolour captures the stormy sky with a hint of sun breaking through and windblown seagulls and the figures on the quay balance the hoist and buildings on the right hand side.

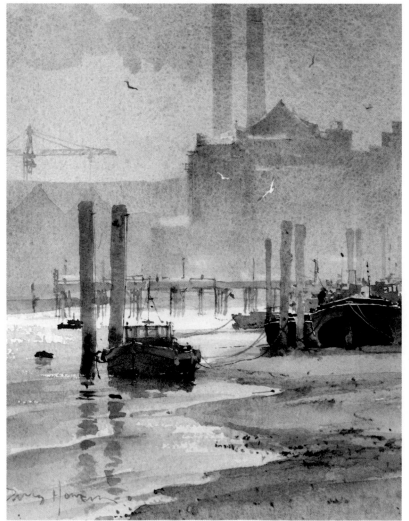

Fig. 7.3 *Low Water, Chelsea Reach.* This is a good example of a working environment that requires common sense and awareness. Getting down to the foreshore of a major river like the Thames means negotiating steps, launching ramps or even ladders that will be slippery as you get nearer the water. If you're planning to sketch or paint *in situ*, make sure you know the state of the tide so that you have some idea of how long you have got before it's time to get out of there.

Fig. 7.4 *Thames Barges at Pin Mill in Suffolk*, with the watering hole of the Butt and Oyster in the background, is painted from an even more vulnerable point on the river side of vessels sitting on the mud. With care it's fine, but do learn to identify which bits you can walk on and which are best avoided and, as ever, watch out for the tide. Getting it wrong can mean getting wet or it could be fatal.

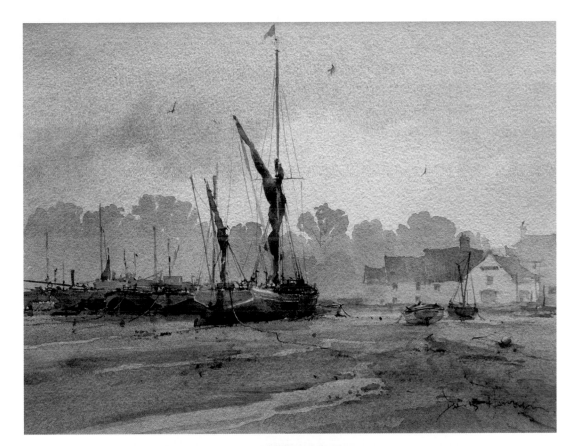

Fig. 7.5 Holding things together. This is an A4 Arboreta sketch book folded back on its spiral binding and clipped down with a bulldog clip. Trying to draw or paint when the page keeps flipping up in the air is nigh on impossible and I always carry a selection of clips for holding things down.

Fig. 7.6 Here is another answer to difficult operating conditions. This pencil apron was made by my wife and enables me to work standing up in places where sitting to paint or sketch isn't an option. It consists of a series of compartments for different groups of coloured pencils and has ties that allow it to be secured round my waist leaving my hands free to hold a pencil and sketchbook. When not in use the fold-over top is secured by studs to stop the pencils falling out and it rolls up like a tool roll.

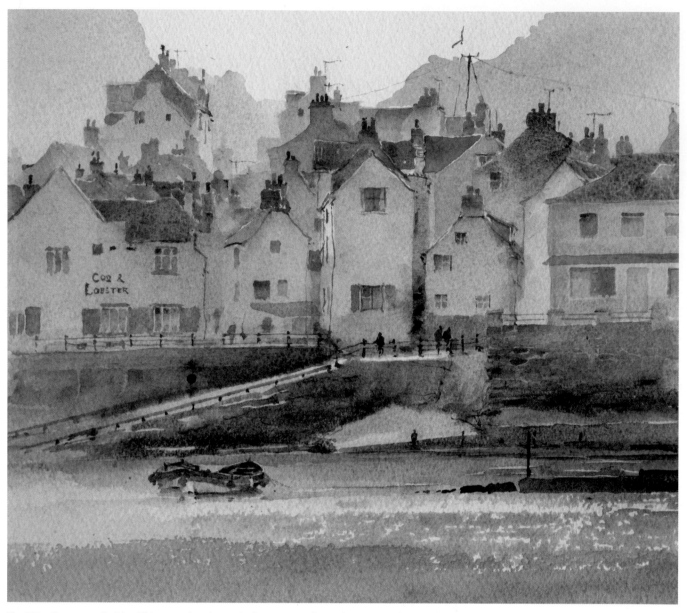

Fig. 7.7 *Cottages at Staithes.* This was painted on a single 11 × 15in sheet of 640gsm Arches rough paper. Although it was clipped to a drawing board a strong gust of wind got hold of it and blew it into the harbour and it took a certain amount of dexterity with a young lad's fishing tackle to get it out again. It says something for the strength of the paper and the quality of the paint that, despite its adventures, the painting survived.

fine detail unless you want to get seriously technical about the whole thing, but you do need to understand what happens when they're afloat and aground and have an ability to capture the characteristics of individual vessels and their various types. As ever a sketchbook is a valuable asset.

The main problem with boats is that they curve in various directions, both laterally and lengthwise and, to add to the excitement, they go up and down with wind and waves and frequently end up at funny angles when aground. Boats are designed and built to be largely functional, particularly in the case of working boats, and to be able to cope with particular seas and operating environments so a painter needs to understand this. A fishing boat operating in and out of a Cornish harbour will be very different to a Cromer crab boat which has to cope with beach operations and the pounding that comes from breakers whilst landing on an open beach. Some will be designed with flat bottoms or twin keels so that they stay fairly level at low tide, whilst others will lean to one side either supported with the hull or side props in the case of many fishing boats; and of course many yachts and deep keel boats need something to lean against or enough water to stay afloat. Marine painters need to be aware of all this and the secret to painting them is like life drawing, don't assume anything. Paint (or draw) what you see and continually check angles and proportions.

Fig. 7.8 *The Harbour at La Flotte, Île de Ré, France.* This corner of the harbour in La Flotte shows a collection of colourful and different boats, ranging from a traditional wooden sailing vessel to fishing boats. None of them in this situation need to be too detailed but they must look right in terms of their shapes and the way they sit in the water. In addition, this is a situation where they are below the eye line and therefore the perspective has to reflect that they are down in the harbour.

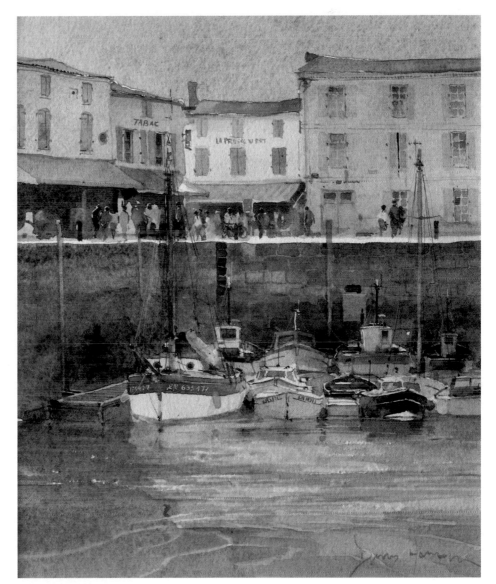

Fig. 7.9 *Fishing Boats at Tenby.* Continually practise drawing boats. Featuring a variety of working boats in Tenby Harbour at low tide, this sketch was drawn standing on the sand down in the harbour itself. This not only depicts hull shapes but wheelhouse and fishing gear clutter as well.

Fig. 7.10 A very different environment to Tenby in Fig. 7.9, this group of boats on the sand are on Muharraq Island in Bahrain. These graceful, wooden-built boats are a very distinctive 'dhow' shape and are typical of those used in the Arabian Gulf for fishing, general cargo and, in days gone by, pearl diving.

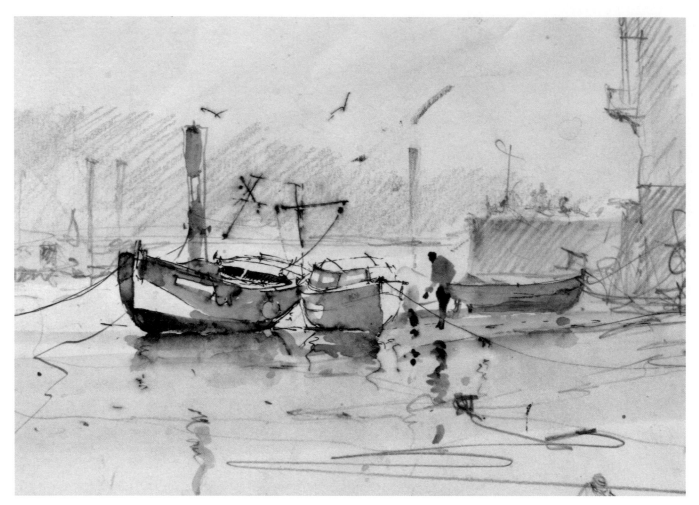

Fig. 7.11 *Fishing Boats at Fowey, Cornwall*. This little study was painted on 135gsm cartridge paper, in a 7 × 10in sketchbook using a mixture of pencil, a barely waterproof sketching pen and watercolour. If you were too concerned about accuracy and fine detail you might be less than happy, but look at the immediacy and life in this rapid sketch produced sitting on a stool just above the water line as the tide recedes. The boat shapes are bang on, the blurred rigging and fishing gear lines give a sufficient impression without too much detail and the sketchy background and gulls say just enough.

From a compositional point of view, groups of boats frequently work better as a subject than a single craft looking lonely and forlorn all on its own and there's nothing to say that a marine painter can't move them about to make the painting work better or leave out the ones that don't fit in. You will occasionally find boats with the right sort of appeal moored alongside, or adjacent to vessels that are either uninteresting or downright ugly, so get used to the idea that they can be re-arranged. Grouping boats together to create a set of interesting shapes and balancing them with other features such as dinghies mooring lines and buoys is all par for the course for a marine painter.

It's a sad fact of life that many of the quiet backwaters, harbours and moorings, where paintable old boats and wrecks used to hide away, are slowly disappearing. Many harbours and anchorages are now dominated by pontoons and rows and rows of GRP plastic leisure boats but studying local maps for likely hideaways, can pay dividends. A dedicated marine painter will have a collection of Ordnance Survey or similar large scale maps, that are ideal for showing hidden creeks and inlets, as well as footpaths and tracks to get to them. Don't expect to be able to get a vehicle anywhere near. This sort of exploration invariably involves a certain amount of walking and often can be a complete waste of time but every now and then something special appears and makes it all worthwhile. Old boats that will never go to sea again, derelict piers, marshes and reed beds – they're all there if you go looking. As ever, be aware of the potential pitfalls of getting caught out by the tide as some marshland will be inundated at high water. Tide tables, which give the time of high and low tides can be found on the internet and experienced marine painters plan their trips accordingly.

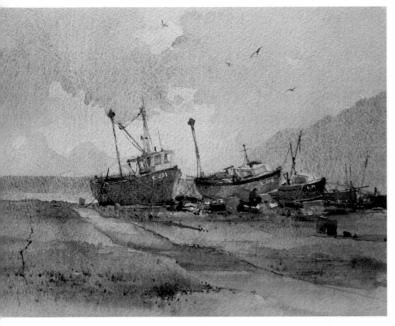

Fig. 7.12 *Fishing Boats at Beer.* These boats are a variety of shapes and sizes and are winched up on to the shingle beach. Rather than portraying them spread along the shoreline, it works better pictorially to group them into interesting shapes.

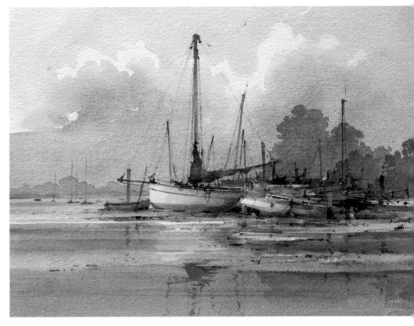

Fig. 7.13 *Dell Quay.* This is another example of grouping boats amongst a lot of the sort of clutter that is found in repair yards and quiet anchorages. You won't find this sort of interest in smart marinas full of plastic boats.

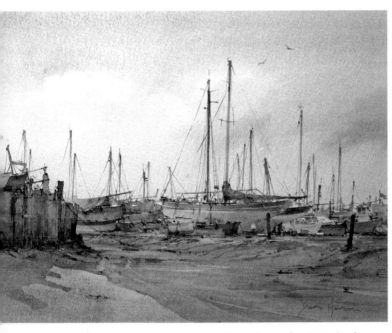

Fig. 7.14 *The Boatyard at Felixstowe Ferry.* This is a fine example of a boatyard that's tucked out of the way alongside the River Deben in Suffolk and houses a selection of boats being worked on, alongside others that look beyond hope. Note the way that the piling on the left leads the eye into the picture with the white and blue yacht as the main focus.

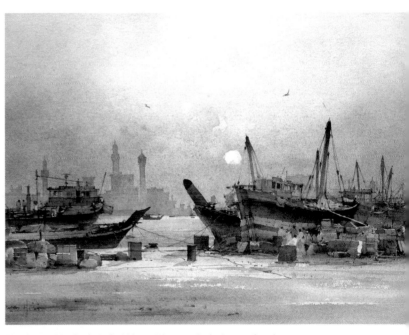

Fig. 7.15 *Maghreb, Dubai.* Most visitors to Dubai marvel at the skyscrapers, shopping malls and the souqs or they simply head for the beach but Dubai Creek can still offer fascinating marine subjects with wooden built Arabian dhows moored alongside.

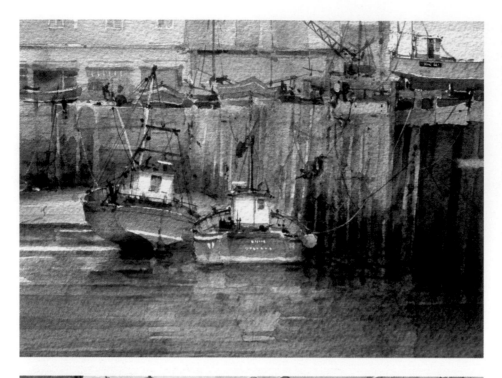

Fig. 7.16 *West Bay, Bridport.* West Bay on the South Coast of England has been tidied up somewhat but still retains a good selection of fishing clutter and boats sitting on the mud at low tide. Note the way the red boat has dried out sufficiently to rest on the keel and the starboard side of the hull, whilst the blue one still has sufficient depth of water to keep it level. You don't need to be a marine expert but you do need to be observant to make your marine pictures effective.

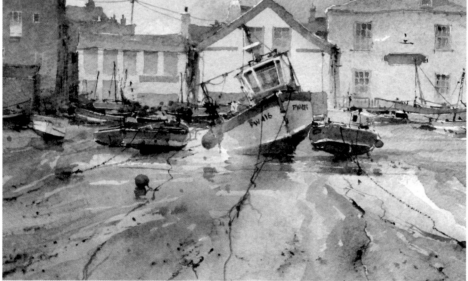

Fig. 7.17 *Low Tide at Port Isaac.* This is one of those harbours where smaller working boats are still in action and, even better, where at low water the harbour allows a certain amount of walking about as long as you look where you're going. Note the way that reflected light off the wet mud shows up on the hull of the blue boat and the hard and soft edges with varied colour of the mud itself aren't overworked. Wet sand and mud will invariably reflect the colour of the sky as well as allowing its base colour to show through.

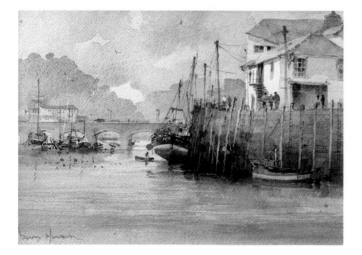

Fig. 7.18 *Looe Harbour.* There's a sandbar in the entrance to Looe Harbour in Cornwall which, if the tide is right, makes a convenient spot to paint from. The fishing boat is sitting on its keel and leaning against the harbour wall. Definitely a spot to get to just as the tide is going out and one to get out of as soon as it's coming back, as there is deeper water between the sandbar and safety.

Fig. 7.19 This sketch of a Pilot Cutter is a good example of rapid pencil work. Attention has focussed on the tonal relationships of sails, sea and sky rather than too much detail, but the essential distinctive hull shape has been recorded as has the way that the boat is heeling over with the wind. A camera would obviously be helpful here for a little more information but it would be better to use that to develop the sketch further, rather than abandoning it and working directly from the photograph. It's so important to keep the sense of movement and so easy to lose it with a copy of a photo.

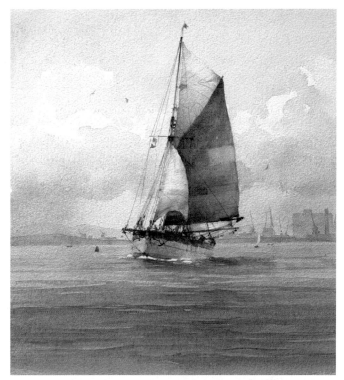

Fig. 7.20 A ketch rigged sailing vessel making its way down Southampton Water, where there's a regular ferry service between Southampton and the Isle of Wight. The background sky is kept loose with a combination of soft and hard edges and Southampton docks are painted in cool colours and with soft edges to maintain their distance. Note how the colour of the water deepens in the foreground and there is darker reflection of the dark mainsail, whilst the hull has reflections of the bright splashes of the bow wave. It's also quite clear where the wind and sunlight are coming from and, as with many of these old boats, the sails have a variety of tones, largely created where various parts have been repaired over the years. They also need to show the curvature as the wind fills them and, in the case of the mainsail in particular, a certain amount of transparency.

Apart from paddling about in harbours and creeks, being out on the water itself gives a wholly different aspect to marine painting. However, unless the vessel that you are on board is moored somewhere you will have to resort to working quickly with a sketchbook at the very least. Things seem to have a slow serene pace when you're viewing events at some distance from the land but, when you're actually at sea, they happen surprisingly quickly. A likely looking subject may appear off the starboard bow and by the time you've got your drawing stuff out it's already much closer and your viewing angle is changing by the minute. Frankly, a camera is handy in such circumstances but the ability to produce fast sketches, as ever, is of considerable help.

Having a friend with a boat, of course, is a great asset and some marine painters have their own, although in that case you might still need someone to take the helm whilst you're working. However, there are other opportunities for getting out on the water, even if it's only a shortish ferry trip. Ferries can give you a completely different viewpoint of distant shorelines, docks, jetties, and all the features that exist along waterways, as well as other craft actually at sea and under way.

Alongside at Brixham is a good example of what can happen if you keep your eyes open. I had walked past this spot a few times during the day when the tide was in and nothing had really attracted me to paint it. It wasn't until the film crew had packed up, and I'd loaded up the bike and was on my way, that the combination of late afternoon sun and the colour and juxtaposition of the two main boats demanded a change of plan. Get used to the idea of grabbing any opportunity if possible when it occurs – it may not happen again. You can of course create painting opportunities if you work out where tide and sun might be at either end of the day. *Daybreak at Pin Mill* is a very early morning picture based on a sketch produced whilst there was a mist coming off the water and the sun trying to break through. After half an hour everything had changed.

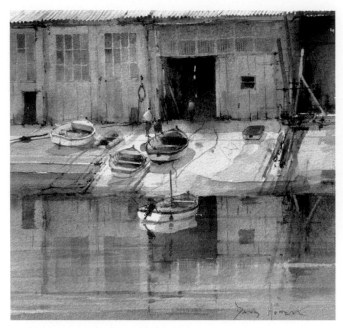

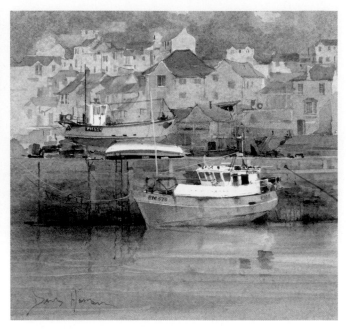

Fig. 7.21 *Salcombe Boat Sheds.* The boats are the main focus of this picture but the background boat sheds are very much part of the composition. With their shaded frontage in sharp contrast to the sunlit ramp in front of them they are nevertheless full of varying colour. This shade area was painted in one wash and most of the detail worked in using wet in wet technique – shaded areas shouldn't be dull! Note the soft reflections in the water and the dark interest of the open door created by using complementary Ultramarine and Burnt Sienna.

Fig. 7.22 *Alongside at Brixham.* Another square section picture, this scene became apparent as I was heading home after a day's filming with APV Films. The late afternoon sun was bouncing off the fishing boat in the water and the state of the tide meant it was at a slightly odd angle. I loved the two tones of blue, which were painted with Cobalt at the bottom and Cerulean on the upper strip and the contrast with the yellow boat up on the quay. It was too late in the day to start another painting and therefore a colour sketch had to suffice and the painting was completed in the studio.

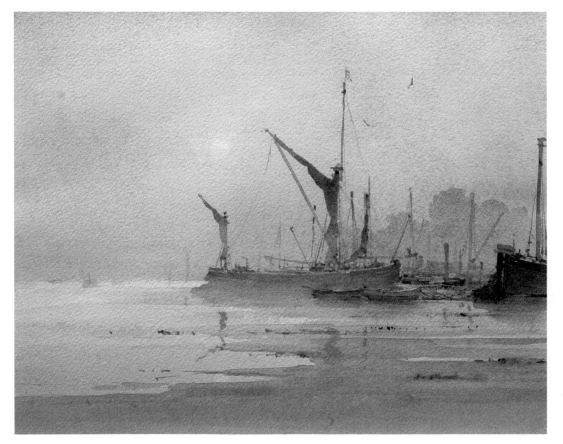

Fig. 7.23 *Daybreak at Pin Mill.* Getting up early is always worth the effort. It's quieter and often the most interesting colours and effects can be seen when the sun comes up. *Daybreak at Pin Mill* is a very early morning picture based on a sketch produced whilst there was a mist coming off the water and the sun trying to break through.

Fig. 7.24 *Early Morning on the Grand Canal.* The original sketch was painted before the sun came up and this is the first wash that records the developing sunrise. The paper is Khadi 640gsm rough, a handmade cotton rag paper, and its handmade unpredictability is in evidence at this early stage with a mark apparent on the left hand side. It's probably caused by a sizing fault but hey, it's handmade, don't worry!

Fig. 7.25 The sky has been worked on to introduce clouds, largely created in the original wet wash. The horizon line has been preserved and emphasized but with more colour on the paper the fault in the paper is even more evident. It's very easy to start pressing the panic button with this sort of problem. Trying to wash it out might make it worse. Leave it, move on!

Fig. 7.26 More colour has been introduced with some hard edges on the clouds. The sky is a vitally important part of the painting as it covers over 50 per cent of the painting and hopefully conveys that early morning feeling. It's the best time to be working on a winter morning in Venice.

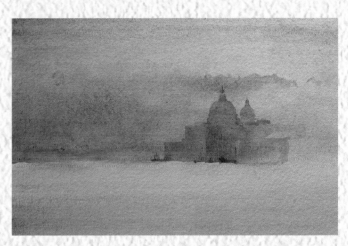

Fig. 7.27 This shows the start of the buildings with the familiar silhouette of Santa Maria della Salute. There's no pencil work involved and this stage of the buildings has been painted initially with a grey wash mix of Ultramarine and Light Red and then tinted wet-in-wet with Raw Umber, Raw Sienna, and Brown Madder as the buildings get closer. Always a challenging stage!

Marine/Venice Demonstration

There can't be many professional figurative artists who haven't at some point headed off to Venice and for amateurs it has a similar appeal. The uniqueness of its water-bound geographical location and the absence of motor traffic, plus its extraordinary architecture and history, preserved and largely uncontaminated by corporate frontages and re-development, make it a magnet for painters and, provided you don't block narrow alleyways or bridges with your gear, nobody minds you working on-site, although be prepared to be filmed by tourists and/or included in selfies. As ever, working on a large scale may not be the best way to tackle things and smaller sketches and watercolours are usually more practical. This particular painting is a large studio work painted from sketches.

There is an overall softness in this painting that is typical of the light at either the beginning of the day before the sun comes up or in the twilight in the evening. There are no obvious shadows and a lack of contrast between light and dark sides of buildings and very often water is unruffled by breezes that will appear as the day progresses. Fig. 7.31 offers an interesting comparison, where the sun has appeared above the horizon and suddenly the view

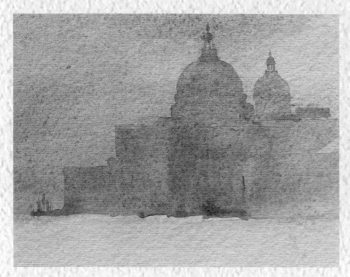

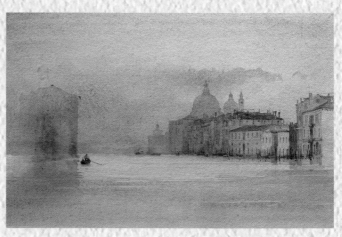

Fig. 7.28 This is a close up of that first stage of the buildings. Painting the overall shapes in pure watercolour without any drawing on the paper, in one wash and then using wet-in-wet technique to add colours, gives the whole group a softness without too much detail that defines the distance from your viewpoint. Closer buildings will have more detail and colour. Interestingly, as pure watercolour work, this has enough going for it to make a picture in its own right.

Fig. 7.29 With a complex picture like this there comes a point where the painting seems to be going on forever and a combination of staying power and patience is necessary to avoid losing interest. The buildings on the right have been developed in more detail as they get closer and those on the left have been given the same treatment as the distant Santa Maria della Salute, in being painted in a one wash silhouette and also a gondolier has appeared.

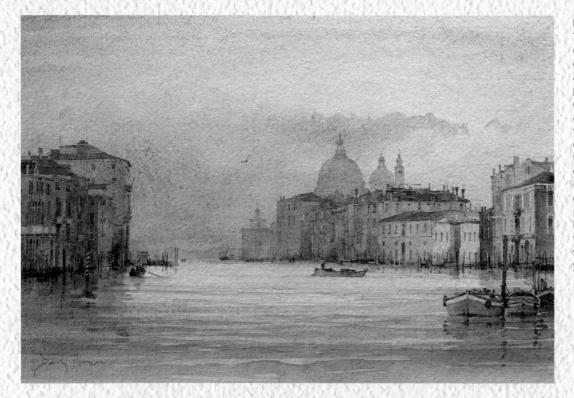

Fig. 7.30 That's it! The final part has been concerned with more details on the buildings and boats and mooring poles. The water has more definition in the waves as they get closer to the viewer and the reflections developed. The fault in the paper that was rather obvious at the beginning is still there, but with more colour and content in the picture in general and a little careful manipulation to incorporate a cloud, you wouldn't notice it unless you were looking for it.

is transformed. More colour in the sky and the contrast between it and the sun itself and of course the brilliant reflection in the water. There's more detail in the buildings and generally deeper tones in the water and the boats which helps to accentuate the sunrise and its reflection.

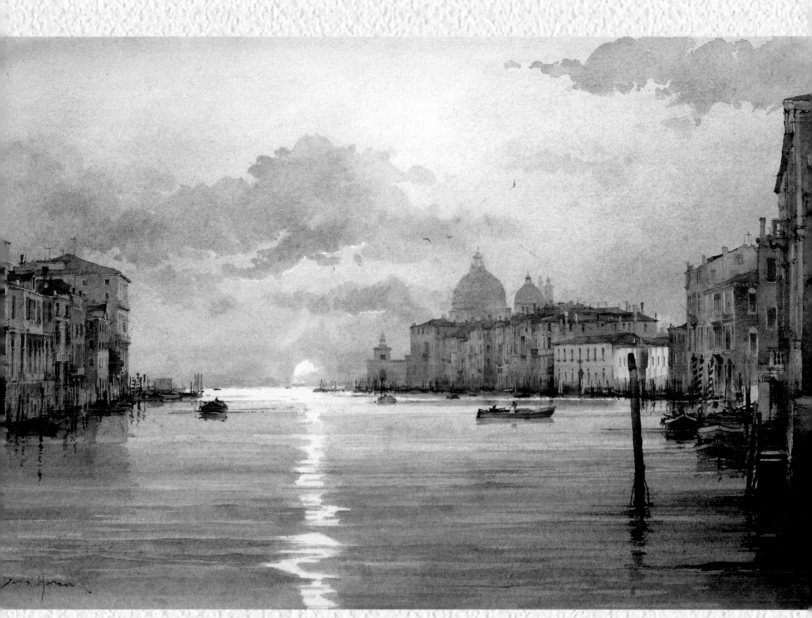

Fig. 7.31 *Sunrise on the Grand Canal, Venice.* I've painted this classic Venetian view so many times, from both under and on the bridge itself, but it's difficult to resist having another go. One of the huge advantages of filling sketch books is that you end up with a library of material that is not only a record of the subjects you have tackled in your painting career but they are also available for another crack if you think you might just do better next time.

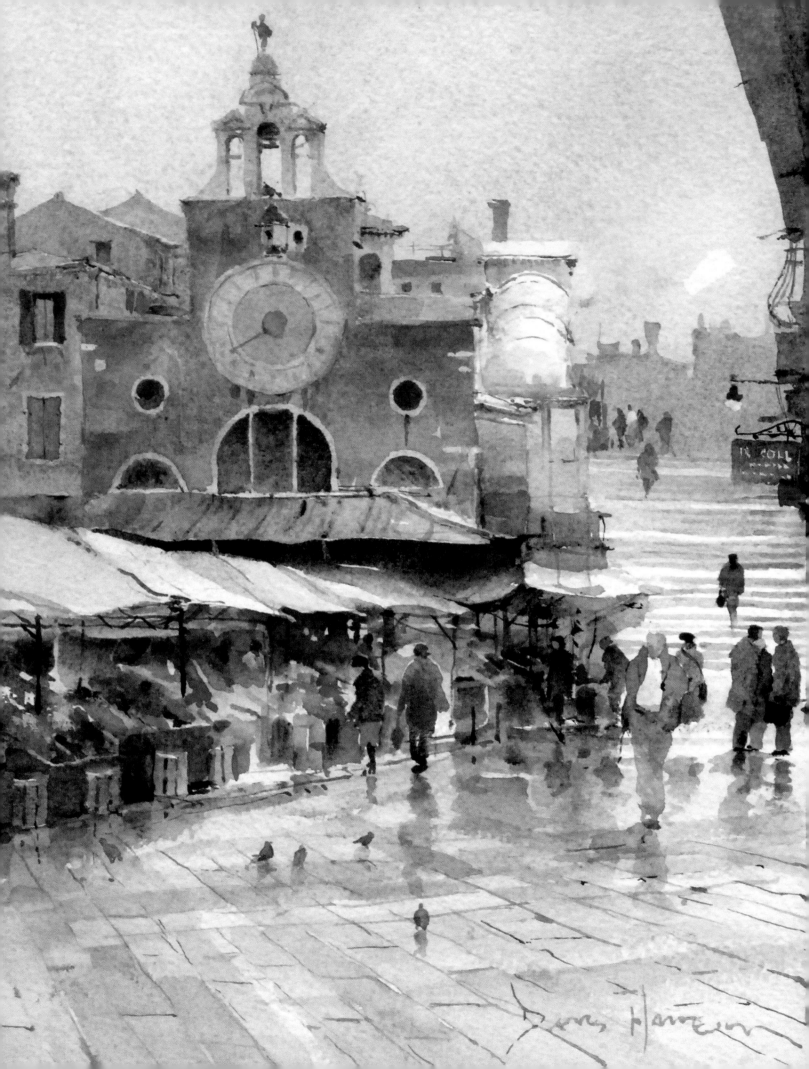

Townscape

Just as the transition from landscape to marine painting depends primarily on the inclusion of tidal waters, the description of townscape is appropriate when the main subject is buildings and the urban environment, but in truth it's highly likely to include many of the elements that demand attention in other environments and it requires the same selective abilities in a painter to decide what's important and what isn't and what needs adjusting to ensure that the composition is effective. In many ways this sort of freedom to adapt things doesn't appear nearly so easy when you're faced with the solidity of stone, bricks and mortar but as a painter you have to remind yourself that your job is to paint decent paintings and not to produce an exact copy of what is there. Buildings in an urban situation are complicated and require serious concentration on perspective and proportion, but ending up with what is effectively an architect's drawing is not the aim of good townscape painting.

Learning to identify attractive shapes and colours in a grouping of buildings, so that they become the main focus of the composition, and diminishing the importance of others or relegating them to simple background is the key to interesting work and an ability to include figures and vehicles where appropriate is equally important. Perhaps above all, it is the ability to paint pictures that capture the spirit of a particular place with a minimal amount of detail.

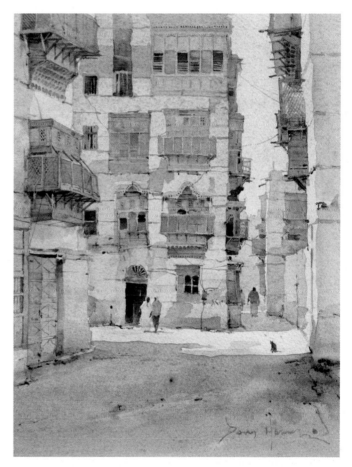

Fig. 8.1 *The Old City, Jeddah, Saudi Arabia.* This townscape is typical of the old city of Jeddah, which is now surrounded by a modern metropolis more attuned to the twenty-first century. Originally it was a walled city with houses largely built from coral stone, with ornate wooden balconies, windows and carved doors. The complexity of the subject and the heat prevented any serious painting on the spot and sketches and photographs had to provide the source material to paint from.

Fig. 8.0 *San Giacomo, Venice.*

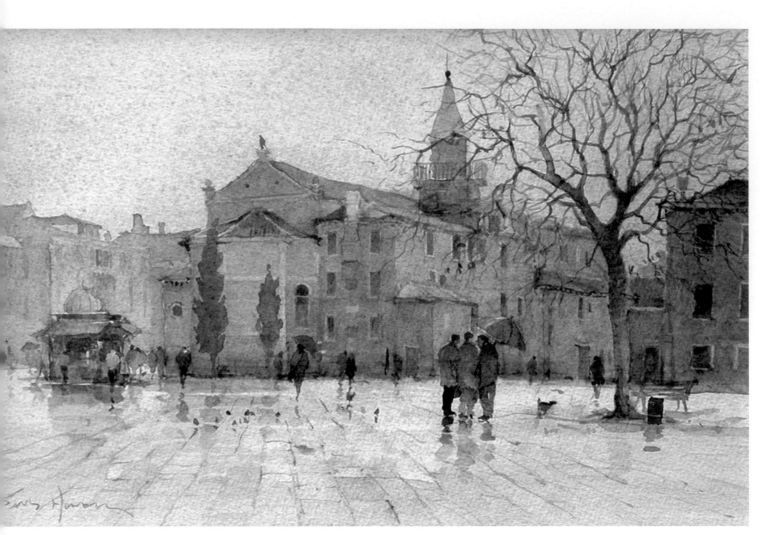

Fig. 8.2 *Campo di San Polo, Venice*. The subject of this painting is a wet winter's afternoon in Venice. The main focus is the group in the foreground with the church of San Polo in the background and the tree, pigeons and other figures help to set the scene. Note how the far distant buildings on the left have been simplified and softened with virtually no detail.

A proper understanding of perspective is essential to good townscape work but to put your own stamp on a picture, you have to be prepared to be creative. Painting exactly what's there with supreme accuracy might just as well be a photograph. It's important to consider the compositional placing of the features that made you want to paint it, so that anyone viewing the finished painting also understands what it's about and a certain amount of relaxation of hard architectural detail will help the painting flow. Roofs and gutter lines on older buildings are often a bit bent and even if they aren't, taking away the rigid straightness helps to ease the harshness. Detail like windows and doors can frequently be painted loosely and suggested, rather than painting every window pane.

Fig. 8.3 *Ouay du Port, le Croisic*. This sketch illustrates the potential complexity of a group of buildings and apart from the amount of work involved, conditions were not ideal for watercolour painting on-site and I wanted as much information as possible without resorting to photographs. The buildings are the main subject but I did take a fancy to the unusual green boat.

Fig. 8.4 In one go, the whole paper has been covered with a graded wash applied with a squirrel hair mop, with Cobalt Blue and Red Umber as the principle colours and then whilst wet, more blue has been added at the bottom to indicate the water, whilst yellow Ochre has been bled into the wet wash for the main group of buildings. Working like this gives an overall harmony to the painting and then when this initial wash is dry the roofs have been painted in with a big sable, using a deliberate variation of colour to suggest the different sections. Note the bare paper left for white chimneys and negative shapes were left for the dormer windows.

Le Croisic Demonstration

Although there is a marine element in this picture, the principal subject is the buildings along the Rue du Quay of this port on the Western coast of France. For a start they are so very French with a fascinating set of roofs and chimneys and an engaging lack of any regularity in the placing of windows.

It's all too easy to get suckered in to a very careful approach with a subject like this, but careful tight drawing is likely to lead to a tight over controlled painting. Let your hair down, take a few risks and get paint all over the paper.

This first stage is so critical but if you tackle it with a certain amount of panache and enthusiasm, you will get a lot done quickly and the resulting washes will be loose, varied and colourful and you will be up and running. This was painted with a maximum size No 10 Isabey *petit gris* squirrel hair mop, whilst the roof details went in with a size 16 sable from Rosemary Brushes. Spaces were left for the dormer windows and a certain amount

of bleeding of adjacent colours was deliberately allowed, whilst the roofs had additional colour introduced, wet in wet, to give variation in tone and colour.

Getting proportions right in a painting like this is not easy but whilst working without pencil drawing might seem a fairly crazy experiment, it does engender a sense of freedom. If you feel the need for some guiding marks, using something like a rigger brush to produce a minimal amount of pre-painting drawing with diluted watercolour can help. Because of the flexible nature of the brush it's impossible to produce tight straight lines and if the paint is sufficiently diluted the marks and the lines either become part of the painting or are effectively washed out when the main washes are applied. Don't forget about drainpipes, gutters, telephone and electricity cables and television aerials — if you ignore all these bits and pieces, buildings can look slightly clinical but do remember you're in charge and if something offends your eye, leave it out.

Fig. 8.5 The roofs have been developed further and the gable end and chimneys of the highest building have been added and more colour has been introduced to the frontages to suggest the slight variations in the colour of the rendering, along with more windows. The green boat has arrived on the scene and the buildings on the left have been blocked in with a cool mix of Cobalt and Red Umber with a touch of Raw Umber and/or Burnt Umber bled into it. I'm always keen to avoid plain flat washes and so there's always a wet-in-wet process going on to achieve variations of colour.

Fig. 8.6 The painting developing. It's easy to start getting a bit bored with the painting by this stage because after all the initial excitement, the process with a complex subject can seem to go on forever. Stick with it!

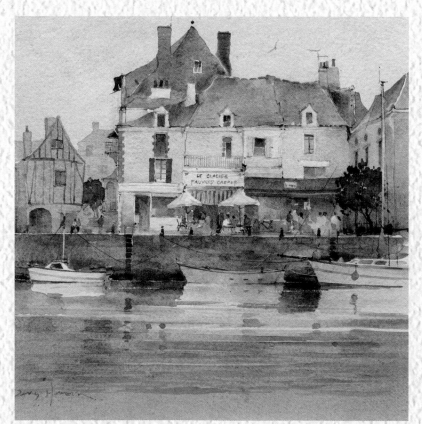

Fig. 8.7 This is the finished painting with the quay and the boats alongside developed and the water complete with reflections painted in. The building to the left has still been treated as a supporting act but enough detail of its half-timbered construction has been included. People have been added along the quay and around the shops and restaurant – without them the painting would have looked strangely empty. Note how the boats have been placed to break up the harsh wall of the quay. Without them it would have effectively cut the picture in half.

Fig. 8.8 *Piazza San Benedetto, Norcia*. Norcia is a small market town in Umbria with a paved central square surrounded by interesting buildings and no traffic. Most of the buildings are of warm colours like deep Ochres and occasionally reds and even the stone of the church picks up reflections of colour from both buildings and paving. There is a sense of space and distance across the square created by both the lines in the paving and in particular by the colours and detail of the paving getting stronger in the foreground. Distant background mountains are simply blocked in using a cool blue/grey.

One of the worst things you can do with a townscape like this is to start at one edge and work your way painstakingly across it, whether in the form of an initial drawing on the paper or in paint. You need to be aware of the whole composition and work over all of the picture area rather than little bits of it and before a brush gets anywhere near the paper, you need to decide what is the most important part of the painting that you are going to build the composition around. Is it the people in the square, the statue of San Benedetto or the church? In this instance it's definitely the church and its tower and that has been deliberately placed roughly one third from the left hand edge of the picture and the paving and the people help to take your eye towards it. If in real life the paving goes the other way, don't be frightened of changing it to suit your painting – you're in charge. As a painter you have the freedom to adjust things to make a better painting and you're not subject to the limitations imposed with a camera. If the paving can be improved, do it. If there's an ugly waste bin right in front of you, leave it out. If during the period that

you're working something else happens, like a colourful group of cyclists or a gaggle of nuns catches your eye, don't automatically include them unless you are sure that they add to the existing composition and aren't just a distraction. Remember the alligators in Chapter 4!

Try to start by seeing the whole composition in blocks. In the Norcia painting it would have been blocks of shade, and colour would have been introduced into the wet shadow shapes to get as much done, wet-in-wet, as possible, so that the painting gets a strong start. This approach is contrary to most of our instincts, which would suggest a cautious start to avoid messing things up on a lovely clean expensive piece of paper. Obviously experience helps but you might be surprised how rarely it really goes disastrously wrong. Be brave! Do remember that shadows are not dark lifeless areas but colourful parts of the painting and, as in many pictures they may make up at least half of the painting area, it would be unacceptable to make them dull and uninteresting.

Fig. 8.9 *Norcia* – first stage. This shows the start of another picture of Piazza. San Benedetto. I've started by painting the blocks of shade, both on buildings and on the paving, making sure that the overall shapes and perspective is right and effectively in the first wet-in-wet I've covered 50 per cent of the painting area with colour and established a framework to build the rest around.

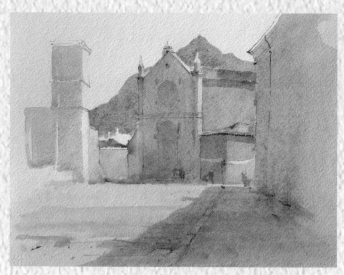

Fig. 8.10 *Norcia* – stage two – building up the painting. This stage two shows the painting moving on with the introduction of more detail and colour and the development of the left-hand tower where the shadows aren't so intense. Virtually the whole of the painting is now in play rather than one area being concentrated on.

Norcia Demonstration

These shadows areas were created by using French Ultramarine to paint in the shapes and then using a touch of Light Red to grey down the mix and then earth colours like Raw Sienna and Raw Umber were painted wet-in-wet, with even a smidgeon of orange created with Cadmium Red and Yellow. The whole idea is to end up with vibrant, colourful shaded areas and you won't get that with using diluted black or the proprietary greys like Payne's Grey. It also helps to work quickly without overworking the paint. Let the brushes and paint do the work and beware of too much tidying up. I used a big Isabey squirrel hair *petit gris* mop to paint these shapes. Squirrel hair mops have the advantage of holding a lot of paint and dropping it quickly and freely on the paper, but at the same time they point sufficiently to allow shapes of buildings to be painted with reasonable accuracy. Note the word reasonable – enough to capture the proportions and character without turning it into an architect's drawing. It was also rather hot in the square and therefore necessary to have enough water in the mix, so that wet-in-wet was possible before it dried to the extent that introducing more colour would have resulted in cauliflowers or tide marks. I used a big size 20 sable to introduce the additional colours because the sable will allow more control when introducing colour into a wet mix on the paper and using a brush this big makes sure I can't fiddle about.

Stage three shows how I've worked on the church and started to introduce figures that give both a sense of movement and scale. The figures themselves are only loosely described and are no more than patches of colour but they and the architectural detail of the church make this shadowy corner full of interest. Observation is essential at this point. Figures must be in proportion to their surroundings and perspective, but painting then in too much detail will lose the fluidity of the painting. Paint them quickly and don't use tiny brushes.

You will find that occasionally you will sub-consciously avoid certain parts of a picture, either because it's of no interest or conversely you're apprehensive about getting it right and keep putting it off. It is much better to tackle the problem area sooner rather than later. The complexity of doorways, shop-blinds and various bits and pieces on the right of the picture is a good example. It doesn't contribute much to the painting but you can't ignore it, so keep it loose and just paint and aim for an overall effect rather than trying to identify individual components.

Do learn to live with the feeling that you could have done better. All good painters will understand that there's no such thing as the perfect painting. The whole painting process goes slightly adrift from the minute you start and it's very rare to end up with what you originally intended. When you don't know much about it, painting is relatively easy but when you do know what you're doing, it gets more difficult.

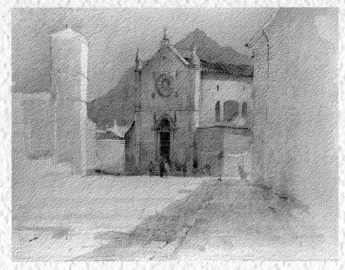

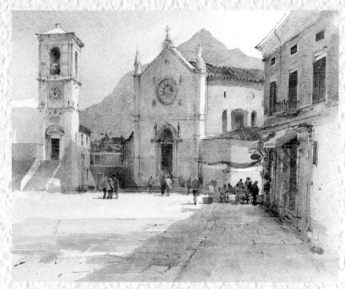

Fig. 8.11 Stage three – the painting with more detail, particularly on the church front, and more figures. Make sure that the figures are in proportion to their surroundings and paint them quickly and don't use tiny brushes to avoid them being stiff and unreal.

Fig. 8.12 Stage four – more detail, figures and colour have been added and the café area on the right has been developed. I have to be honest and confess that this café and the people in front of it were originally supposed to be the focal point of the composition but at the moment the architectural content is taking over.

Fig. 8.13 *Norcia* – the finished painting. The final picture has a lot more figures added to balance the activity in the square, some pigeons have joined the scene and we end up with a busy lively composition. This seemed a good time to walk away from it. As Pierre Bonnard once said, 'You don't finish a picture, you abandon it.'

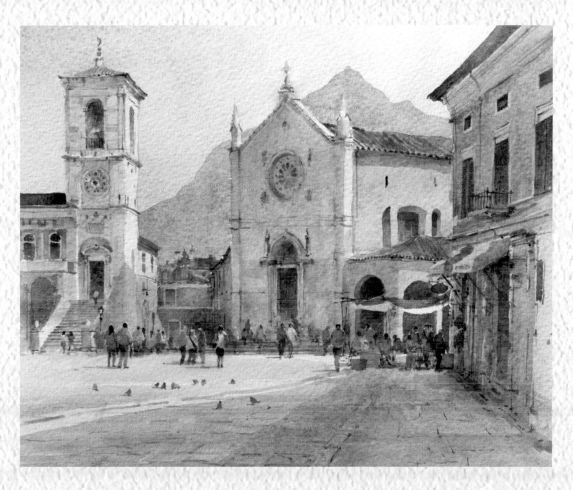

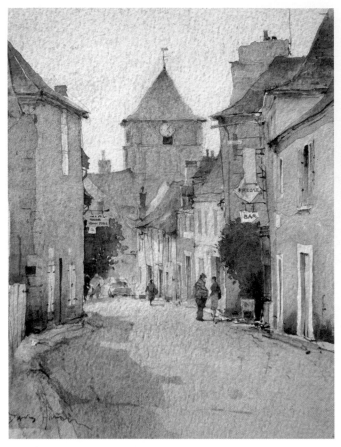

Fig. 8.14 *Rue de Tournon, Angles sur l'Anglin*. Looking down what is effectively the main street of this beautiful French village in Poitou-Charente. The perspective on the roofs and window lines of the cottages at the bottom tells the viewer that the street is going downhill and the figures help to give a sense of scale and movement. The other nice thing about these old buildings is that there isn't a straight line anywhere.

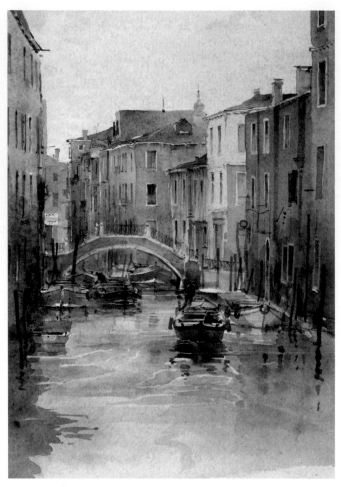

Fig. 8.16 *Rio della Mosche, Venice*. Another Venetian townscape with boats. Rio della Mosche is typical of the numerous back 'streets' of Venice. Lots of colour and of course reflections. Note the placing of the boat and boatman in the foreground, so that it becomes the initial focus and then leads the eye along the canal.

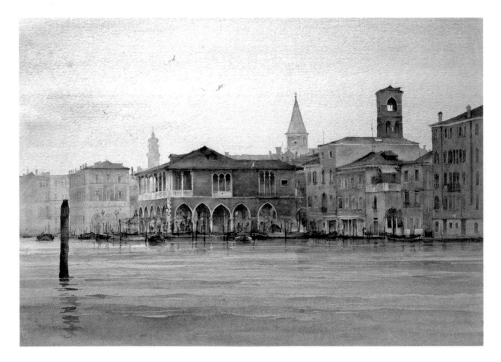

Fig. 8.15 *Il Pescheria, Venice*. It might well be argued that this is a marine picture but the subject is very much architectural and perhaps the absence of conventional streets in the city makes it acceptable. The concentration of the shapes of buildings on the right-hand side is the focus of the picture and the more distant ones on the left have been diminished by the use of aerial perspective.

Fig. 8.17 *Chambellay, Maine-et-Loire, France.* This has a bit of everything in it, but is essentially a picture of the village of Chambellay beside the River Mayenne in France. The main subject is the church but the sunken boat in the river adds balance.

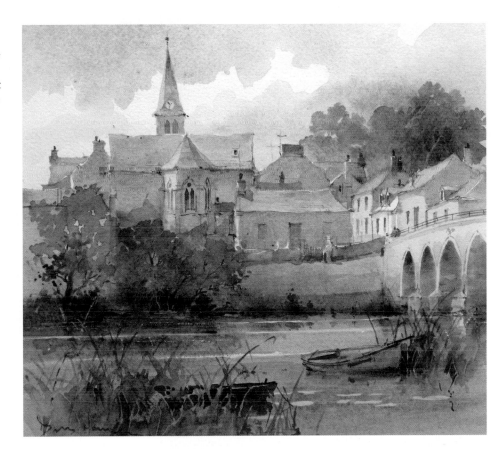

Fig. 8.18 *Morning in Old Jeddah.* This is another painting of the old city of Jeddah in Saudi Arabia. We associate most modern Middle Eastern cities with very contemporary steel and glass structures, wide boulevards and shopping malls and Jeddah is no different, but tucked away close to the harbour is still the old city of Jeddah, protected from the bulldozers, preserving some of this ancient city's history and architecture.

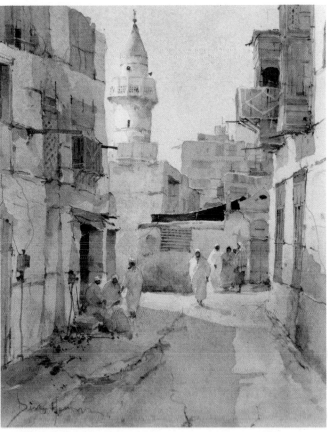

One of the great attractions of Venice is that the buildings are all on different levels, often leaning and frequently looking slightly the worse for wear but, as a combination of colours and shapes, they take some beating for a painter. You're always aware when working there that many others will have painted from the same spot but it's still possible to find something that little bit different in terms of the light and conditions and your own personal touch.

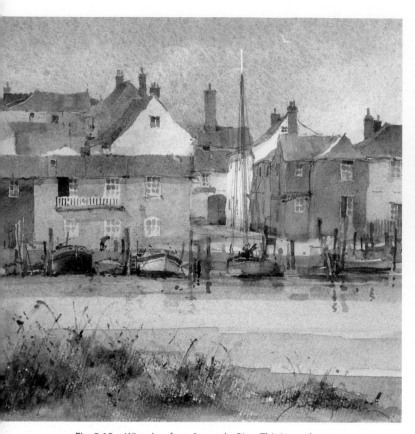

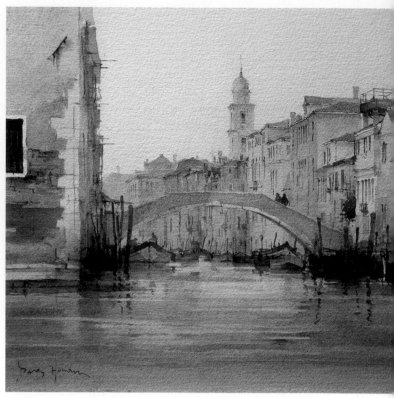

Fig. 8.19 *Wivenhoe from Across the River.* This is another townscape where boats have crept into the picture. There is a certain amount of thought in the placing of the boat with the tall mast, so that it acts as a balancing factor to the main focus, which is the colourful gable end of building on the left and roofs of various shapes, colours and tones.

Fig. 8.20 *Rio degli Ognissanti, Venice.* Again, although there's water instead of a street, this is a cityscape with a bridge and boats. The interest is the jumble of different buildings and the colours.

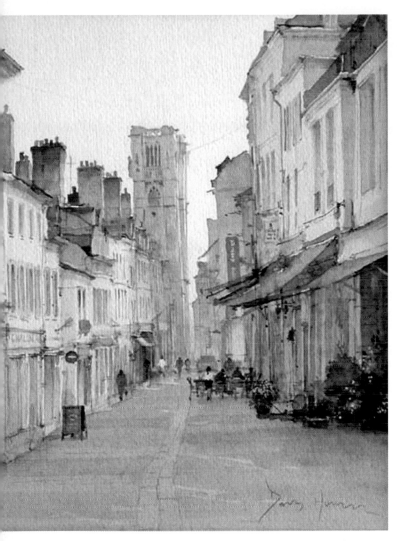

Fig. 8.21 *Chalon sur Saone, Burgundy, France.* The city centre of Chalon in Burgundy on the Eastern side of France is one of numerous French towns and cities where painting possibilities are all around you. This watercolour was produced from an early morning sketch before the shopping area became too busy. The nearer of the twin towers of the cathedral appears to be not quite vertical but the fact that I have recorded it like that suggests that is actually how it is and it fits in well with all the other variations of walls, chimneys and roof lines.

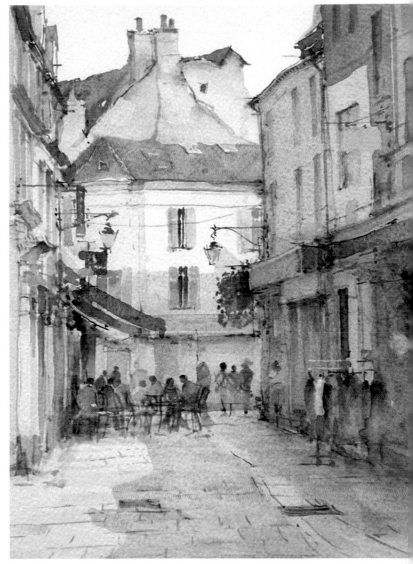

Fig. 8.22 *A street in Beaune, Burgundy, France.* France lends itself to urban painting, not least because towns and city centres have been largely preserved and have kept their very French character. Dealing with the harsh realities of modernized frontages and burger joints and building society corporate signage is rarely a problem, and of course the climate lends itself to the café culture where you can sit outside for lunch or a coffee and not have to get out of the way of passing traffic.

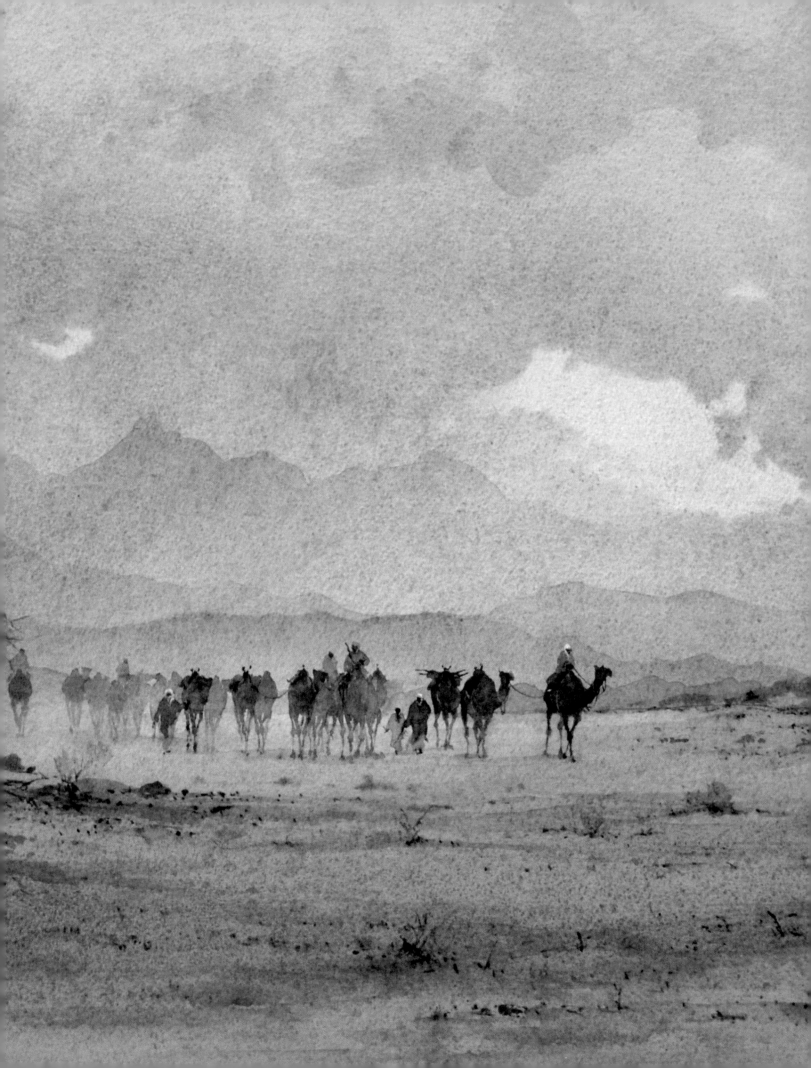

Putting Life into Paintings

There are very few places in this increasingly crowded world where you can set yourself up to paint and not have any living thing appear in front of you and that fact is evident in many of the paintings in this book. You might be limited to the odd bird or two with some landscape situations or it might be cattle, horses or sheep that put in an appearance but inevitably, as soon as you get to townscape and many shoreline marine situations, you will encounter human beings. I've worked in some of the more remote deserts of Arabia with nothing but a rocky and sandy wilderness in view but even that far off the beaten track, there's a fair chance that as you get to work, someone will appear as if from nowhere to find out what you're doing.

It's perhaps somewhat surprising therefore, that so many painters either try to avoid including figures in their paintings or become rather anxious about the process and come up with stiff, awkward and overdone examples, where what is actually required is a relaxed approach and the sense of not making too much of a big deal about it. As with everything in painting, observation and practice is of great help and nothing beats taking the time to look at what's going on around you. If you choose to make the effort to sit and sketch in a public place, you will quickly discover that people are all sorts of shapes and sizes and that they lean on things, each other, gather in groups, stare at mobile phones, carry handbags and so on and certainly don't stand up nice and straight at regularly spaced intervals. Being able to draw them quickly is essential, as is the ability to glance quickly at someone and then hold on to enough information in your head to get it down on paper, because next time you look they will have moved. You will ultimately find that you don't actually have to be very accurate

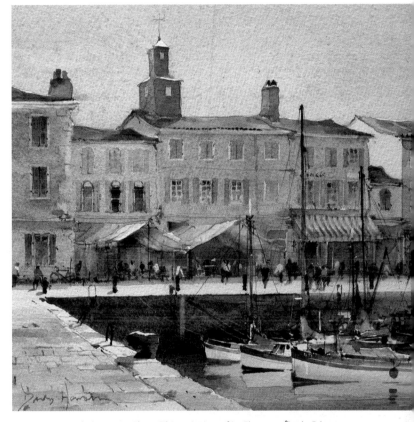

Fig. 9.1 *Quai de Senac, La Flotte.* This painting of La Flotte on Île de Ré, off the west coast of France, is a combination of marine and townscape but it would look strangely empty without the figures on the quayside. They add a sense of life and movement.

Fig. 9.0 *Travellers at Quada, Hijaz.*

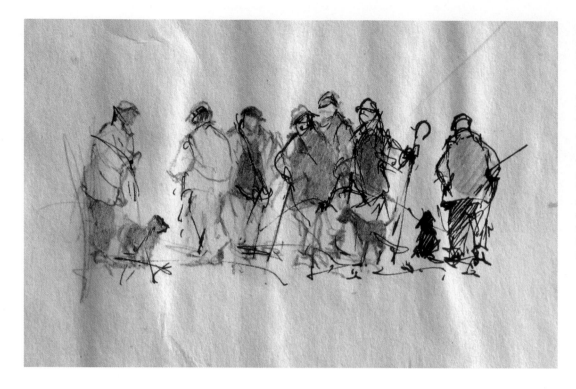

Fig. 9.2 *A Group of Beaters on the Local Shoot.* This sketch was produced using a combination of a Faber Castell PITT pen and a pencil, although a bit of green crayon seems to have sneaked in. It was apparently raining at the time, which explains the wrinkled paper but there's a nice rough immediacy in the sketch. No overdone detail but just enough to convey a bunch of country folk with their dogs, having a chat before the next drive.

and when painting them it's more about the suggestion of figures rather than detailed drawing and as ever, the more you work at it, the easier it becomes.

Building up your confidence with figure work and in the process a library of sketches that can be used in paintings, is invaluable. All that is needed for this sort of quick opportunist work is a pencil or two and a modest sized sketch book that is small enough not to be too obvious and that will ideally fit in a pocket or bag.

With sketches like the beaters above, you must grab the opportunity when it occurs and you won't have time to get out all the bits and pieces you might think you need, but as long as you have a pencil, pen or for that matter anything to draw with and something to draw on, you're sufficiently equipped. Most of my outdoor coats have the odd pencil stub stuffed in them and an A5 sketchbook will fit nicely in a pocket, but you might need to protect the point of the pencil as they do get broken easily. Carrying a penknife to sharpen it is one way of solving the problem but that takes time. A better solution is to use a retractable clutch-type pencil which allows the point to be retracted into the safety of the case or, with conventional pencils, a pencil extender which is designed to extend the life and length of a short pencil by providing a slip-on handle. These are very effective if reversed and slid onto the sharp when on the move, to protect the point.

It's perfectly possible to take things a stage further than the odd scribbled sketch and set yourself up in a more organized way in an out-of-the-way corner, where you can spend a happy hour or two sketching or painting people as they appear before you. Tourist spots, cafés and shopping centres are equally productive for this sort of exercise because people are more likely to be casually wandering, rather than rushing about and that gives those extra seconds or even minutes that will allow you to get something down. Do try and identify groups of figures that relate to each other – something like a group of friends discussing where to go next with all the interaction that entails – as this will make a much more interesting feature in a painting and may even be the main or a significant point of interest in a picture.

Both the beaters (Fig. 9.2) and the camel sketch below (Fig. 9.3) have a nice grouping and a sense of compositional considerations in their own right. They certainly could be used in an appropriate painting pretty well as they are and could be used as a focus for a landscape, in the case of the beaters, and a suitable Arabian setting for the camel handlers.

Fig. 9.3 No rain or dogs this time. These two characters were loading up a camel just outside Taif in Saudi Arabia. Taking a photograph may well have attracted too much attention but a quick pencil sketch from the car worked fine. There's always a nice feeling of movement in fast sketches produced under pressure. They were only going to be there for a few minutes and much of the sketch was worked from a process of quick glances and then memorizing enough to concentrate on the sketch and remembering enough to be able to complete the drawing when they moved off. Working in a stationary vehicle without any air conditioning running with an outside temperature of 40°C plus in the shade is another incentive to get a move on!

Fig. 9.4 *Rio di San Barnaba, Venice.* This is taking things a whole lot further in that it is very much an overall scene in Venice. However, the figures, whilst loosely drawn in very much an impressionist manner, are the main point of interest and that is reinforced by their grouping and placing, roughly a third from the bottom and right hand edges. Again the sketch has that loose and fluid approach that says enough about the subject without turning it into either an architectural drawing or a copy of a photograph. Perfect for working from back in the studio.

Fig. 9.5 *Tunis Souq.* In places like this there is no way you can have the luxury of sitting down or even standing to work for long periods and so you have to develop the ability to get down as much as possible and retire gracefully before you become the centre of attention. However, the whole point of painting a busy souq is the hustle and bustle of all the people and this drawing captures enough of the action to turn it into a painting. There's virtually no attempt to record any detail – just enough to suggest the figures and the shadows and depth of the alleyway into the distance. Trying to depict them all individually would bring the whole thing to a standstill

Fig. 9.6 Not humans this time, but taking the time to make sketches of animals that can be used in future landscape paintings is always worth doing. Like people, cattle don't stand still very long if they're grazing and will normally quickly move on. This slightly scruffy effort probably took about three or four minutes, but it contains enough information about some of the basic shapes of a herd of bullocks for future reference. Sketching like this produces essential visual notes and frankly, it's fun.

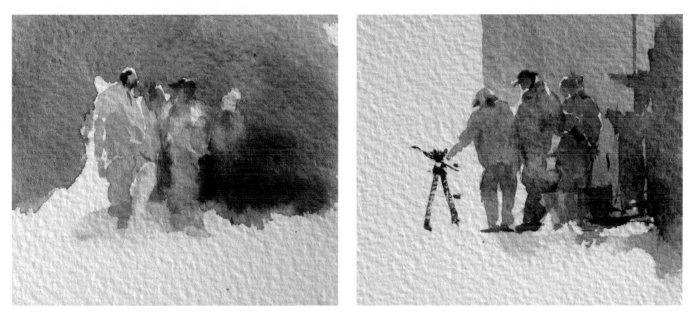

Figs 9.7 and 9.8 These two little studies were painted in Italy, the one on the left of people who just happened to be there for a moment and the one on the right is of one of my students with an audience. Note how a little bit of background has been included to give a sense of how the figures relate to their surroundings and how the light round heads and shoulders is shown by deliberately leaving bare paper.

Fig. 9.9 This was painted on a beach on Île de Ré where I was lying about enjoying the sun but this couple were just too good to miss. Painted on a small 20 × 20cm Senellier Aquarelle block with a NOT surface, this study took less than five minutes from the moment I dug the kit out of the bag. No pencil, just watercolour. Working like this, effectively in blocks of colour, give the figures a sense of movement. The two figures on the right were poking around in the sand and got included!

Get used to seeing figures and animals in shapes rather than just in linear form and a relatively blunt but soft pencil will do the job better than a nicely sharpened HB. The cattle sketch above is rough and ready but it also has movement and a sense of the weather at the time. I can't honestly be sure what was used but I suspect a clutch pencil, something like an 8B pencil and a brown crayon. There comes a point where if you have developed the skills of observation of figures and sketching with graphite implements, moving on to sketching in watercolour becomes not only feasible but a practical and colourful way to create reference material. Keeping your equipment to a minimum helps, not least because if you turn up with an easel and a lot of gear, you might just find that you become the centre of interest rather than the other way round. A small watercolour block works beautifully, together with a decent size brush which will help to keep things loose and not too detailed. I normally use a size 12 retractable Escoda sable, along with my little Winsor & Newton paint box with its own water supply.

Fig. 9.10 *Beaters Heading Home.* There's no doubt about what the subject is here. The group of beaters is placed vaguely one third from the bottom and right edges of the paper and the track leads the eye towards them. They are still figures in a painting rather than a painting of figures because the composition is also about the trees, a winter afternoon with the light going, bit of a fog coming in, damp dripping off the branches – time for home!

Fig. 9.11 *Misty Morning, Malton.* Another painting where the figures of horses and riders are the main subject but again, they are figures (and horses) in a painting rather than a specific study of riders. The whole point of the painting was to capture that early morning feeling with the sun just breaking through the mist. Racehorse strings get out on the gallops early and the only way to create this sort of opportunity is to be an early bird too and, as with the picture above of the beaters, it's so important to convey a feeling of time and place.

Always be aware that when you feature figures in a painting there's a tendency for the viewer's eye to head towards them and therefore the placing is critical. They may be the subject of the painting but if they aren't and are just part of the scenery, do be careful where you put them. What you don't want to do is paint a picture and then realize that figures are needed and put them in the wrong place and in the process, wreck the composition. If in doubt, try cutting people-size pieces of dark paper from a magazine or similar, making sure that they are roughly to scale and place them on the painting and move them around to see where they work best before making a commitment in watercolour.

Neither of the two Venetian paintings (Figs 9.12 and 9.13) could be considered figure paintings – they're much more about the city, boats and canals – but without figures there would be a curious lack of human interest that would appear odd. When including figures in a setting do remember the need to make sure that the perspective is right in terms of their size and how they relate to adjoining doorways, windows and other features. It's very easy to get this wrong and not realize you have a problem until the painting is dry and it's too late to do anything about it.

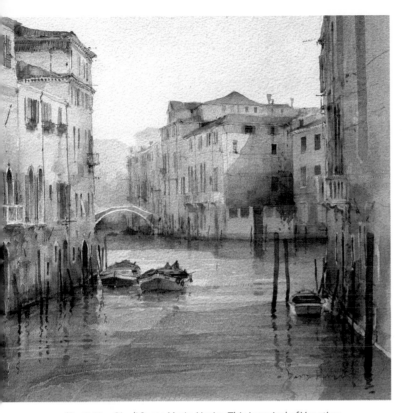

Fig. 9.12 *Rio di Santa Maria, Venice.* This is typical of Venetian backwaters, away from the tourist hotspots and finding places like this may take a little time. Without something happening, this scene would have looked empty but the blue boat has become the point of interest because of its placing within the composition and that has been reinforced by the inclusion of the figures on board.

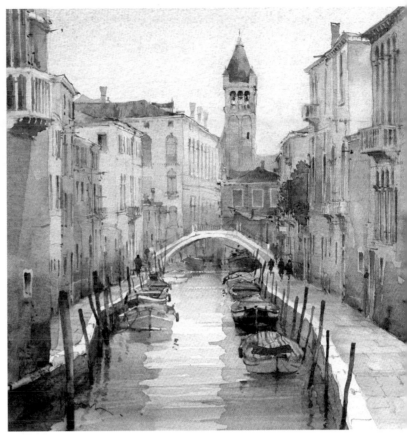

Fig. 9.13 *Rio di San Barnaba, Venice.* Unlike the sketch, earlier in this chapter, the subject of this painting is the campanile in the mid-distance with the canal, buildings and pavements leading the eye towards it. Figures are included because it would look odd without them but they are incidental rather than the subject of the painting. However, they give a sense of scale, distance and movement.

Fig. 9.14 *Al Souq al Kabir.* This picture is all about the figures and they are placed very much as the subject in compositional terms, with the entrance to the souq quite understated so that it acts purely to set the scene. This Arabian group, with their gentle variations in the colour of their robes, either standing or sitting on the stonework and sacks, makes a painting in its own right but placing them in the right setting makes it even more interesting.

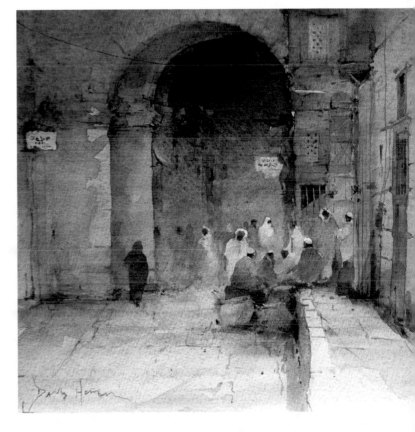

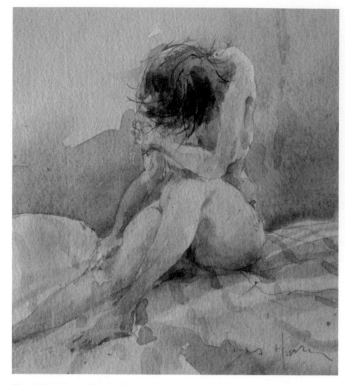

Fig. 9.15 *Seated Nude.* This study commenced with loose guidelines in pencil, concentrating on getting proportions right but also trying to keep the whole thing loose and free. Very careful drawing would have taken too long and also would have made the whole thing too tight. You have to continually remember that this is a painting of a model, not a statue.

The Meaning of Life

Life work is where the human figure itself, usually naked, becomes the prime subject and at one time, until drawing went out of fashion, most serious art colleges required students to spend many hours in the life room working from a model, because it taught them to paint or draw directly from the subject and to concentrate on what they saw, rather than what they assumed and to understand what they were looking at in terms of shapes, proportions and perspective. Even the smallest child can come up with a scribble or drawing of the human form, even if it's only a matchstick man drawn on the kitchen wall, and most adults can come up with a vague representation but it's only when, as a painter, you're confronted with the real thing that you realize that things are not nearly so straightforward as might be imagined. Quite simply it's arguably one of the most challenging subjects you can tackle. Being faced with another human being without any clothes on who is quite happy to pose whilst they are drawn or painted, takes a little getting used to and to anyone who isn't used to painting or drawing directly from any sort of motif, the learning curve is steep. Not only that, but if you're attending life classes you have the competitive pressure of other artists around

Fig. 9.16 *In the Life Room.* An example of a rapid two- to three-minute sketch. This is on cartridge paper, using a Caran d'Ache Neocolor crayon which is ideal for loose fast lines rather than precision drawing. The whole idea of these short poses is to ensure that there is no time for tidying up or generally fiddling about, but what you get when working rapidly like this is a fluid lively drawing with lots of spare marks that give clues as to how the figure was assessed and angles and shapes calculated.

you, some of whom may have been going to life classes for years. Don't worry about them, just do your own thing and persevere.

More than anything, life work teaches you to really look and think about the angles and proportions of a human figure, with all its variations and blemishes from one model to the next, rather than some idealistic, air-brushed representation. You will find that many of the lessons learned in the life room can be applied to other forms of painting.

What you must get used to with a live model is generally working quickly. Models after all are human and they get cold, cramp, complain about drafts and generally don't want to be standing or sitting in one position for too long. I'm a great fan of very short poses, where students have to produce enough in the way of a drawing in two or three minutes before the pose changes. You quickly realize that you have to have a drawing implement and

Fig. 9.17 *Reclining Nude.* This is an example of painting with virtually no prior pencil work at all. It has been painted mainly using size 16 and 20 round sables, plus a rigger, and there has been no effort made to tidy up things that probably aren't quite right but it concentrates on the overall feel and appearance of the painting. Fiddling about trying to change things would have spoilt it. Colours used are predominately Yellow Ochre and Cadmium Red with occasional Brown Madder and Alizarin Crimson mixed in and even a little Burnt Umber, plus Cobalt Blue where appropriate.

paper at the ready and there has to be an immediate assessment of proportions and angles and enough in the way of marks and lines to be able to work from the drawing later and most importantly to make sure it fits on the paper.

Do be aware that if you start at one end of the model and work towards the other it's surprisingly easy to find you've run out of space, which in turn might lead to legs not fitting on to the paper or being made shorter than they actually are, or if you've started at the feet you might run out of room for the head. Get used to the idea of making a minimal number of marks and quick lines to check how everything fits and the time honoured method of holding up a pencil with an adjustable thumb works fine for checking proportions. Similarly, the same pencil can be held vertically to check angles of the head, limbs, pelvis etc. – after all pencils aren't just for drawing! Don't assume anything. Watch out for the effect of gravity on the softer parts of the human body and check for foreshortening of legs and arms in particular, caused by perspective. There's no time to study the model in detail in these very short poses but with practice you will end up with studies that have movement and fluidity rather than a longer considered work that ends up looking like a statue.

Longer poses, of course, do offer the possibility of working directly in watercolour with the model in front of you. You might again want to start with a few guidelines to check angles and proportions, which can be with soft pencil or something like a rigger brush and diluted paint but watercolour in general works best if you are prepared to take risks and never more so than with life work. Painting the figure in shapes of colour rather than a pencilled outline is a perfectly logical progression.

Moving on from life sketching and drawing to producing convincing paintings usually requires a little more imagination as it's unlikely that your model will be in the right surroundings to create a finished work, unless you have an arrangement that allows you to create the appropriate surroundings in a life room at an art college, in the studio or at home. More often than not you will find the environment at local life classes cluttered with easels, stools, electric fires to keep the model warm as well as other painters, with a background of a school classroom or the local village hall. Whilst you might have some acceptable graphite, charcoal or watercolour sketches of your models, turning them into paintings will probably mean some separate work on backgrounds.

Keep your eyes open at life sessions for things that will work, even if you have to paint them after the model has gone for a cup of tea. Oddly enough, nude paintings often work best when the surroundings are somewhat incongruous and the contrast between the soft curves of a model and easels, studio paraphernalia and the odd doorway can make very interesting paintings. These backgrounds don't need to be too detailed and in fact can just be just indistinct shapes and colours that enhance the picture as a whole and create a composition rather than just a figure study.

Fig. 9.18 *Bev in the Studio.* This is a painting rather than just a study, in that the model is in a studio setting and the mirror, bottles and brushes in the background create secondary interest and shapes in the picture, whilst the strong verticals on the right help to provide a contrast to the shapes of the human form. The dark background also has been used to enhance the colour range, providing a contrast between the skin tones of the model and at the same time making sure that the background stays that way. Just like other forms of painting, life work is about shape, colour, tone and composition and creating a painting rather than concentrating on detail and accuracy.

As ever, the colours used in these 'life' pictures are from the same standard selection that I use for everything else. One of the fascinating things about working from a nude model is the way that skin colour is influenced by both the light and shadow areas and also by reflections of surrounding colours. My basic palette for this sort of work will be to use a dilute mix of Cadmium Yellow and Cadmium Red for the lighter areas with the occasional bright area of unpainted paper, and as the colour needs a little reinforcing I will usually switch to Yellow Ochre mixed with Cadmium Red depending on the skin tones of the model, Yellow Ochre mixed with Brown Madder will provide some strong colour. If you think about these colours, they are essentially mixing reds and yellows and producing various tones of orange and the complement of orange is blue. Therefore, shadow areas include Cobalt Blue to ensure that the shaded areas are still colourful and

subtle. Note also in the painting above how shaded edges of the model are softer in contrast with the hard edges towards the light side, which in turn emphasizes the curves and shading.

Above all, life work is an excellent way to get used to painting from the subject. Waving cameras around in the life room is definitely out and you have to learn to cope without mechanical aids. Those who use photographs to work from as a matter of course will find it's a steep hill to climb, but if you persevere, the lessons learnt can be applied to painting anything else. It you are capable of producing a competent and interesting figure sketch in five minutes, the same skills can be applied to other subjects and it will become second nature to rely on your drawing and painting skills rather than resorting to a camera and your painting will improve accordingly.

Fig. 9.19 *Standing Nude.* This is a watercolour study where no preliminary pencil work has been used at all. It's painted on Khadi 310gsm rough paper which has a finish that has an appearance almost of cloth. The resulting painting has a nice textural feel and as Khadi has an amazing ability to allow wet in wet work with minimal blending, both the model and the background have a nice loosely painted appearance.

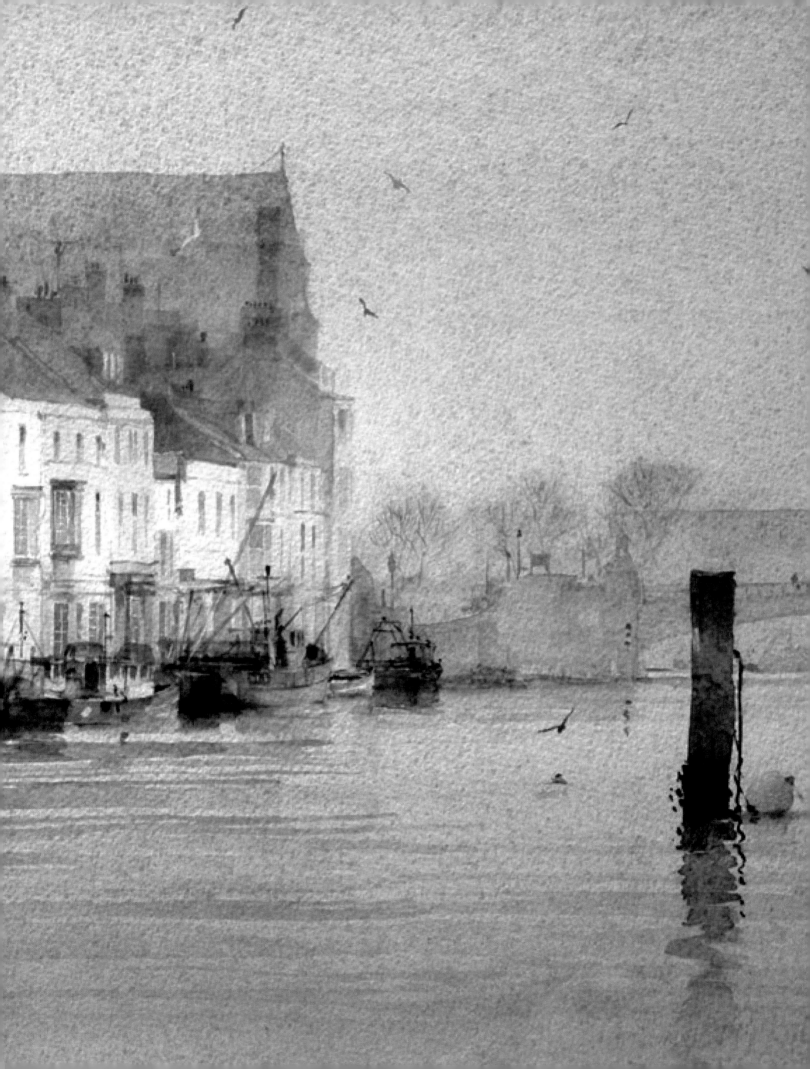

Chapter 10

Framing and Finishing

If you've gone to all the trouble of making sure that you are using the best materials for your paintings it can be very counter-productive to then cut corners when it comes to framing, not least because a cheap frame and mount suggests that you don't value your work and this will certainly put off many potential buyers. A decent quality frame and mount should enhance a watercolour and whilst you don't have to get too carried away on price, there are certain minimum standards that should be demanded. If you have gone to all the trouble and expense of using acid-free cotton rag paper for your painting with artist quality paint, then the last thing you want is to have it mounted in cheap non-acid free mount board, because the acid content in the board will migrate to the painting over a period of time and will ultimately damage it. A distressingly large number of framers tend to use inexpensive materials because they assume that the customer won't pay for better quality or don't know any different and that may be fine for real beginners or for framing inexpensive prints but if you're exhibiting and selling pictures, you have a responsibility to make sure that it's framed to a proper standard.

Whether you are using a local framer or doing it yourself, the aim is to mount the painting in an acid-free environment. That means using a quality, acid-free mount board or even better, one that is to conservation standard. You will regularly see paintings that have been framed for a year or two, where the bevel of the mount immediately round the picture has turned brown. That's the acid content beginning to show and apart from the eventual threat to the work itself, it looks horrible. The painting should be suspended from an acid-free barrier sheet or board behind it, by using proper acid-free or conservation mounting tape and the mount over the top to create in effect an acid-free sandwich.

Fig. 9.0 *Weymouth Winter Mists.*

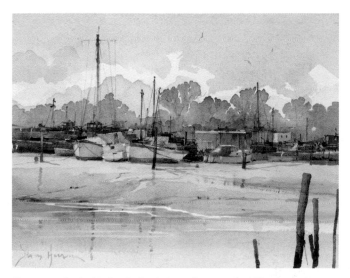

Fig. 10.1 *On the Mud at St. Osyth.* A small watercolour like this looks so much better with a good quality mount and frame.

The barrier sheet or board at the back is there to protect the artwork from the final backing material, which will normally be something like MDF, hardboard or card, none of which wants to be actually touching the painting itself. Just sticking a painting to the mount itself with masking tape, sellotape, craft tape or some sort of parcel tape is simply not good enough because again, these will deteriorate over a relatively short time and apart from the possible adverse effects with the painting itself, some are virtually impossible to remove later without damaging the artwork. Again, it's slightly worrying how some framers will use a quality acid-free mount board when requested and then stick down the painting with something you might use to wrap a parcel and have the picture resting against a sheet of MDF at the back. That's not good enough. The painting needs to be framed with an air gap between the picture and the glass, in that acid-free sandwich where no part of it is exposed to material that will damage or

contaminate it and then glazed and sealed to protect it from the atmosphere, dust and small bugs.

A good framer should know all this but there are plenty who cut corners, either to keep costs down or because they don't think it's worth the effort, but having invested your time and money in producing a picture with top quality materials it's not acceptable for a framer to mount it with the cheapest board and tape available and back it with cardboard. It's difficult to know what has been used when the picture is assembled and ready to be hung on a wall and this discussion needs to take place before you decide on who gets the job. An experienced framer should understand your requirements and be able to advise and quote prices accordingly.

There are alternatives to normal picture glass which promise more UV protection and non-reflective properties but I think it would be fair to say that most framers and painters don't bother, not least because the high-tech stuff gets expensive. If you do go down this route, forget non-reflective diffused glass. It requires the artwork to be virtually touching it but it still looks as though the picture is being viewed through a slight fog and its use is banned in many watercolour exhibitions. However, there are much more sophisticated examples of glass that promise additional UV protection and virtually no reflections, whilst at the same time providing a clearer view of the painting. They do add a significant price hike to the cost of framing but might be worth considering if your individual pricing structure justifies the additional cost or if you are sending in work to exhibitions where you want to make an impression and where the non-reflective properties might just give your work that extra edge.

One way of ensuring that your paintings are framed properly is to do it yourself but, without the proper equipment and appropriate skill, it isn't easy. For a start you really need a proper mount cutter, rather than a plastic ruler and a Stanley Knife. There are reasonably priced examples available from art material suppliers and DIY sources that can cope with cutting mounts up to about 30in in width but they tend to work better with smaller dimension mounts. They will allow you to cut mount windows with a bevel edge and in the right hands can produce a well finished mount. Do be aware however, that sheets of conservation mount board are relatively expensive and if your DIY skills are a bit dodgy, you might end up with some expensive scrappage in the waste bin. If you are producing a lot of work, there does come a point where a proper professional mount cutter might be worth consideration. Apart from the investment, they need a fair amount of space and to be placed on a proper solid work surface but they are designed for accurate and constant production of mounts and make life so much easier for the serious framer. If you have the room and need to make at least eight or ten mounts a month, they are worth consideration.

As ever, practice improves things and never more so if you decide to go in for cutting your own glass. Experienced glass cutters are able to cut the stuff with nonchalant ease but for the amateur, armed with a glass cutter from the corner shop, it can be a disaster zone and possibly downright dangerous. It takes a lot of practice and frankly it's probably better to find a glass supplier who will cut it to size for you. That just leaves the moulding. There are some very cheap mouldings available from hobby shops and frankly they look it and if they've been nailed together on the kitchen table with a bit of super glue they don't do very much for the pictures involved. If your carpentry skills with a mitre saw and assembly processes are exceptional, fine, but frankly unless you are prepared to invest in even more equipment you will never get to the standard that professional framers can achieve with powered underpinners and mitre cutters.

One way to handle the more difficult aspects of framing is to get a framer to make up frames complete with glass and backing but handle the mount cutting and final assembly of the painting in the frame yourself. Apart from ensuring that the artwork is properly mounted, it also means that you can order frames for stock and accordingly shorten the time between a painting being finished and being available for delivery, either to a gallery, exhibition or to a customer. It also helps you standardize on a particular moulding which suits your paintings and then stick with it because it looks so much more professional if you are showing at an exhibition or gallery when all your pictures are mounted and framed in the same way.

Exhibiting and Dealing with Galleries

Paintings are produced to be seen. Exhibiting them is a way of displaying your own interpretation of a particular subject and being judged amongst and by your contemporaries and it should be an inevitable part of the painting process that at some point you will seek the opinion of others outside a close circle of friends and family, who may feel a need to be too polite to be constructive or alternatively, might be very opinionated but actually clueless about what makes a good painting. If you are sufficiently serious, there will come a time when you need to be in a bigger arena, where your work can be seen by a wider audience and by people who know what they're talking about and of course by collectors who buy paintings. Many of you may be already be exhibiting at various levels but for those who aren't or for those looking to move up in the painting world, there's a point where some serious and honest self-appraisal is required. This can only be done by looking at the work of others, both at local exhibitions, galleries and where possible regional and national open exhibitions. Be

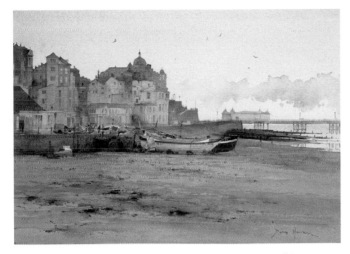

Fig. 10.2 *Crab Boats at Cromer.* This early morning picture of Cromer has a lot going for it. Architecture, boats and their attendant clutter, a lively sky and the fishermen provide human interest. It's the sort of busy painting that will always appeal to both galleries and collectors.

realistic and analytical because if you are entering work for shows that are clearly above your level of ability and getting regularly rejected, that can get both expensive and pretty depressing.

Everyone has to start somewhere and if you are a member of a local art group or society there's almost certainly going to be an annual show where your paintings can be displayed alongside other painters' work and where there will be the chance of selling a painting or two. Most of these shows allow you to take part if you are a member but things get considerably tougher if you want to move up the ladder and enter work for regional or national exhibitions. The majority of these require work to be submitted for consideration and are examined by a selection panel. It will involve submission fees and very possibly a requirement for digital images to be forwarded before the actual selection day and it does pay to do a little reconnaissance work before committing yourself to the expense and time involved as well as the very real risk of rejection. If you are honest with yourself, neither being too gung ho nor a fading violet, you should be able to come to some sort of realistic assessment as to how good you are by visiting the more important open shows. Don't bother with trendy and largely pointless events featuring video installations and conceptual rubbish but look for exhibitions that show the work of real and successful painters and try and determine whether you could hold your own amongst them. If you think that you can, then entering work for one of these events is worth having a go at. You will be up against some formidable competition from other artists as many of these exhibitions only take 10 to 20 per cent of what is submitted at the most and you will have to get used to the disappointment of rejection but be equally aware that when you do get something accepted, it's a massive boost to your confidence. Just remember, all good painters worry about what

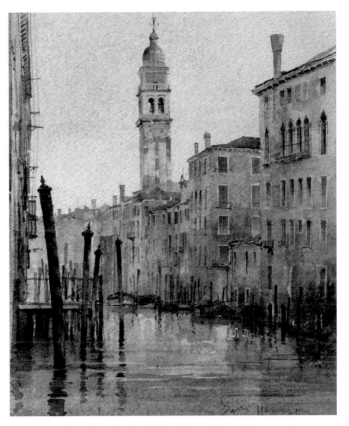

Fig. 10.3 *Chiesa San Giorgio dei Greci, Venice.* The ability to produce good quality digital images of your work is essential if you want to be submitting work for open exhibitions and to galleries for their websites and general publicity. You may also consider having your own website where a regular supply of new images is always an advantage. Do remember however, that images for websites should be reduced in size because if the file size is too big it will slow down the page-loading process. Additionally, it also increases the risk of someone, somewhere, pirating your picture and either printing it to hang on their wall or even to reproduce it in the form of cards or prints. Copyright law isn't universally recognized!

they do and to have a distinguished selection panel vote to hang one or more of your works balances the books somewhat.

Participation in a recognized regional or national exhibition will give you the opportunity of being discovered by galleries, to have your work seen and possibly purchased by discerning buyers and, if you can attend openings and Private Views, you should have the chance to get to meet fellow painters and even rub shoulders with some of the better known artists. Having your work shown in galleries can similarly advance your painting career but again there is a need to be sensible and businesslike with your approach to them. Different galleries specialize in different types of work and you need to be looking at galleries that hang similar style pictures to yours. It's unlikely that one specializing in large-scale acrylic abstracts will want to be talking to you about small watercolours, however competently painted. However, if you are looking at a gallery that displays a good selection of watercolours, ask yourself whether they are in a different league to your own

work, or is there a possibility that what you are doing could hold its own in that particular environment. Obviously if a gallery makes contact with you because they have seen your work in an exhibition, that makes things so much easier but most will always be interested in a new painter who produces work that is competent, saleable and sufficiently distinct from their existing gallery artists. That doesn't mean that you should just turn up with a collection of watercolours under your arm and expect a gallery owner, or whoever is manning the desk, to drop everything to have a look at what you've got to offer. Be professional, make an initial contact by phone or email and ask whether they are interested in looking at some new work. If you get a positive response, then an appointment can be arranged to see some of your work and to discuss how you might fit in with their plans. Do understand that you are dealing with a business and that commitments made, for instance, for supplying paintings for an exhibition at a certain date have to be adhered to.

Do accept that a good gallery business in a prominent location will have considerable overheads for both premises and staff and therefore need to charge a sensible commission rate. Most will expect you as a painter to supply paintings on a sale or return basis and the price of your work on the wall may well be somewhere around twice what you want for it. Some painters constantly moan about gallery commission rates but galleries are a way to a much wider audience of buyers and we need them to be running a business that means that they will be there for many years. Just tell them the figure that you want and let the gallery worry about the retail 'wall' figure. What isn't acceptable of course is a gallery that neglects to tell you that something is sold and hangs on to your money after a sale for an extended period. Paying you at the end of the month is fine but be wary of those that only seem to have just sold something when you happen to pop in.

Photographing Your Work

Having played down the need for photography in relation to your actual painting, exhibiting in general and supplying paintings to galleries will require the use of a decent camera. Most exhibitions will need submissions in the first place with digital images and the majority of galleries have their own website where potential customers can view paintings available and even make buying decisions on line. Gone are the days when the Private View of an exhibition might see eager buyers, clutching a printed catalogue and queueing outside the gallery before the doors opened, so that they could get first choice. These days it's important that you have images ready to be sent weeks before the show opens and that they need to be of a quality that means that they look good,

whether before a selection panel, on a website, or in particular in a catalogue if required.

Digital cameras have made this whole process much more straightforward. Gone are the days when paintings had to be photographed with transparency film and then sent away or taken to a local photo-lab to be processed, with no guarantee that the results were acceptable and might have to be done all over again. Most digital cameras from quality manufacturers are capable of excellent images but a certain amount of expertise is required to get the best out of them. It is important that the painting is photographed in decent light if possible and that it is square on to the camera. Photographs on a mobile phone, taken at an angle with half of the frame included and slightly blurred, simply won't do.

Ideally, when photographing paintings, the camera should be mounted on a tripod, which will not only avoid camera shake but will help in lining up the painting accurately. That of course requires a camera fitted with a tripod bush, which eliminates a surprising number of the compact variety. Zoom lenses should be set at a mid-point, both for the focal length setting and the lens aperture, rather than at their widest and most will have a white balance control which is used to adjust the camera according to the lighting available (the automatic setting is fine) and of course auto-exposure and auto-focus are the norm. A self-timer is handy to avoid camera shake at low shutter speeds, even when mounted on a tripod and you need to be able to set the ISO setting at around 100 or 200 to ensure top quality – oh and avoid using flash, unless you want to invest in a twin flash set-up that can be fine-tuned to provide an even flash illumination from either side of the painting. A standard 'on camera' flash will usually wash out colour on the image.

If this is all a load of gobbledy gook or your eyes are glazing over, you will realize that you either need a very good and knowledgeable friend or partner that might be persuaded to photograph pictures for you or you are going to have to learn a bit more about digital photography. Without diving any deeper on the technical side, it's fairly safe to say that most cameras of the single lens reflex variety (known as SLR's) will have everything you need. They are, however, somewhat cumbersome and can get fearfully expensive at the top end of the market but, for photographing paintings, the more basic SLR's are fine but they do have a downside that only a few have the ability to see a screen preview of the shot. Most SLR's don't, as they are primarily designed for use with interchangeable lenses and you get a very accurate view of the subject through the lens via a viewfinder and mirror system, plus an instant shutter release that captures the image in a split second. This makes them first choice for the serious amateur and professional photographers but with most you only see what the result looks like on the screen after the shot is taken.

Fig. 10.4 A digital single lens reflex (SLR) camera. First choice for professional and keen amateur photographers, they can be very expensive, bulky and heavy. Advantages include an accurate through the-lens viewfinder and interchangeable lenses making them still the best option for moving subjects and carefully composed and timed photographic shots. However, there are other options for photographing paintings.

Fig. 10.5 Canon G11 compact digital camera. This compact is roughly a third of the size and weight of the Nikon SLR above. It has a viewfinder, which is of marginal use but it also has a swivelling screen, which is definitely helpful when photographing paintings. Image quality is excellent and as well as studio use, it's small enough to slip into a rucksack or pocket for general photographic work.

Virtually all compact digital cameras have no viewfinder, apart from one or two top end models, but they do allow you to pre-view the image on a screen and some have screens that can be swivelled and adjusted to various viewing angles which can be very handy.

Even the cheapest compacts have far too many whistles and bells for most of us in electronic terms, but may well lack some of the more crucial features like a tripod bush, and certainly lens quality for copying paintings to a standard that is suitable for re-production needs to be much better than something designed for holiday snaps. However, there are compacts from the recognized top manufacturers that rival SLR's for image quality and, in addition, there a couple of other variations on the theme that are worth consideration. The so called Bridge cameras look like smaller versions of an SLR, but they don't have the interchangeable lenses associated with their larger brethren. What they do offer however, is the flexibility of both a screen preview and an electronic viewfinder and often an extraordinary lens range. This makes them very flexible all-rounders for general use as well as for studio copying and in more recent years compact 'System' cameras have appeared. Whilst these appear to be very similar to a normal compact, these too have the flexibility of an electronic viewfinder and screen, with the additional ability to change the lenses like an SLR. Even if you use them with just a 'standard' lens, this makes them similarly versatile and because they are aimed at the enthusiast market, they will tend to have the lens quality and equipment that is needed for accurate copying of paintings.

Just in case you thought that might be it on the photographic side, I'm afraid it doesn't end there. You will need photographic editing software on your computer. Once again, if you are not terribly technically savvy you might need some help but you have to be able to download images from the camera and at least do some basic processing. For a start the image will need cropping so that all you end up with is the painting itself and not part of the mount, the easel it's sitting on, or Auntie Edna in the background. Most cameras produce a photograph of a painting that seems a bit dull and dowdy in comparison with the original when displayed on a computer monitor, but processing software will allow you to improve this considerably by adjusting and correcting the tonal levels and colour balance. As a tip, don't rely on the automatic level adjustment – it is usually too bright and with too much contrast and it's better to learn how to do it manually. There are all sorts of other manipulative buttons that you can play with but frankly if you've used a decent camera and you've mastered cropping and levels, you should have a quality image to send on and of course, to add to your own records.

As a final point, the processing software will allow you to reduce the size of an image file. This is very handy for sending a number of images in particular because smaller files don't take an age to send and don't gum up the e-mail system and certainly for web use, smaller files are a must.

If you are consistently successful in having work accepted for open exhibitions, over a number of years with nationally or even internationally recognized societies, it's highly likely that they will offer you the chance to become a member. This process usually takes a few years, not least because existing members will be interested in your ability to consistently produce work of a high enough standard, but the crucial point is that in most societies it's the members who decide whether you're good enough. That's a tough hurdle but if you make it, you may well start with some sort of associate membership that in turn will lead to full membership. Being voted into a society on the basis of the quality of your work, rather than knowing people in the right places, is both an honour and a great achievement that the very best amongst us should aim for and painting should always be about working towards something better. Good painters will always think there's room for improvement and that there's always more to learn, but mastering watercolour and turning it into something bold and exciting has to be a worthy ambition for all of us.

Index